CW00520714

Caribbean Mothers:
Identity and experience
in the U.K.

the Tufnell Press,

London,
United Kingdom

www.tufnellpress.co.uk

email contact@tufnellpress.co.uk

British Library Cataloguing-in-Publication Data
A catalogue record for this book is
available from the British Library

ISBN 1872767 524

Copyright © 2005 Tracey Reynolds

The moral rights of the authors have been asserted.
Database right the Tufnell Press (maker).

All Rights reserved. No part of this publication may be reproduced, stored in a retrieval system, or transmitted in any form or by any means, electronic, mechanical, photocopying, recording or otherwise, without the prior permission of the publisher, or expressly by law, or under terms agreed with the appropriate reprographic rights organisation.

First published 2005

Printed in England and USA by Lightning Source

Caribbean Mothers: Identity and experience in the U.K.

Tracey Reynolds

In loving memory of

Daphne Reynolds

Contents

Acknowledgements

Special thanks to my parents, George and Daphne Reynolds, and my sisters, Karen and Sandra Reynolds. Your love, unfailing support and encouragement throughout all of the years have made all of this possible. To my best friend, Mariette Goulbourne, who has stuck by me through the good and bad times, dishing out your own unique brand of guidance, wisdom and common sense. Big hugs and kisses to my special friends, Helena Amartey, Charlotte Croffie, Marcia Smith and Debbie Bernard-Weekes. Thanks for allowing me to escape back into the 'real word' from time to time and for being there for me. You are all stars!

Very special thanks to Heidi Mirza and Rosalind Edwards whose supervision of my Ph.D. thesis gave me the confidence and freedom to develop my own ideas and for detailed comments on earlier drafts of the thesis. Thank you also to Janet Holland, Fiona Williams, and Patricia Hill-Collins, your positive feedback helped to encourage me in turning the thesis into this book. To Harry Goulbourne, John Solomos, Elisabetta Zontini, Kanwal Mand, Beverly Goring and Shaminder Thakar, and also the other members of the Family and Social Capital ESRC Research Group, many thanks for your support. Chapter Seven draws on material collected in a research project, *A small scale study of black welfare based community organisations in the U.K.*, funded by the Research Development Fund, London South Bank University, led by Professor Harry Goulbourne.

Finally, I reserve my biggest thanks to the mothers who participated in the study. This book would not have been possible without your participation. I am forever grateful that you allowed me into your homes and into your lives with so much trust. All of you are very special people. I am particularly indebted to Bridget, Carol, Dolly, Doris, Jheni, Paula and Marcia who really questioned me and put me through my paces during interviews that lasted five hours on average! Thank you all.

Chapter 1
Introduction

In the U.K. today, Caribbean[1] mothers are much maligned and misunderstood. In current social policy debates the popular perception of Caribbean mothers as strong, independent, self-reliant matriarchs mean that they come under criticism from all sides as bearing the brunt of responsibility for the breakdown of Caribbean family life and male absence from the household. Equally, in the rapidly expanding body of literature on motherhood and mothering, they are generally absent from the debates or are measured against yardsticks that reflect the norms of white middle-class mothers. Rarely, if ever, are Caribbean mothers a subject of study in their own right outside of stereotypical and pathological assumptions. Consequently, we know very little about how Caribbean women construct and understand their mothering. Nor do we know much about these women's experiences as mothers. This book presents an insight into the lives of Caribbean mothers in the U.K. based on the views of the mothers themselves. The research, on which it is based, explores how a range of cultural, historical and structural factors determine the mothers' experiences, identity and practices.

Caribbean mothers, as the central focus of debate in the study, raise new questions about social constructions of mothering. In addition, mothering is revealed to be equally as racialised as it is gendered. Contemporary mothering discourses generally overlook this factor and universalistic claims of mothering are based on white, middle-class, and heterosexual practices. The specific focus of this study also demonstrates that mothering issues that white, (and usually middle-class) mothers have only recently become attentive to (such as balancing and negotiating work and family roles; lone-mothering, kinship/community networks and extended family relationships) are intrinsic to Caribbean mothering and these mothers have long-standing historical experience of these areas. The study documents the experiences of a cross-section of first, second and third generation Caribbean mothers in the U.K. The mothering identity forged and mothering practices performed by these mothers represents their attempts

1 In the U.K. the term 'Caribbean' (also referred to as 'black Caribbean') is an official racial-ethnic category that is used to classify people originating from Caribbean ethnic backgrounds. For the purpose of this study the term 'Caribbean mothers' and 'Caribbean mothering' refers exclusively to African-Caribbean mothers and their mothering experiences. African-Caribbeans (i.e. people of African and Caribbean origin/descent and family heritage) are the largest and most instantly recognisable Caribbean migrant community in the U.K. (Owen, 1997; Goulbourne, 2002). However, I recognise that the Caribbean as a region and as ethnic category comprises diverse racial groups originating from European, Chinese, Indian, and Middle Eastern (i.e. Syrians) Diasporas.

to maintain established cultural, social and kinship links to their cultural and
ethnic origins[2], whilst at the same time adapting to the social circumstances of
being part of a black and minority ethnic community in the U.K.

Re-thinking mothering ideologies: intersections of race, class and gender

In the last fifty years a large body of research work has developed to address
the complexity and interactional nature of mothering and what it means to be
a mother in contemporary times. Much of the work has been dominated by
particular concerns. So for example, debates have concentrated on biological
versus social constructions of mothering; women's abortion and reproductive
rights, the mother-child relationship, mothers and paid work, maternal rights
and statutory provision, lone-motherhood, surrogacy 'new' reproductive
technologies such as in vitro fertilisation (IVF) and the genetic modification
of embryos. Undeniably, these concerns have been of interest and relevance to
black[3] mothers in the U.K. However, the intersection of race and gender (and
class) mean that black mothers also have vastly different mothering issues
and concerns that have often gone unrecognised in mothering discourses. For
example, during the 1970s the main emphasis of feminist concern centred on
women's reproductive rights, particularly women's right to control their fertility
and limit reproduction. In this political landscape, white women politically
mobilised to champion increased abortion rights for women (Richardson, 1993).
Black women, however, articulated very different concerns over this same issue
of reproductive rights. They highlighted that racist assumptions and attitudes to
black family life resulted in black women being coerced into abortion and forced
sterilisation and they politically mobilised against this issue and championed
women's right to have children (Bryan et al., 1985). Similarly, in education a
primary agenda for white mothers involves the matter of increased 'choice' in
choosing children's schools (Davis, 1993). In contrast, black mothers have

2 I recognise that seeking to construct a collective Caribbean mothering identity in the U.K. that connects
 back, and is rooted in, the Caribbean could in itself be considered problematic. The (mis)representation
 of the Caribbean as a collective and unitary region conflates and disguises the fact that the Caribbean is
 a diverse and differentiated region with each territory possessing its own unique traditions and customs.
 Further to this, in each specific country divisions of class, caste, ethnicity and rural/urban living all influence
 household family patterns, and family relationships.
3 Throughout the study I continually interchange between describing the mothers as black and Caribbean.
 This deliberate act reflects the interactional nature of their Caribbean cultural ethnic origins and black
 racial politicised status in the U.K. in shaping their mothering identity. In addition by using the term
 'black' I understand that many issues I highlight in the discussion will also be relevant and applicable to
 other black and minority ethnic mothers because they share the same structural racialised subordinate
 location.

focused their attention on rallying against the high rates of school exclusion and academic underachievement of their children (Goring, 2004). In recent years, for white mothers there has been increasing emphasis on achieving greater balance between work and home life (Reynolds et al., 2003; Edwards et al., 2004). Yet black mothers regard this as of secondary importance to their attempts to end racism and racial harassment in the work place (Harley, 1997; Dale and Holdsworth, 1998). Even the family, which white feminist critique as being oppressive for women, is identified by black feminists as supportive, and a 'safe haven', against racist society for black women (hooks, 1982).

These differing mothering issues and concerns experienced by black and white mothers clearly demonstrate that mothering cannot be understood in isolation from the intersecting factors of race, class and gender divisions. Hill Collins (1994) suggests that the narrow focus of analysis on white middle-class women in feminist theorising around mothering routinely minimizes the importance of these interlocking structures. This creates two problematic assumptions.

First, mothering is an individual act of caring and nurturing performed solely in the confines of family (typically nuclear) households. For black and minority ethnic mothers, mothering reflects both individual and community concerns involving paid work for family economic provision; strategies designed for the physical survival of children and community; and individual and collective identity.

Second, race and class divisions shape only the mothering context for minority ethnic and working-class women. In reality, race and class shape all women's mothering contexts and relationships irrespective of ethnic and racial categories but for white middle-class mothers their racial and class location is usually invisible in the debates. Exploring the mothering relationships of black and white women, Glenn (1994) suggests, '*race and class hierarchy creates interdependence as well as difference between white middle-class and working-class ethnic mothers*' (Glenn, 1994: 7). One example of this interdependent relationship is that historically white middle-class mothers, on account of their race and class privilege, regard mothering and child care services as commodities that are purchased from working-class and minority ethnic women, who are often mothers themselves. These women are then forced into finding other relatives to care for their own children while they are employed in providing child care and mothering services for the privileged mothers (Dill, 1988). Research also indicates that other social, cultural and economic developments reinforce the racial and class contexts of mothering. In the U.K., for example, high and

middle-income women have largely benefited from advances in reproductive technology such as in vitro fertilisation (IVF). Legislation and the medical profession control access to this treatment. White working-class and minority ethnic women have less opportunity to access this reproductive technology because of the high financial costs involved and the limited availability of free or financially affordable treatment offered under the National Health Service (Richardson, 1993). The issue of surrogacy, where an embryo is translated into another woman's womb, and is also achieved through medical advancements in IVF, further expands the possibilities for exploiting poor women's—especially black and 'third world' women—lack of economic options, because these women may be encouraged to sell their bodies for reproductive purposes (Glen, 1994). The racial and class contexts of mothering is also demonstrated by the high infant mortality rates that continue to disproportionately affect poor, working-class, black and minority ethnic groups (Duncan and Brookes-Gunn, 1997; Taylor et al., 1997). In another direction, the rapid rise of HIV/AIDS in developing countries such as Africa and the Caribbean and amongst poor and black people in advanced countries has expanded the number of young children who are orphaned or who provide mothering care themselves for their sick parents and siblings (Ellis, 2003). The number of adults that are dependent on mothering care in western societies has also greatly expanded because of an increasing elderly population. Such care, traditionally provided within family units and usually by a female relative, is either being turned over to nursing homes or family members are buying in carers to perform tasks in their relatives' homes. Here again in western societies people who tend to purchase care provision services are the white middle classes and the majority of carers are migrant women from the developing countries such as the Caribbean, Africa, the Philippines and Eastern Europe states (Gordon et al., 1996; Sevenhuijsen, 1998).

Researching Caribbean mothers in the U.K.

The analysis of Caribbean mothering in the U.K. commences from the post World War II period (late 1940s) and continues to present day[4]. This post war period marks the beginning of Caribbean mothering in the U.K. because it was during this era that Caribbean women arrived *en masse* to work in health,

4 Whilst this study does not go beyond the post war years it is important to note that black communities were established in the U.K. prior to this period, and as early as the 1900s. These were mainly in the old sea-port and dock areas of Bristol, Cardiff and Liverpool, where Caribbean men worked as seamen. However, it was almost exclusively men who migrated from the Caribbean and they married and raised families with the white indigenous women of these areas (James and Harris, 1993).

public utilities and the manufacturing/industrial sectors in large industrial metropolitan areas and in response to labour shortages in key industries (Dodgson, 1984). The young demographic profile of these migrant women meant that a large proportion of them were already mothers with young children when they migrated to the U.K. or they became mothers in a few years of their arrival here.

The research documents the mothering experiences of forty Caribbean mothers. During 1996 to 1997, I conducted in-depth qualitative interviews with twenty-five mothers living in four areas of London. These interviews were part of my doctoral thesis investigating African-Caribbean mothers in the U.K. (see Reynolds, 1999). In 1999 I carried out a further number of in-depth interviews with fifteen Caribbean mothers living in the geographical areas of London, Manchester, Birmingham, Coventry, and Huddersfield. These interviews were part of a small-scale study investigating Caribbean women's role in black community voluntary organisations (see Goulbourne and Reynolds, forthcoming; Reynolds, 2003b). The main advantage of a relatively small sample size of forty mothers is that it allows for an in-depth focus on the lives and experiences of these women. This is particularly important in under researched area of Caribbean mothering in the U.K. The age groups of the mothers range between 19 to 81 years-old. This wide age range facilitates the analysis of inter-generational similarities and differences. Four of the mothers in the study are third generation mothers, between the ages of 19 to 24 years-old; twenty-one mothers are second generation mothers, 25 to 40 years-old; eleven mothers are either second or first generation mothers, 41 to 60 years-old, and five mothers are first generation, 61 plus years-old and retired. These retired mothers provide a retrospective account of the mothering and the particular issues and concerns that they faced as first generation mothers raising black children from the 1950s through to the 1970s. The retired mothers' retrospective accounts are also vital in highlighting the generational shifts in child care and employment patterns that have occurred for black mothers over the years. In addition, these retired mothers assist with the care or of their grandchildren and great grandchildren today and so they continue to do mothering work.

In terms of the mothers' marital status, sixteen mothers are married (including mothers who have re-married) and twenty-four mothers self-define themselves as lone-mothers. There is a lot of variation in their understanding and definition of lone-mothering and this category comprises mothers who state that they are single-never married, divorced, widowed and living with their partners in conjugal

or 'visiting' relationships. (See appendix 1 for summary of the mothers who participated in the study). This relatively uneven distribution of mothers according to age category and marital status is a consequence of the 'snowballing' sample method I used to access the mothers for interview in a number of different sites. These included my own personal friends and contacts; black churches; colleges and universities; Caribbean community groups and black professional organisations. Following on from my interview with each mother they would refer me to one or two other mothers in their personal networks (primarily family and kinship members, friends and work colleagues) that I could approach for interview. The very randomness of this snowballing process meant that it was impossible for me to secure an equal number of mothers in each age category. The interviews took place in varied locations including their homes, place of work and voluntary community venues. Several interviews took place in the presence of children. All the mothers had children with black partners (primarily of Caribbean heritage) despite the high prevalence of mixed relationships between black and white partners in the U.K.[5] Consequently, discussions concerning 'mixed relationships' and its implications for black mothering and family life that have been highlighted elsewhere (for example, Tizard and Phoenix, 1993) are not fully explored in this study.

The interviews were generally lengthy and time-consuming, lasting approximately three hours. During the interviews I was especially concerned with thinking reflexively about how my status, a Caribbean woman and not a mother, would influence my interviews with the mothers. This form of reflexive thinking fits in with black feminist researchers' concerns with understanding the intersections of race, class and gender in the research process (Bhopal, 1997; Sudbury, 1998). My own experience as a Caribbean female researcher interviewing other Caribbean women, in essence my 'insider/outsider' research status, meant that I was attentive to how gender, race and class status impacts on the research process and interactions with the mothers. From the very onset when I was establishing my research sample I initially assumed that it would be easy for me to find other Caribbean women willing to participate in the study on the basis of our shared gender, ethnic and cultural background. However, my initial request for interviews were met with an ambivalent response by the mothers and the particular age of the woman was a primary factor in this. The (relationally) younger black mothers (those who I term in the study as 'second' and 'third' generation mothers, born and raised in the U.K. during the 1960s

5 I am unclear about the reasons for only securing mothers in black partnerships in my study but it is clear that
 the snowballing method where the mothers directed me towards other mothers in their personal networks
 is a primary factor in the sample generated.

onwards) openly welcomed my request to participate in the research. In contrast a substantial proportion of older mothers (age 50 plus, 'first' generation mothers who were born in the Caribbean and migrated to the U.K. as adult women or young girls) generally regarded my request with great unease, suspicion and mistrust. To overcome this reluctance by some of the first generation mothers I had to rely upon black community workers and senior members of the black church as my first points of entry. These women were well liked, trusted and respected in the black community. The mere fact that I was also a Caribbean woman counted for little.

Some of these first generation black mothers' responses towards me offer confirmation of Angela McRobbie's (1982) view that 'no research can be understood in a vacuum' and consequently, these women's responses must be considered in a wider social context. In the U.K., for example, black women have historically occupied a problematic position in social research. With some notable exceptions, and primarily developed through black feminist theory (for example Bryan et al., 1985; Mama, 1993; Mirza, 1992 and 1997; Reynolds, 1999; and Sudbury, 1998 amongst others) there has been a tendency in social research in the U.K. to either identify black women as marginal to the debate or as occupying a pathological and problematic position in society. This suspicion of me from some of the mothers also demonstrates that they recognised that, despite my status as academic researcher, my structural location as a black woman ensured that I was subject to similar structural constraints and issues of inequality and discrimination as themselves in academia. As a consequence the mothers understood that my role as interviewer did not automatically translate into me having overall control of the data and the way in which the raw data is analysed and reported because like other black women I am subject to similar patterns of control and exploitation. At the start of each interview I was frequently asked who was I doing the research for? Was anyone else involved in the project? Would I be involved in the finally writing up of the study? Underpinning these questions was an implicit assumption and concern by the mothers that my role as researcher would be strictly limited to conducting the interview; and that another more powerful person (i.e. a white male academic) would have the responsibility for analysing and reporting the data.

A more complex discussion of power relations demonstrates that social research is inextricably linked to wider race, class and gender divisions in society. Diane Wolf (1996) argues that social research is generally conducted by individuals and groups in society who posses a higher social status than the

individuals and groups who they are researching. So for example, (and using crude and simplistic binaries), it is common for researchers from a middle-class background to investigate the experiences of working-class groups.

Cultural historical factors also go some way towards explaining some black women's reluctance to participate in research. bell hooks (1989) contends that historically black women have been socialised to keep personal thoughts to themselves and if they must be discussed, this should occur in the private confines of the home with family and close friends. Black women's 'silences' have historically acted as a site of resistance in societies that seek to denigrate them. For example, during the slavery period black women's 'silences' in the public domain led to personal survival and the opportunity to sustain various aspects of their cultural heritage (Chamberlain, 1995).

Black feminist researchers have had to develop a reflexive understanding of their own racialised and gendered location in society and the way that this may inform power relations in the research process. Kum Kum Bhavnani's discussion (1993), concerning her interviews with a group of adolescents about their schooling is particularly useful in demonstrating the impact of societal structural divisions on shifting power relations between the researcher and research subject during the research process. Bhavnani comments: *'my age, and my assumed class affiliation may have been taken as sources of potential domination. However, my racialised and gender ascription suggested the opposite. That is, in this instance, the interviewees and myself were inscribed in multi-faceted power relations which had structural dominance and structural subordination in play on both sides'* (1993: 101). As the above quotation indicates, Bhavnani's 'Asian-ness' and 'female-ness', two fundamental aspects of her personal identity, inscribed her a structurally subordinate status in relation to the white boys whose 'whiteness' and 'maleness' placed them in a structurally dominant location. This was demonstrated in the interviews where she allowed them to dictate and control the style and pace of questioning at this localised and personalised level of research. However, her shared racial background and age with the Asian girls meant that she could utilise her higher social class status to assume control in the interviews with schoolgirls.

In this study, class and generation divisions influenced the interview process in various ways. First, the mother's own individual assessment of social class difference created a shifting power dynamic between us. During the interviews I alternated between being perceived by these women as either working-class or middle-class and this affected their response to me. For example, the middle-class

status I was given by some of the mothers who defined themselves as working-class created the belief that I had access to certain information and resources that they, as working-class women, would be restricted from accessing. Some of the working-class mothers, in particular those who had low educational attainment, would ask my opinion about the social and educational aspects of higher education. In addition they would ask my advice on career and housing matters. They also requested my help in obtaining information for them from officials because they felt that my requests would have a more positive outcome. Second, with regards to generation divisions, often I felt intimidated when interviewing some of the older mothers because of the wide age difference and the fact that these mothers possess a wealth of experience. My own cultural background also meant that I was raised to respect my elders and not question them on matters that would prove to be embarrassing or intrusive for fear of appearing disrespectful. As a consequence I felt reluctant in posing questions to these mothers that I had no problems asking the younger black women, such as the discussion areas that centred on constructions of black female sexuality and sexual identity. In this instance, I felt once again that power and authority rested with the research participants, contradicting the traditional viewpoint of the 'powerful researcher.' This interaction between race, class and gender suggests that power in social research is not a fixed and unitary construct, exercised by the researcher over the research subject. Instead power is multi-faceted, relational and interactional and is constantly shifting being re-negotiated itself between the researcher and the research participant according to differing contexts. Consequently, any understanding of Caribbean women's experiences in social research, either as a researcher or a research participant, needs to be viewed in the context of their wider structural location in the U.K. This research relationship is a salient feature of my analysis of Caribbean mothering in the U.K.

Chapter outline

This book is concerned with exploring Caribbean mothers' experience, identity and practices. This chapter introduced the subject of study, Caribbean mothers, and outlined the rationale and importance of the research. But before we can begin to understand the experiences of these mothers it is important to clarify the feminist approach that shapes this study. Chapter 2 provides a detail analysis of black feminism and the particular ways this feminist approach has developed a black feminist standpoint theory to critique westernised mothering discourses. Despite the limitations of black feminist standpoint theory, which I highlight in

this chapter, this study of Caribbean mothering derives from, and is motivated by, this feminist approach because of its desire to place black women's experiences at the centre of analysis. Commonalities exist between the Caribbean mothers with regards to a shared racial and cultural background. An important aspect of the study is to construct and demonstrate a collective mothering identity, and the factors that shape this. However, in doing so, it is equally important to guard against representing these mothers as an essentialised and homogenous construct. Chapter 3 achieves that by identifying those discourses of difference which underpin the mothers' narratives. The chapter draws on the mothers' accounts in the study to reveal that they conceptualise and understand difference on a number of distinct but intersecting levels, including racial difference, social class divisions and difference informed by transitory individual subjectivities and life-cycle.

Chapter 4 outlines how the mothers utilise these discourses of difference in their mothering to construct a collective mothering identity. This identity relies upon cultural traditions and cultural memory and it is shaped by factors of racism, and their racial 'other' and minority ethnic status in the U.K.

Chapter 5 demonstrates that an important part of Caribbean mothers collective identity and mothering work involves the development of child rearing strategies to resist and respond to their marginalised and racialised location. The strategies the mothers utilise as modes of resistance include: the mental and emotional preparation of their children to confront and challenge racism in their everyday lives; the surveillance of their children's education; constructions of cultural belonging through the celebration of Caribbean cultural traditions; and the policing and monitoring of children in public spaces.

Chapter 6 demonstrates that for Caribbean mothers another important facet of their collective mothering identity is paid work. Economic provision for their children through paid work, in addition to mothering and child rearing work in the home, is intrinsic to Caribbean mothering and a central feature of the Caribbean mothers experiences in the U.K. Both structural economic and cultural explanations are used as evidence of this long standing historical experience.

Chapter 7 introduces the notion of 'community mothering' to establish that Caribbean mothering also encompasses maternal responsibility and mothering work for family, kinship, community and members. In the U.K., the increasing number of welfare based Caribbean community organisations that provide care and support for children and other vulnerable adults (elderly, mentally ill

and disabled) that are established, headed up, and dominated by Caribbean mothers, is testimony of a mothering identity defined by individual/family and collective/community concerns.

Chapter 8 looks at the mothers' views concerning male participation and involvement in family life and ways that their 'absent presence' and 'present absence' actively informs their mothering. Much of the literature concerning women's role and status in family life has overlooked the participation and involvement of Caribbean men. There is limited analysis to challenge the common characterisation of Caribbean men as absent, irresponsible, feckless and marginal in family relationships. From a wider structuralist perspective there is limited understanding of how patriarchal relations govern family relationships between Caribbean men and women and household arrangements.

The conclusion, chapter 9, brings together the main themes and issues raised throughout the book to understand its policy relevance in U.K. society today. It examines how the material in previous chapters combines to form a Caribbean mothering identity based on collective and diverse experiences, practice and values.

Chapter 2
Whose Experiences? Re-thinking Caribbean mothering

Introduction

To make sense of the Caribbean mothers' narratives that unfold in this study it is important to clarify the feminist approach and theoretical perspective that have shaped this research. In feminist writings differences between women based on ethnicity, race, sexuality, class are being increasingly acknowledged (Barrett and McIntosh, 1985). Similarly there is a growing body of literature in black and white feminist writings that challenge the invisibility of black women's experiences (Williams, 1989; Phoenix, 1997). These debates provide theoretical accounts of the intersectionality of race, class and gender, conceptualisations of racism and the racialisation process that occur in nation states (see for example, Anthias and Yuval-Davis, 1992; Phoenix, 1994; Carby, 1996; Mirza, 1997). Nonetheless and despite these gains, black feminists have been critical of conventional approaches to ideologies of mothering in feminist analysis because of their general failure in highlighting race, class and gender divisions in socio-political discourses of mothering (Dill, 1988; Hill-Collins, 1994). This chapter highlights some of the feminist approaches to mothering and black mothering. It also explores how black feminist perspectives, in contrast to conventional discourses of mothering, utilise black feminist standpoint theory to position black mothers, and their mothering experiences, at the centre of analysis.

Feminism, black feminism and mothering ideologies

Mothering involves caring work on the part of women (Tarlow, 1996). Mothers and women are often treated as synonymous categories because motherhood is viewed as women's primary identity (Bassin et al., 1994; Glenn et al., 1994). Feminism opened up research and conceptualisations of mothering and it openly questioned motherhood as a biological destiny for all women (Richardson, 1993). Research was developed around understanding mothering as identity, experience and practice (Arendell, 2004). More recently a body of conceptual and empirical work is developing around care and caring (Ungerson, 1990; Sevenhuijsen, 1998).

Much of the feminist critique of the mothering literature, developed from the 1970s onwards and propelled by the women's movement, concerned itself with challenging the 'naturalisation of motherhood' (Chodorow, 1977;

Dinnerstein, 1979; Oakley, 1979; Ruddick, 1980; Chodorow and Contratto, 1982). Actively promoted during the 1950s by mothering 'experts' such as Bowlby and Winnicott (1953), this viewpoint reinforced the idea that mothering is a natural act because mothers possess an instinctual need or drive, a maternal instinct, to mother their infants. In contrast feminist scholarship emphasised the social construction of mothering and the specific social and cultural contexts in which mothering is embedded. They highlight that what is vital to explore is the social and cultural translation of this reproductive function, and not the function itself, that positions women as mothers/potential mothers. Some of the earliest feminist research by Firestone (1970) and Oakley (1977), for example, argues that patriarchal relations and the economic production of labour in industrial capitalist societies are the primary route though which women's reproductive capacity translates into mothering as 'natural.' These relations structure a dichotomous split between the public and private, ensuring work (paid employment) and the family are perceived as separate. Gendered segregated roles, positioning men in the public sphere and women in the private one, lead to male control of the economic resources through his activity in the public sphere. In contrast, women are subordinated in the domestic sphere. Conceptualisations of mothering as 'natural' and 'human' are therefore central to patriarchal constructs of mothering (Millett, 1970; Rich, 1977). The literature suggests that by situating mothering ideologies in biological instead of contextual socially constructed discourses, women are encouraged to accept their subordinate position without questioning this structural location. Two universal but contrasting images sustain existing gender relations: firstly, images of the female body as corrupt, and impure; and secondly, images of the mother's body as pure, sacred, nourishing and asexual. The former is presented as a challenge, a threat to masculinity and the latter as destiny for all women. Victorian constructions of the 'angel-wife/mother' and the 'immoral prostitute' best represent these universal paradoxical images of women (ibid.). These images are still deeply enmeshed in societal norms today, sustaining gender inequalities intergenerationally. The 'institution of motherhood' where marriage and heterosexuality is universally ascribed primarily exists to serve male interests (ibid.). Mothering that falls outside of this boundary, such as lone-mothering and lesbian mothering, is vilified because they are outside of male control and authority thus acting as a direct challenge to the existing *status quo*.

Feminist perspectives concerning the role of patriarchy as a determinant of the 'naturalisation of motherhood' begs the question whose patriarchy? Dominant

feminist conceptions of patriarchy imply male domination over all women (Walby, 1990). This essentialised model of gender relations treats men as an undifferentiated group independent of class, race and status divisions. Black feminist debates are critical of this approach because they understand that race and social class are fundamental to men and women's relation to patriarchy (Davis, 1981; Carby, 1982; Anthias and Yuval-Davies, 1983; Amos and Parmar, 1984; Bhavnani and Coulso, 1986; Hill-Collins, 1990; hooks, 1990; Brah, 1991; Maynard, 1994; Mirza, 1997). Black feminists such as Michele Wallace (1978) and Angela Davis (1981) argue that white women's subordinate position is very specific to gender relations with white men. Black men, as a result of their subordinated masculinised identities and racial oppression have never assumed dominance and authority over white women. In fact, history suggests that white women have colluded with their male counterparts to racially oppress both black men and black women. Nonetheless, it is important to clarify that black men are not exempt from patriarchal relations and the power and privilege this affords them in relation to black women. Patricia Mohammed's (2004) analysis of black male and female relations in a Caribbean context contends that, contrary to conventional beliefs, patriarchy existed in the region prior to European colonial rule. However, the European system of patriarchy developed under colonial rule institutionalised patriarchy and established it as a central feature of the cultural and political economy of the region. Although black men were effectively denied access to social and political resources, each generation was socialised to internalise and support these patriarchal ideals whereby male privilege and power is regarded as their entitlement. This explains why across diverse Caribbean communities in the Diaspora patriarchal relations inform black male-female relations despite a culture of female-centred households (i.e. matri-focal households). In instances where a male figure is present in households he assumes power and authority over family and household affairs. Chapter 8 explores this issue further.

Re-thinking Caribbean mothering

Before we can go onto examine the very specific experiences of Caribbean mothers in the U.K. it is necessary to first understand the ways that their mothering is framed around particular social, cultural and historical contexts. There is much evidence to suggest that Caribbean mothering in the U.K. represents both a structural-economic and a cultural phenomenon. Structural-economic because Caribbean mothers, as a result of their racial and gender

status, occupy a collective subordinate location and they have unequal access to resources compared with white men and women. The collective experiences of slavery, colonialism, migration, racism and sexism have each encouraged this unequal access to resources. In addition, historically for Caribbean mothers the gendered division of labour that traditionally separates men and women's activities, according to public and private spheres, is much more blurred and interwoven. Generally speaking, as Hill-Collins (1994) observes, the separation between public and private spheres is not maintained for black mothers because *'mothering and work experiences occur at the boundaries demarking these dualities'* (Hill-Collins, 1994, p. 48).

Some writers have argued that this interweaving of the public and private spheres for black mothers is rooted in African patterns of family organisation that have been transplanted, transformed, and survived the institution of slavery in the Caribbean and North America to continue into present day. (Herskovits, 1941; Sudakasa, 1996; Nnaemeka, 1997). While other writers claim that black mothers' structural location is rooted in, and attributable to, European slavery (Frazier, 1948; Gutman, 1976). Those writers that support this *Africanist* perspective refer back to studies by W. E. B. DuBois (1908), one of its earliest advocates. Dubois stressed the importance of understanding the relevance of Western African heritage on black family organisation in Caribbean and North American societies. He contends that although the institution of slavery in these societies prohibited the replication of African lineage and family life, it did not remove the core values and societal codes underlying them. The slaves brought with them values that highlight family membership based on consanguinity, in other words kinship rooted in 'blood ties'. African families were organised around consanguineal cores of adult family members that were either patri-or matri-lineage. These blood ties have far greater importance to African family life than conjugal ties that dominated family organisation in European societies. Under this form of family organisation, each family member took on different roles and labour in and outside of the family compound. This was dependent on their seniority and family status and not a gendered division of labour. In the family unit, both the male and female elders wielded considerable power, authority and influence along with mothers and adult sisters in terms of responsibility and decision-making for the family.

Supporters of this viewpoint, that suggests African patterns have survived and continued in present day, point to the way that Caribbean families have traditionally been organised around matri-lineage structures—such as matri-

focal households or family units—that comprise mother, child, and extended matri-lineage kin. R. T. Smith's (1953) influential study of Caribbean family life acknowledges that in the Caribbean the concept of family primarily means relationships created by 'blood' rather than conjugal ties. This is seen in the way that motherhood is culturally valued over and above marriage and the organisation of family units are not necessarily dependent upon conjugal ties. Children are socialised to think in terms of obligation to mothers, siblings and other 'close kin' as more important than obligation to outsiders such as spouses, (Clarke, 1957; Barrow, 1996; Smith, 1996). These typical family structures and household arrangements mean that women's activities in public/private spaces are not so rigidly defined and their power and authority in their family are equally governed by seniority, determined by age or status, as well as gender (Gonzalez, 1982; Mckenzie, 1982; Berlant-Schiller and Maurer, 1993). Of course, not all Caribbean families emphasise consanguineal relationships and factors such as class, education and social status historically have influenced the consanguineal or conjugal family structures. Middle-class families are more likely to favour conjugal family units and the poor/working-class are much more consanguineal focused in their family groupings (Roopnarine and Brown, 1997).

The relevance of Africa for understanding black family relationships and household structures in the Caribbean, U.K. and U.S.A. have been criticised by those writers who recognise that slavery as the starting point for the analysis of black families in these societies. Two leading authors of this perspective, Franklin Frazier (1948) and Herbert Gutman (1976), argue that it is difficult to identify the particular ethnic groups or communities that influenced the organising principles of black families because of the sheer diversity of cultures, language and social structural factors of slave descendants. In addition, the *Africanist* position fails to account for the socio-economic context of slavery in which black family structures developed and the influence of European values on family organisation. They contend that the blurring of the boundaries marking out public/private spheres that characterise black women's relations is firmly rooted in, and attributable to, European slavery. The organisational principles of slavery created a structure in which black women, irrespective of their maternal status, were viewed as commodities and, alongside their menfolk, they provided free labour and were positioned as 'workers' (Gutman, 1976; Davis, 1981; Shaw, 1994). The adaptation of the 'slave culture' *vis-à-vis* socialisation, and in response to black people's socio-economic circumstances, is responsible for women's continued worker/mother role in the public and private sphere and

female-centred households. Leading commentators on the Caribbean family return to this adaptation model to understand why Caribbean mothers' long standing status as 'workers'—whether it be free, indentured, migrant or paid labour—has continued from slavery, across successive generations and up to the present day (Dodgson, 1984; Bryan et al., 1984; Berleant-Schiller and Maurer, 1993; Seguera, 1994).

Despite these contrasting perspectives concerning the origins of role relationships, family structures and household arrangements both approaches suggest that Caribbean mothers and their family relationships encompass social-structural issues and cultural traditions that mark them out as 'alternative' to European/western white family models and relationships. Black feminists' discussion of the family also supports this stance challenging conventional feminist claims that mothering is primarily based on sets of complex and interacting relationships between self/mother, family and child (see Ribbens, 1995). Patricia Hill Collins' work (1994) recognises that, instead, for black mothers, mothering extends beyond this essentially private realm of the family. The care black mothers provide for their children '*is inextricably linked to socio-cultural concerns*' (Hill-Collins, 1994:47). In this sense mothering does not merely involve the physical, mental and emotional care of the individual child but also 'strategic mothering' wherein these mothers engage in strategic child rearing practices to encourage their children to move beyond racial stereotypes that seek to constrain them (Higginbotham, 2001; Reynolds, 2003 and chapter 5 of this volume).

Black feminists argue that in contrast to white middle-class mothers, whose norms and values are mirrored and affirmed in mainstream society, black mothers' work, irrespective of ethnic grouping, involves them actively challenging societal norms and values which identify their children and familial experiences as inferior (Hill-Collins, 1994). Consequently, these women's mothering work is not just an individual activity because it has important ramifications and wider implications for black communities at large. At a community level black mothering represents conscious and collective modes of resistance. Hill-Collins (1994) introduces the concept 'community mothers' and Naples (1996) the term 'activist mothering' to historically map black women's role, across successive generations, in providing informal and voluntary care through community projects and education programmes for black children residing in their local communities. Similarly, shared mothering has been an important mothering practice for black mothers (Stack, 1974; Roschelle, 1997). In the Caribbean

context, Lynda Pulsipher's (1994) study of multi-generational low-income houseyards[1] in the Caribbean reveals that caring for children and other kin is shared among other houseyard members. Studies by Elsie Leo-Rhynie (1997) and Karen Fog Olwig (1999) both acknowledge that in the Caribbean a well established feature of family life is that children regularly reside with, and are cared for by, their grandmothers or senior female relatives (e.g. great-aunt) on a permanent basis in order to encourage mothers to seek employment. The idea that senior female relatives should care for children so that the mother can act as economic provider for the family is regarded as a functional and pragmatic approach to child rearing. Evelyn Dodgson's (1984) analysis of Caribbean mothers who migrated to the U.K. in the post war era highlights that the vast majority of these women left their children behind in the Caribbean to be cared for by relatives until they could send for them to live in the U.K. at a later date. This practice still continues today with a new wave of Caribbean mothers who have been recently recruited to teaching and nursing posts in response to labour shortages in these areas (Reynolds, forthcoming). Similarly, writing about black mothering in the U.S.A. context, Stack and Burton's study (1994) of low-income African American multi-generational kinship networks demonstrates the reciprocal nature of kinship caring. Underpinning kinship relationships is the cultural expectation and obligation that care will be shared among family members. Members are 'kinscripted', or recruited to care for family who may have previously cared for them.

Ultimately, this family and community work by black mothers represents their collective and individual resistance to societal institutions, structures and processes that seek to subvert them. Unfortunately, in contemporary western mothering ideologies, the social and cultural significance of black mother's practices, values and work are typically overlooked or down played because the mothers assume a marginal or oppositional location in the discourse. Black feminists have attempted to redress this imbalance by developing a methodological framework to study black women's experiences and position their voices at the centre of analysis.

1 In the Caribbean, small, enclosed properties of half an acre of less, with a number of dwellings, small livestock, fruit trees, herb gardens, protected play and work space.

Whose experiences? Whose Voices?
Black feminist standpoint theory

Black feminist standpoint theory attempts to position black women at the centre, instead of the margins, of debate so that they assume an active role in (re)naming and (re)defining their own lives. At the heart of black feminist standpoint theory is the view that there exists a specialised knowledge produced by black women that clarifies a particular standpoint of and about black women (Hill-Collins, 1990). The critical analysis of black women's lived experiences is crucial to the construction of theory (Griffin, 1996), and knowledge production is based on notions of a collective history, and collective struggle by black women against racial and gender inequalities (Amos and Parmar, 1984; Mama, 1995). Supporters of black feminist standpoint theory look to black women's everyday experiences as possible sources of knowledge production about black women. Black women's desire to voice their experiences and collectively organise themselves is articulated through the key sites of motherhood and family, education, employment and community activism. These sites not only allow black women to define their own experiences using their own voices' but it also enables them to challenge the dominant discourse of black womanhood that either marginalises or pathologises their experiences.

Recent discussion of mothering and the family offers a clear case in point. Feminist debates have focused on the issue of 'choice', and in particular women's choice to decide and define their family relationships and household structures outside of normative (i.e. nuclear, married and heterosexual) family arrangements (Woodward, 1997; Jagger and Wright, 1999; Silva and Smart, 1999). Discussions have also centred on changing attitudes to maternal employment and the implications of this for family relationships and gendered division of labour in the home (Duncan and Edwards, 1999; Reynolds et al., 2003; Edwards et al., 2004). Although these discussions have been of some concern to black women a plethora of research exists that indicates that their primary focus and struggle are framed around the development and deployment of strategies with which to challenge racial inequality in their own and their children's lives (see chapter 5 in this volume; Phoenix, 1987; Exploring Parenthood, 1997; Goulbourne and Chamberlain, 1999; Reynolds, 2003a). Caribbean mothers have used the concerns they have for themselves and their children to politically and collectively mobilise themselves towards collective action (Sudbury, 1998; Reynolds 2003b; Goring, 2004)

Black feminist claims of a black feminist standpoints rest on the concept of 'experience.' The concept of 'experience' was seized upon as a critical tool by feminist theory in order to distinguish their theories from those masculinist discourses believed to dominate the existing natural and social sciences. 'Experience' provided the foundation from which feminism could offer an alternative theory (Weedon, 1987; Lennon and Whitford, 1994). However, the concept is generally assumed be self-explanatory and there has been little in the way of systematic investigation of what the terms actually means. Lazreg (1994:50) argues that as a concept 'experience' *is elusive, multiple and discursive.'* It could therefore mean emotional, personal or personality. However, the different components that comprise this concept are conflated to a unitary and distorted meaning and the concept 'experience' has become 'concrete-ised' to reflect solely structural factors such as the cultural, national, economic and political contexts that shape women's lives (ibid.: 51). Lewis (2000: 173) recognises the way feminist theory has oversimplified analysis of '*experience*' and suggests that analysis of this concept should be '*widened, deepened and embedded.'* Drawing upon the work of U.S.A. based writers, Joan Scott and Chalpade Mohanty, Lewis examines the socio-historical specificity of 'experience' and the manner in which this is constituted through '*webs of social, political and cultural relations which are themselves organised around axes of power and which act to constitute subjectivities and identities*' (p. 173).

As a concept 'experience', and its centrality to theory, derives from the very masculinist tradition of the natural and social sciences that feminist standpoint theories are critical of and seek to separate themselves from. This theoretical position can be traced back to what is often termed the classical era of philosophy. Karl Marx, for example, assumed a proletariat standpoint to develop a critique of bourgeois capitalist society and move beyond the ruling class ideology (Hartstock, 1997). In a similar manner to feminist standpoints, Marxist theory seeks to situate individual subjectivity in a collective subjectivity. Notions of individuality and collectivity become inextricably linked and interconnected and individual subjectivities rest upon the juncture of self, community and identity. Black feminist theory adopts an almost identical approach to the notion of self and community in the analysis of black women's lives. In black feminist research black women's sense of self and their individual subjectivity also continue to be constructed through their relationship to 'community' (Mama, 1995; Sudbury, 1998, Lewis, 2000). For example, Julia Sudbury's study (1998) highlights the strong sense of individual moral obligation that black women feel in maintaining

close ties to the 'community' (if only at an ideological level). Caribbean mothers in the U.K. also invoke this relationship between self and community on both practical and emotional levels through their strong investment in the 'community' and involvement in community activities and programmes (i.e. the running of black supplementary/Saturday schools and other community based programmes) (Reay and Mirza, 1997; Reynolds, 2003b; Goring, 2004). 'Community', and what appears to be a strong moral obligation and personal investment in this, is understood by Caribbean groups as both constitutive of a spatial geographical community and one that is 'imagined' (Anderson, 1981), constructed through their shared racial, gender and cultural location.

Black feminist standpoint theory raises a number of problematic assumptions. In privileging experience, images of authentic and essentialised black women are promoted. Those black women that do not fit the essentialised model are effectively excluded from analysis because in shaping a black women's knowledge based on a collective black women's experience, black feminist standpoint is reductionist by its very nature. The diverse experiences of black women are reduced and conflated to present a particular worldview. Specific groups of black women's voices come to the fore and come to speak for all black women and those black women whose experiences who do not fit with this group are silenced. One of the most obvious cases concerns the experiences of black lesbian women. Whilst black lesbian writers have been central to the development of black feminist epistemology and the right for black women to have their voices heard, their viewpoints have been often silenced or marginalised in the debate. Black feminist standpoint theory has yet to fully critically engage with the homophobic stance that exists in some black communities. The idea that black feminist epistemology is a specialised knowledge stemming from the collective experience of black women worldwide is further challenged because to date African-American feminists' perspectives have dominated the theorisation of black women's experiences and the production of a black women's knowledge. There is no denying that African-American feminist thinkers have been essential to carving out new ways in thinking about black womanhood. However an inherent danger with this U.S.A. dominated knowledge is black women's experiences elsewhere in the world receive limited theoretical consideration in the production of a black feminist standpoint. This hinders an understanding of the differing cultural and social in which contexts other black women live and and how this informs their experiences in the U.K. Black feminist standpoint theory for example, recognises the distinctive migration pattern of black women from

Africa, the Caribbean, and the Indian sub-content in shaping their experiences
and their collective and individual struggles (Mirza, 1997). Similarly, black
feminism in the Caribbean is concerned with the influence of gender relations on
social class/status divisions, ethnic/colour divisions, poverty and development.
It is also concerned with the impact of outward migration and HIV/AIDS
on the region (Barriteau, 2003; Rheddock, 2003). Black feminists, working in
developing societies, the so-called 'third world', have been especially critical of
the implicit assumption that black feminists in western societies speak for, and
represent the experiences of, black women globally (Minh-ha, 1989; Mohanty,
1992; Bar-On, 1993; Narayan, 1997).

Donna Haraway (1988) and Sandra Harding (1991) explore this relationship
between knowledge and power by examining the knowledge production process.
Black feminist standpoint should be viewed against this backdrop. Harding's
and Haraway's respective findings indicate that all knowledge (including the
claim of a black feminist standpoint and knowledge), is socially constructed,
and representative of a partial perspective or standpoint in specific historical
and cultural contexts. All knowledge production is also context bound and time
bound. Volker Schmidt (2001: 139) clearly sums up the contextual nature of
knowledge production with his claim that all knowledges *have their own history,
are rooted in a particular tradition, and in a peculiar way they all symbolise and
embody important elements of the socio-historical context in which they emerge.*'
Nonetheless, black feminist standpoint is 'subjugated knowledge' because it
runs counter to the dominant ideology and is not accepted as valid knowledge
by dominant groups in society (Hill-Collins, 1990). As subjugated knowledge
determined by their 'other' or marginal structural location black feminist
standpoint provides the basis of a 'new politics of resistance and critique' (Hall,
1992: 251). New forms of dialogue are also created. Heidi Mirza's analysis of
black feminist standpoint, for example, recognises black women's 'other' status
as a 'third space' between the margins of race, gender and class (1997:4). In
this space, she suggests, there exists 'no official language and discourse' and as a
consequence black women are placed in the unique position of active agents in
the construction of discourses that tell their stories. Black women's position as
'other' affords them the opportunity to manipulate the boundaries of race and
gender to suit their own ends (Wallman, 1988). Thus, despite the problems
associated with the privileging of 'experience' in black feminist standpoint
theory, some of which I identify above, it has sustained a central focus in the
discussions. Gail Lewis (2000) points out that that this has everything to do

with its political importance for black women as collective position from which to challenge dominant standpoints.

Conclusion

The mothering experiences of Caribbean, and indeed black mothers in general, have been marginal to ideologies and discourses of mothering in the U.K. Whilst, feminist debates have highlighted the gendered power relations and patriarchy that underpin biological and social constructs of mothering, they have been less successful in exploring how intersections of race, class and gender create very different gender and patriarchal relations, and access to resources, for diverse groups of mothers. Black feminists argue that black mothers have very different mothering experiences in relation to white women as a result of their subordinated racial and gender status in society. Despite its theoretical limitations and the problems associated with the privileging of experience, black feminist standpoint theory is politically important for black women because it provides primary opportunity through which they are able to articulate a discourse of mothering that position their racialised mothering experiences at the centre, rather than margins, of debate. By utilising black feminist standpoint theory in the following chapters I am able to demonstrate the particular ways that a collective Caribbean mothering identity is framed around mothering work in the interwoven public and private spheres; family and kinship relationships that value consanguineal ties, and shared community mothering; and individual and collective resistance.

Chapter 3
Mothering and difference
Introduction

A central concern of the study is to challenge homogenous and essentialist constructions of mothering. One primary way this is achieved is by emphasising difference and diversity between mothers. This chapter reveals the various approaches to conceptualising difference by focusing on the diverse mothering experiences of Caribbean mothers in the U.K. Their mothering highlights that difference is conceptualised on three distinct but intersectional levels. First, there is racialised difference between black and white mothers. Second, heavily influenced by the post-structuralism tradition, there is experiential difference between the mothers as a result of the shifting, multiple and transitory contexts in which they are situated. Third, there are structural differences between the mothers as a result of social class divisions. With this in mind, the chapter opens by theorising the relationship between race and gender divisions. It explores the significance of this relationship in encouraging social constructions of black mothering in media and policy debates. The chapter focus then turns to analysing the divesity of household structures, family patterns and living arrangements that historically characterise Caribbean family life. Finally, I explore social class divisions between the mothers to challenge the conventional assumption that black women in the U.K. are defined by a homogenous working-class identity.

Re-thinking difference—theoretical approaches to difference

Black feminism has contributed to the development of theories of difference in feminist thought. Prior to such developments, discussions of difference were marked by the political differences in feminism: radical, liberal and socialist feminisms (Williams, 1989; Bryson, 1992). However, black feminism emerged to critique feminist notions of sisterhood, solidarity and unity, based on the common bond of womanhood. They argued that some of the earlier feminist analysis normalised the experiences of white, middle-class, western women, whilst denying those of women belonging to other racial and social class groups (Carby, 1982; Amos and Parmar, 1984; Brah, 1992; Aziz, 1992; Mirza, 1992; Ashfar and Maynard, 1994). In feminist debates the voices and experiences of black women were silenced and their differing experiences to those of white women, informed by 'race' difference remained unexplored. Where

representations of black women existed, they were problematised and labelled as 'deviant' or 'other' in relation to white middle-class standards and established norms (Aziz, 1992). For example, within the policy arena, the relatively high rates of female-headed households and teenage motherhood amongst black families were used to justify claims of dysfunctionality. In this discourse black mothers are constructed as going against the western middle-class idealised notion of the two-parent, married family household.

By the 1980s feminists responded to the charges concerning universalism of white women's experiences and the suppression of 'race' difference in the literature by re-visiting and revising debates to acknowledge 'race', as well as class difference, amongst women (see for example, Barrett and MacIntosh, 1985). Their efforts resulted in a more complex and de-constructionist analysis of the concept 'woman.' Today, it is commonly accepted that the category 'woman' as an essentialised, universal construct no longer exists because structural divisions, such as race, class, and gender, mean that women experience this gender status in diverse ways (Spelman, 1990).

Post-modernist feminists have further contributed to feminist debates on difference by addressing how individual identities are constituted by subjectivities. These subjectivities are contextual, actively shifting and taking up new positions according to each discourse and location. As such,

> Socially given identities such as 'woman' are precarious, contradictory and in process, constantly being reconstituted in discourse, each time we speak. (Weedon, 1987:33)

The consequence of post-modernism for feminist ideologies is that the emphasis is not so much on the difference between subjects:

> ... but upon understanding how those differences are constructed and how the categories ... are themselves constructed through difference.
> (Williams, 1996:64)

However, despite the progress made by feminists' attempts to the fill gaps in the literature they still have some way to go in developing detailed analysis of the structural factors that shape and constrain divisions between black and white women. Feminist perspectives continued focus on women's oppression at the hands of men, as a result of patriarchal relations, fail to provide detailed

interrogation of the way white women have colluded with white men in black women's collective experiences of subordination and exclusion. Patricia Hill-Collins (1990), for example, draws attention to the exploitation of black and Hispanic migrant women in the U.S.A. as cheap labour, providing child care and domestic duties that enable white middle-class mothers to successfully enter the work force in professional and well paid occupations. In the U.K., Fiona Williams' work (1996) highlights that power relations that underpin notions of racial divisions mean that white women's racial status translates into structural dominance over minority ethnic women.

Avtah Brah (1992) extends this discussion of power relations by establishing a four-part typology of notions of difference that underpin this. First, there is difference as experience—that is the differing day-to-day experiences individuals encounter; secondly, difference as subjectivity, supporting post-modernist and post-structuralist claims; thirdly, difference as social relations—that is difference between people from diverse ethnic groups; and finally, difference as identity. Difference as identity recognises individual difference but see these as conflated in 'collective coalitions' (Mohanty, 1988) or 'conscious coalitions' (Mirza, 1997). This binds together people of specific ethnic and racial groups in a 'politics of solidarity' (Brah, 1992). This solidarity is informed by the:

> ... structural, political and historical basis of the commonality of its experience. Experience is understood here primarily in terms of collective histories. (Brah, 1992: 194)

In the U.K. the collective histories of African, Asian and Caribbean populations are constructed and shaped by the collective experiences of imperialism, colonialism and racial inequality. These groups of people have been able to politically mobilise against perceived acts of racism and marginalisation as a result of their collective structural position (Anthias and Yuval-Davies, 1992; Brah, 1992).

Using their collective position, black women have re-constituted their marginal position as 'other' from its original meaning to create new forms of dialogue and challenge dominant discourses and conventional constructions of black womanhood. Stuart Hall contends that this act of re-naming 'other' provides the basis of a 'new politics of resistance and critique' (1992: 251). Similarly, as Heidi Mirza (1994: 4) argues black women's position as 'other' offers them a 'third space' between the 'margins of race, gender and class' to act as active

agents in the construction of discourses that tell their stories. Therefore, black women's resistance derives from black women actively pursuing their positioning as 'other', manipulating the boundary of race and gender 'other' to suit their own ends. Black women's status as 'other' is a temporal, shifting category, in need of social groups to define itself against, (for example, black men, white women, 'third world women'). Sandra Wallman (1988) assesses the social boundaries in which black women constitute themselves as 'other', and they in turn are constituted as 'other' by dominant groups in society:

> A social boundary happens at the line of difference, the interface between categories of people or systems of organisation; when that difference is used by either side, for whatever purpose, to define itself, or to establish its identity in opposition to the 'other'. Both its position and its significance are fluid. They may vary with the need to differentiate, and according to the availability and appeal of other criteria of difference.
>
> (Wallman, 1988:209)

By assessing black women's experience outside of the black/white binary construct it is clear that many differences exist between black women globally in terms of histories, cultures, class, sexuality, language and religion. Even in a specific ethnic grouping, such as Caribbean women, there is great diversity shaped by, for example, class, status, age, generation and cultural differences. However, attempts to focus exclusively on structural and racial divisions between black and white women limited analysis of the many differences that exist between black women. Essentialising black womanhood in the bid to champion their collective difference in relation to white womanhood also raises issues of 'authenticity'. Constructions of the 'authentic' black woman, exclude those women who do not fit this essentialist model. Black feminists writing from outside western societies have been critical of the way black women's experiences in the U.S.A. and other advanced societies are privileged over those black women in developing societies. These women's standpoints, in the former category, are perceived as representing black women globally (Mohanty, 1992; Minh-ha, 1989; Bar-On, 1993; Narayan, 1997). The tensions that emerge over claims of authenticity highlight the fact that black feminists continually face a balancing act in recognising and celebrating diversity and individual difference whilst at the same time constructing a strong collective identity that binds black women together and through which they can politically engage in collective struggles.

Racial difference, racism and 'othering' of African-Caribbean Mothering

In the context of Caribbean mothers' lives in the U.K. the shared struggles around racism and racial inequality constitute the primary medium through which their mothering is experienced and positioned differently to white mothers. John Solomos (1989)) defines racism as:

> those ideologies and social processes which discriminate against others on the basis of their putatively different membership.
>
> (Solomos, 1989:9).

The membership that Solomos speaks of is racially and culturally determined. Avtah Brah (1992) also contends that in the U.K. black people's cultural and it is defined by inferiorisation, subordination and oppression' (Anthias, 1990: 126). Therefore, and as a result of their racialised status, across successive generations, black people continue to encounter racial inequality, racial discrimination and harassment, as well as unequal access to resources across a variety of social and political institutions. Paul Gilroy (1987), in his earlier work, identifies this unchanged intergenerational relationship as the 'changing sameness of racism.'

To understand how racism impacts on lived experiences of black people in the U.K., racism must be understood as involving both the emotions—prejudice, and issues of morality—and the political. Barnor Hesse (1997) defines racism as a modern form of governance whereby those white groups dominant in western society have, over the course of modern history (the post Enlightenment period onwards), developed procedures and practices to shape, survey and re-construct the 'other'. Those ethnic groups in this 'other' category are represented as 'deviant' or 'abnormal', whilst the dominant group's own position is re-constituted as 'universal', 'normative', and 'unquestioned'. Keenan Malik (1996) puts forward a similar analysis of racism in support of Hesse's viewpoint of racism as governmentality or governance. Malik argues that since the development of modernity (the Enlightenment) successive western societies have imposed racially divisive categories between what Stuart Hall terms 'The West and The Rest' (Hall, 1991). These racialised categories have then been used to entrench, legitimate and manage claims of western superiority and universalism, whilst classifying 'non-western' groups and cultural practices as 'inferior' and 'other' (Malik, 1996). Both Hesse's and Malik's (ibid.) re-working of racism in western societies can be extended to social constructions of black mothering in mothering

discourse and policy debates. Mothering practices that reflect ethnic or cultural backgrounds of black mothers (such as Caribbean mothering traditions) are represented as 'inferior' or 'other' in the public imagination (Glenn et al., 1994; Hill-Collins, 1994).

Policy and media representations of African-Caribbean mothering

With regards to Caribbean mothers in the U.K. two images are in the foreground of these negative representations. These are the *superwoman* and the *babymother*. These pathologised and racialised images of black mothering are used in the media (most notably newspapers) and popular debates to identify black mothers as responsible for many societal ills such as juvenile delinquency and the increased rate of teenage pregnancy (see Edwards and Song, 1996; Reynolds, 1997a). The 1991 census recorded that as many as 51% of Caribbean families in the U.K. are 'female-centred' or headed by a lone-mother (Owen, 1996). Analyses that attempt to understand this phenomena focus on two questions. First, what social and cultural traditions encourage Caribbean matri-focal (or female/mother-centred) families to continue across successive generations? I examine this issue in depth in a later section of this chapter. Second, to what extent are Caribbean women deliberately choosing lone-motherhood as a result of the general breakdown in black male-female relationships?

From the 1990s onwards, the media, particularly the black and white newspaper press, promoted this pervasive idea of Caribbean lone-motherhood and it has now transformed itself into commonsense discourse. In debates, rationalising lone-motherhood amongst Caribbean women they are either personified as the archetypal *superwoman* or *babymother*. There is a social class and socio-economic component to how Caribbean lone-mothers are characterised as either the *superwoman*—professional well-educated lone-mothers or the *babymother*—poorly educated lone-mothers who are on low income and/or recipients of welfare benefits. In terms of the *superwoman* image it is suggested that professional Caribbean women are deliberately and rationally choosing lone-motherhood as a result of a lack of available, eligible black men who can equal them educationally and professionally. The following newspaper articles from the *Voice*; a black owned newspaper in the U.K., illustrate this:

> There is a cry by Black women, particularly those in work or who have middle-class aspirations, about the lack of eligible men. More and more they are echoing their American sisters who have long since bemoaned

the fact that all Black men are either gay, in jail, unemployed or only
interested in white women [...]. They have got fed up of waiting for
an eligible man who has a job, has ambitions and will offer them the
emotional and financial securities [...] fed up of waiting for the right
man to come along they are increasingly deciding to have babies alone,
without the would-be father's knowledge [...] it's very cool, calm and
collected. They're the type of person who is going to have a year's supply
of nappies delivered'

(Voice, 2 August 1994, p. 12)

Becoming a *superwoman* is regarded as a rational, calculated ploy for
Caribbean middle-class women in response to a perceived lack of eligible men
of equal social status. In contrast, however, the *babymother* image is presented
as a reflection of the lack of social choices and opportunities available to low
income, poorly educated Caribbean women. Becoming a *babymother* therefore
is presented as the only viable route into adulthood and it also reflects an ill-
conceived desire to exert control over, and financial gain from, their children's
father or state benefits:

faced with high unemployment and underachievement at school ...
pregnancy is the best of the bad lot [...]. Frustrated by a lack of control
over their lives and over their men they will 'pin-prick' a condom.

(Voice, 18 April 1995, p. 19)

Both of these images position relatively affluent middle-class and low income
working-class Caribbean lone-mothers in different ways. Yet, a common factor
with these constructions of lone-mothering is that they are both considered
detrimental to Caribbean family relationships. The *superwoman*—women who
are represented as succeeding against the odds—has been cited as a primary
cause of black male unemployment (as a result of them taking black men's
jobs), as well as contributing to the high rates of black male-female relationship
breakdown (as a result of them leaving behind their lazy and unsuccessful male
partners). Likewise, the *babymother* is viewed as sustaining a cycle of poverty
and welfare dependency because these low income lone-mothers are choosing
to have multiple children with multiple partners that are 'feckless', 'irresponsible',
and 'sexually promiscuous', out of desperation or 'welfare greed'. (For further
analysis of these issues see Reynolds, 1997a).

Policy makers in the U.K. equally apply this racial stereotyping of low-income black female-headed households, who are dependent on state welfare provision. Many of their ideas are drawn from, and influenced by, U.S.A. policy debates on welfare spending. In the U.S.A. context, the *welfare queen and baby mamma* are explicitly racialised terms that have been used by policy-makers, and the media, to position poor and black female-headed households as 'undeserving' recipients of social welfare (Hill-Collins, 1998; Gilens, 1999). The general consensus by right-wing and conservative policy-makers such as Charles Murray (1998) is that welfare benefits like, Aid for Families and Dependent Children (AFDC), Medicaid, food-stamps and public housing, have directly caused the breakdown of the family and encourage black women towards setting up female-headed households. During the 1990s these concerns over the breakdown of the family in the U.S.A., and in particular the black family, expressed by conservative policy-makers formed the basis of welfare reforms (Deacon, 2002). The *Transnational Aid to Needy Families* (TANF) was introduced in 1996, for example, with the aim of shifting the onus back on to the family, and in particular men, for economic responsibility for the family.

In the U.K., and in contrast to the approach taken by policy makers in the U.S.A., this racial stereotyping of black (primarily Caribbean) lone-mother households is far subtler and it occurs at an implicit level. Ann Phoenix (1996) suggests that there is both an underlying moral and racialised context to policy-makers' viewpoint concerning the 'deserving' and 'undeserving' recipients of social welfare and that black lone-mother households fall into the latter category. Policy attempts to reduce welfare expenditure in family income have been primarily thought of with the 'undeserving' households in mind. With regards to the 'undeserving' lone-mother, a black racialised identity is immediately assumed and so there is no need to refer to it explicitly in policy. Two recent policies introduced during the 1990s, and involving government intervention in family life to reduce welfare expenditure, support these claims. In 1991 the Child Support Agency (CSA) was set up to monitor and legally enforce absent fathers' financial contribution towards their families, whilst at the same time reducing the state's contribution to the family. Although the CSA acts as a universalistic system of obtaining financial provision by absent fathers, the disproportionate numbers of Caribbean fathers that have been under investigation by the agency suggests that there is a racial context to this policy (Hylton, 1996).

A second policy initiative introduced during the latter half of the 1990s similarly enforced an implicit understanding of the 'undeserving' black family.

The New Deal for Lone-Parents (NDLP) was set up in 1998 in order to offer advice and information on training, financial incentives and affordable child care provision to low income single-parents so that they could (re)enter the labour market. Whilst Caribbean mothers have traditionally continued to experience high rates of economic activity through full-time paid work, in recent years there has been an increase in unemployment for young Caribbean mothers under the age of 25 years (Berthoud, 2001). On the one hand, various researchers have suggested that this increased rate of unemployment amongst young Caribbean mothers represent a wider trend in 'black youth' unemployment in the U.K. whereby 30% of black women between the ages of 16-24 are currently unemployed (Commission for Racial Equality 1997; Berthoud, 1999). On the other hand, however, there is, an as yet underdeveloped, viewpoint that young Caribbean mothers' reluctance to engage in full-time employment on the same scale as older Caribbean mothers represents their support of a 'gendered moral rationality' that identifies moral costs to the children and family as a consequence of mothers working full-time hours (see Duncan and Edwards, 1998; Reynolds, 2001; chapter 6 of this volume).

Regardless of the differing rationales underpinning Caribbean young single-mothers decreasing employment activity, policy-makers in the U.K. have utilised the common perception of the Caribbean welfare dependent lone-mother to their advantage. Despite Caribbean people's minority status in the U.K., Caribbean lone-mothers assume a highly visible role in the publicity material advertising the NDLP. Indeed, it could be argued that the image of the Caribbean lone-mother has acted as an important marketing strategy in publicising the initiative nationwide. By doing so, the notion of the Caribbean lone-mother and her welfare dependent household as the primary recipients of benefits is immediately reconfirmed in the public's imagination.

From the media and policy representations of Caribbean family life and the promotion of these two problematic images of Caribbean mothering, it could easily be assumed that the family is in 'crisis.' As I have identified above this 'crisis' is constructed around the perceived degeneration of male-female relations in the Caribbean community and the high incidence of female-headed households. Even Lord Scarman's report (1982) felt it was necessary to refer to breakdown of Caribbean family relationships *vis-à-vis* the matriarchal family structure as one of the underlying causes of the 1981 Brixton Riots. However, this 'crisis', referred to, and popularised by the media, academic and policy debates alike, is greatly exaggerated and does not reflect the realities of Caribbean family life. For example,

Heidi Mirza (1993) notes that 79% of Caribbean mothers who are officially classified as 'lone-mothers' actually have a male partner and reside in a stable conjugal union. Admittedly, the mothers in these relationships do the majority of child rearing and domestic tasks but this is by no means culturally specific to Caribbean households as there is evidence of similar divisions of labour in white (and other minority ethnic) families (Richardson, 1993; Woodward, 1997).

Caribbean matri-focal family, diverse family models and adaptive family forms

Female-headed households are strongly embedded in Caribbean history and they exist as a long standing and well-established cultural tradition of Caribbean families. Historically and cross-culturally, the celebratory image of the *Matriarch* who is strong, independent, and the 'lynch-pin' of family life continues to be the most dominant image of Caribbean mothering. In Caribbean family literature, much has been written about female-centred or matri-focal families and also the child rearing practice of child shifting[1] but less explored are the diverse family models and adaptive family forms Caribbean mothers move through in their lifetime. The following discussion considers some of these issues in relation to Caribbean mothers' family life in the U.K.

The Caribbean Matri-focal family

In literature of Caribbean families the term 'matri-focal' is used interchangeably with 'matriarchal', 'female-centred', 'female-headed', and 'matri-lineage' households to represent Caribbean mothers' central role in family relationships. However, R. T. Smith (1973; 1996) contends that female-centred or female-focused families (what Smith terms matri-focal families) does not automatically equate to female-headship because as a concept it rests on 'women's role as mothers who come to be the focus of relationships' (1996: 42). Nor, he suggests, is matri-focality culturally specific to low-income Caribbean families because it is observed in the family structures of other ethnic and socio-economic groups. Furthermore, matri-focality increases over time for mothers as they progress through their life-cycles:

> During the period of early cohabitation (which may or may not be based on legal marriage), the woman is fully occupied with child-rearing and maximally dependent upon her spouse, but while men contribute to the support of the household they do not participate very much in

1 The practice of sending a child to live elsewhere with other family members or with other families.

child-care or spend much time at home. As the children grow older, they gradually begin to drop out of school to help with household tasks [...]. The woman is gradually freed from the constant work of child-care and when the children begin to earn they contribute to the daily expenses of the household. It as this stage that one begins to see more clearly the underlying pattern of relationships in the domestic group; whereas the woman had previously been the focus of affective ties she now becomes the centre of an economic decision-making coalition with her children.

(Smith, 1973: 124-5)

Smith's analysis centres mothers' economic decision-making and household authority in family relationships. His analysis also marks an important departure from conventional wisdom of matri-focal families in that he does not associate this family relationship to male absence from the household. Instead, Smith recognises that the matri-focal family exists in households where men are both absent and present. Smith is also sceptical of claims that attribute the existence of matri-focal families to slavery and its persistence as reflecting adaptive capacities of low-income groups to poverty. For Smith, such an understanding only reinforces matri-focal family structure as pathological, and deviating from the normalised, and idealised, nuclear family structure.

Some of the earlier studies to examine the root causes of matri-focal families emerged in U.S.A. and focused on family structures of African slaves. Frazier (1939) and Herskovits (1945) were the first comprehensive studies of African-American slaves' family structures. They proposed that the mother-child unit was the primary family unit that persisted throughout the slavery period, but while Herskovits regarded this as a continuance of the domestic arrangements of African societies, Frazier, attributed this to men's displaced role under slavery. He draws on other historical material to suggest that, wherever possible, black men tried to develop and maintain family structures based on strong conjugal unions and paternal headship and authority. Later work by Gutman (1976) highlights how the black matriarch is fundamental to low-income families' adaptive capacities for survival. He claims that in order to survive the separation of men from their homes during slavery, black families culturally adapted themselves to female-headed households. This family structure continued to evolve across successive generations because of black people's unequal access to social and material resources.

These ideas expressed by Gutman, Frazier and Hershkovits, were adopted and fitted into analysis of Caribbean families from the post World War II era onwards (Smith, 1996). Fortes (1956) for example, points to a strong cultural emphasis on blood ties, such as mother-child bond and sibling relationships and a much lower emphasis on legally sanctioned marriage and conjugal ties, to suggest that it is *'this aspect of family relations which is crucial in producing matri-focal structure across West Indian societies'* (p. 53). Marriage is viewed in terms of status and legal significance but family and kinship ties have cultural significance. Gonzalez's (1982) analysis of matri-focal families in the Caribbean adopts Smith's mother-centred approach but she also incorporates into this analysis a focus on children's expectations of female authority and dominance in households especially around household decision making and child rearing. Gonzalez suggests that in matri-focal households children expect that *'maternal figures would be strongest, most stable and most dominant; they would see their mothers as being not only nurturing but disciplinary figures'* (p. 233). Other writers also suggest that what characterises Caribbean matri-focal families is their long standing tradition of maternal economic activity and financial provision to support their families (Massiah, 1986; Safa, 1986).

In the U.K. today, matri-focal families are one of many models of family life, family forms, and household structures that Caribbean mothers move through in their lifetime. Yet, the matriarch image and matri-focal families are the most pervasive image of African-Caribbean mothering. On the one hand this type of family structure could be said to represent the mothers' varied and changing understanding of families and the *'moralities and rationalities that underpin how families work'* (Carling et al., p. xiv). On the other hand, however, they also reflect a cultural and strategic response to specific social and economic conditions that Caribbean mothers face in the in the U.K.

Adaptive Family Forms and household structures
Dorien Powell's (1986) analysis of Caribbean families offers a flexible and pluralistic understanding of family life by examining the dynamic and shifting nature of family and household structures. Powell develops a 4-part typology of Caribbean family relations to argue that female-headed households are not static, an almost universal given. Rather they are one of many family forms and that most black mothers move through several in their lifetime. These family forms are (1) single (complete absence of male partner), (2) common-law (joint residence without legal sanction); (3) married (joint residence and legal sanction)

and (4) 'visiting relationships'. This last concept, first introduced by R. T. Smith (1962), represents those households where the male partner does not reside in the household on a permanent basis he is nonetheless regarded as part of the family by other family members and regularly visits the family household.

In the Caribbean 'visiting' relationships dominate amongst the black poor and lower social class groups. The households it produces—female headed-households—are representative of the adaptive capacities of poor low income black families to survive poverty and economic disadvantage (Barrow, 1996; Roopnarine, 1997; Waters, 1999). Writers discussing the Caribbean family in U.K., and in particularly the prevalence of 'visiting' relationships amongst low income working-class Caribbean households, have applied and adopted these ideas of the correlation between the 'visiting' family patterns and poverty and economic insecurity to a U.K. context (see Dench, 1996). However, the view that female-headed households in the U.K. simply continues, and evolves from, a Caribbean tradition hinders the understanding that female-headed households are not the universal and singular family structure for black families in the Caribbean. Some territories, such as Jamaica, have a high prevalence of 'visiting relationships' especially amongst its poor lower socio-economic social groups. However, in other Caribbean territories, married two-parent household comprise the largest family structure across diverse socio-economic groups. For example, 40% of women in Barbados and 38% of women in Antigua are married and live in 'traditional' nuclear households, (Barrow, 1996).

Consequently, the concentrated focus on female-headed households has been at the cost of ignoring the sheer multiplicity and diversity of family forms in which Caribbean mothers live. In this study, sixteen mothers are married and the remaining twenty four mothers live in family structures and relationships that range from 'single' to 'visiting' to 'cohabiting' relationships. The dynamic and fluid nature of the mothers' relationships with their partner mean that they move through different family forms over a period of time. For example, five out of the sixteen married women in this study were previously in 'visiting' relationships with their partners prior to marriage. Two of these mothers commented that they primarily saw this period as a 'getting to know you' phase before moving onto a common-law relationship and finally a married relationship:

> After we had the first child, we were spending all of our time together but I was used to my independence. At that stage in our lives I don't think either of us were ready to settle down and live together like man and

wife and so we sat down together and decided that he would stay with us some of the time to see how things developed with us. Obviously things worked out fine for us because we got married in the end.

[Anita, age 43, married, first generation]

I am used to being on my own and doing my own thing and I couldn't ever imagine me being welded to a man's side. About two years with him living here part-time I thought this isn't so bad and marriage just seemed to be a natural progression. [Tina, age 49, married, first generation]

The above quotations show that these mothers were not permanently fixed, in some pathological way, into a 'visiting' relationship. Instead a 'visiting' relationship was considered as a way to adjust to a change in their relationship status. Other married and partnered Caribbean mothers that I interviewed moved from 'visiting' to common-law to marriage relationships as a consequence of external factors. For example, Sandy a second generation mother openly admitted that her transition from 'visiting' to marriage was a result of family pressures from her parents who did not want Sandy to be seen to be conforming to the negative public perceptions of black female-headed households. Two other mothers from the this study acknowledged that their movement from 'visiting' relationship to marriage was related to changing levels of family income and in particular to the increased level of the partner's contribution to household income. Georgia, a second generation mother also existed in a 'visiting' relationship with her partner whilst he was unemployed. It was only when he found a relatively secure job as a car mechanic, and could financially contribute towards the family income that they decided to marry. Similarly, Angela, also a second generation mother, married her partner when he obtained a permanent work contract that offered much greater job security. These mothers' previous family arrangements can therefore be viewed as a rational response to their social and economic conditions. However, another reason clearly revealed to me by the mothers in both studies who choose to live with their partners in 'visiting' and 'common-low' relationship, is that they greatly valued their independent and autonomous status.

Child shifting
Child shifting is another well-established feature of African-Caribbean family life and this has been extensively documented in Caribbean family literature (Brodber, 1974; Senior, 1991; Russell-Browne et al., 1997). Child shifting,

involves the shifting of child rearing responsibility from the mother to other family relatives, usually female kin, on a permanent or temporary basis. It represents an informal adoption practice that is viewed by many as a '*strategy for economic and social survival of the mother and child*' (Russell-Browne et al., 1997, p. 224). Maternal migration is an essential characteristic of Caribbean life. Mothers migrate outwards in search of employment opportunities that will provide them with financial independence and enable them to achieve better life chances for themselves and their children (Senior, 1991; Fog Olwig, 1999). Historically, this has involved internal migration by mothers from rural areas to urban cities, and outward migration to other Caribbean territories and, principally, North America and the U.K. From as early as the 1970s Caribbean mothers in the U.K. have also been part of this process of secondary migration to U.S.A./Canada where Caribbean people who initially migrated to the U.K. have utilised extended family links established in these countries to seek out further social and economic opportunities (Goulbourne and Chamberlain, 2001). A large number of migrating mothers belong to low-income socio-economic groups and they do not have the economic means or support networks readily available to take their children with them. Consequently, they consider that the child's best interest is best served by being left behind and cared for by their relatives. In the majority of child shifting cases the principal carers are the maternal grandmother or a maternal aunt (Russell-Browne et al., 1997).

In this study I spoke with mothers who decided to leave their children behind in the Caribbean when they first migrated in order to establish themselves in the U.K. or they themselves had experienced child shifting as children. In addition, earlier this year (2004) I interviewed three Caribbean mothers—two from Jamaica and one from Guyana—as part of another study (see Reynolds, forthcoming). These mothers are trained teachers actively recruited from the Caribbean to work in British schools as a result of teacher shortages. Similar to mothers who migrated in post war years these mothers also decided to leave their children behind to be cared for by their relatives. In each instance they saw child shifting as a temporary measure and they were in the process of sending for their children to join them here.

With child shifting the mothers do not relinquish maternal responsibility. During their time apart from their children their maternal responsibility is framed around, maintaining regular contact with their children and carers, and, sending money and gifts back home to them. Whilst these mothers readily acknowledge that their children's best place is with them, and they highlight the

emotional costs and worries of leaving their children behind, they also adopt a pragmatic approach to understanding that benefits of improving their children's life chances far outweigh the costs of separation. The following quotation by Millicent, reflects on the costs and benefits of child shifting:

> My eldest two [children] stayed behind with their grandmother in St. Mary [parish of Jamaica] for nearly eight years. I felt it was better for them to stay at home [Jamaica] because I had no idea what I was coming into when I was coming here [U.K.]. I just knew that I wanted them to have the things I never had when I was growing up because I come from a poor farming family. My plan was to finish my nurse training, get myself a good nursing job and have a nice home ready for them. Those early days were hard times because I missed them so badly. I was very down because I longed to hold my babies and I worried about them constantly. I was also scared they wouldn't remember me because they were babies, 5 and 3 years-old, when I left. In those days we kept in contact by writing letters and I would enclose a 'small piece' to my mum to help out with minding them. It took much longer than I expected to set myself up mainly because I had two more children soon after [arrival in U.K.] so it was a struggle financially. But I never gave up. I was determined that I was going to send for my children. That kept me going when I felt like giving up. Once I saved up enough money for their passage I wrote to my mother and told her to send them come.
>
> [Enid, age 69, first generation mother, married]

Strong reciprocal kinship relationships are an important feature of Caribbean families and child shifting practices reinforce this. For example, it is an accepted practice for Caribbean mothers to 'give' or 'lend' their children to female relatives who are childless or require male/female children's companionship (Sanford, 1976). Two mothers in the study encountered this form of child shifting and reflect on their experiences:

> *Lisa*: My aunt tried for years to have children but she couldn't have any. So because my mum had five of us, and I was the youngest she sent me to live with my aunt when I was a baby, I think I was eight months old. My aunt raised me as her daughter and I didn't know she was my aunt

until I started primary school. My mum, that's my biological mum, and my aunt, who I call mum, sat me down and explained the situation

T.R.: How did that make you feel?

Lisa: No different, I was fine about it because we were really close as a family, we all lived on the same street and I spent most of my time with my brothers and sisters so it didn't make a difference to me

[Lisa, 36, living with partner, second generation]

My mum had four girls and three boys and her sister, my mum 'auntie Vy', who I call mum, had 6 boys and no girl children. 'Auntie Vy' really wanted a girl child; I think she wanted some girl company around the house and I imagine she also wanted a girl child to help out around the house; my mum told 'auntie Vy' that she could take me to live with her. So I really grew up around my auntie.

[Enid, age 69, married, first generation mother]

There are a number of studies that examine the negative impact of child shifting. In the Caribbean and the U.K., there have been documented cases of mothers who simply abandon their children to a succession of temporary carers; children who are taken into state authority care and children who have experienced neglect and abuse (Brodber, 1974; Rhodes, 1992). Studies have also looked at the impact of child shifting on carers. Brodber's study (1986) of care givers in Jamaican society shows that many carers are from low-income groups themselves and they find it difficult to make ends meet and successfully fulfil their role as carers. Potential conflicts can also arise between principal care givers in the Caribbean and the mothers who have left their children behind (Olwig, 1993). Other studies have explored the psychological and socialisation costs to children who experience child shifting and reunification with their mothers (Senior, 1991; Arnold, 1997). On the whole, however, the Caribbean mothers welcomed child shifting as a positive solution to their social and economic circumstances.

Challenging essentialism: Social class divisions

Social class divisions are an important characteristic of black communities in the U.K. Yet, 'class divisions, perhaps more than any other axis of difference, are often obscured in black community organising' (Sudbury, 1998, p. 143). In recent times a number of studies have challenged the conventional assumption

of a homogenous black working-class. They have achieved this firstly, by deconstructing and socially stratifying the category of black community along ethnic lines (Modood, 1997; Sudbury, 1998).

Secondly, by examining the role of the black middle-class in defeating racism and advancing the black communities through their increasing access to social and material resources, higher education institutions and their participation in the formal electoral process (Goulbourne, 1989). Such studies portray the black middle-class in the U.K. as a newly established phenomenon that is achieved through differing levels of socio-economic progression by various minority ethnic groups.

> While Chinese, East African Asians and Indians are accessing further education, gaining professional employment and starting up enterprises, African, Caribbean, Bangladeshi and Pakistani communities remain at the bottom of the socio-economic pile (Sudbury, 1998 p. 143).

With regards to the Caribbean community, Julia Sudbury's (1998) study suggests that socio-economic stratification and class divisions between Caribbean men and women are being increasingly promoted in popular discussions. This supposed differential is attributed to the rising status of Caribbean women through educational and occupational mobility. As a result these women are 'leaving our men behind' (p. 156). Earlier on in this chapter, in my discussion of *superwoman*, I also allude to these perceived gender and class divisions in the Caribbean community. Of course discussions that promote socio-economic divisions in the black community as ethnic and gendered, create artificial divisions between ethnic groups and misleading assumptions concerning gender divisions in the Caribbean community. It also obscures the fact that, despite high rates of educational attainment, the majority of Caribbean and minority ethnic women are concentrated in intermediate and low level service and public sector jobs where they encounter limited opportunities for social and occupational mobility (Modood, 1997).

A third criticism of discussions concerning class divisions and ethnic minority groups is that the analysis fails to acknowledge that migrants arrived in the U.K. with their middle-class status already established. This has important implications for how they understand their current class status in the U.K. For example, East African Asians who migrated to the U.K. from Kenya, Uganda, and Tanzania during the 1970s were from middle-class professional and

entrepreneurial backgrounds (Goulbourne, 1998b). In terms of Caribbean migration to the U.K. during the post war years, the majority of people came from rural, poor, working-class backgrounds. There was only a small number of professional and middle-class Caribbean migrants (Goulbourne, 1998a). In this study three of the first generation mothers were originally from middle-class backgrounds in the Caribbean but this did not automatically transfer to a middle-class status in the U.K. because of their changing occupational and socio-economic status in their adopted country.

In the Caribbean a complex range of intersecting issues involving race, colour, status, and wealth underpins social class divisions. Historically, gradation of skin colour—from white, light skinned, brown skinned to black or dark skinned—is used to define racial identity. Racial identity is a principle determinant of class identity because it informs individuals' access to resources, social capital, power and status. Despite, in recent years, increased social mobility and economic advancement of dark skinned individuals into the middle-classes, social class divisions still continue to be principally organised according to race and colour lines. They are 5 main social class categories consisting of (1) upper classes—comprised of white landowners; (2) upper middle-classes—light-skinned owners' of industries, (3) middle-classes—brown skinned educated professionals, business owners, and entrepreneurs; (4) working-classes—dark skinned, black or African non-professional workers, and small farm landowners (5) the underclass—black or dark skinned inner city urban poor, and rural peasants (James and Harris, 1993; Smith, 1996; Hillman and D'Agostino, 2003). This relationship between racial and class identity is built on three key institutions: slavery, the plantation system, and colonialism and the lasting legacy of these factors has been the creation of a dominant system where white identity is given *'special value and the aesthetic standard to which people aspire'* (Baranov and Yelvington, 2003, p. 211). The 'cultural nationalism' movement, that developed after World War I, through thinkers such as Marcus Garvey and his *Universal Negro Improvement Association*, tried to challenge the dominant value given to white identity by emphasising black racial pride (Nettleford, 2003). Yet, despite such advancements essentially there has been limited change in this relationship between class and race across successive Caribbean societies. Furthermore there is evidence to suggest that Caribbean migrant communities continue to maintain these ideas of race and class divisions in their adopted countries while forging new understandings of class identities that are based on their new racialised status and socio-economic position (Foner, 1979; Vickerman, 1999). Baranov

and Yelvington (2003: 210) suggest that '*social class must be understood as part of an ongoing, fluid process of contestation rather than as fixed, static and unchanging categories.*' The viewpoints expressed by the mothers concerning the transitory nature of their social class identification would certainly support this viewpoint as the following quotation indicates:

> In England I'm working-class because like most black people that came here in the 1950s I've had to struggle to make a life for my family. But at home [Antigua] my family have a lot of property and I am upper middle-class and I never thought of myself as a black person. My family was wealthy, so money was never an issue growing up as we always had it. It was a real shock coming to the U.K. and seeing that black people are all the same because in Antigua my family was very light-skinned and not black, so we were treated differently. If you're light-skinned, you are brought up to feel that you're better than everyone else who is black [dark-complexioned].
> [Pearl, age 61, married, first generation mother]

Pearl's quotation reflects an understanding that definitions of class status are transitory and changes according to differing contexts and locations. Pearl, when considering her class position in the Caribbean, reverts back to Caribbean legacy of colour and class to define her class location. However, in the U.K. context Pearl recognises that socio-economic status and collective struggles with other black people around access to social resources embeds her firmly in a working-class category.

In the U.K., there is limited research exploring class divisions between black women and it is implicitly assumed that they have a homogenous working-class status (Mirza, 1998). With regards to the Caribbean mothers in the study, eight mothers defined themselves as middle-class; twenty-seven mothers stated that they are working-class, three mothers are undecided and two mothers chose not to define their status because they believed that race is the only factor that determines their current structural position and socio-economic status. Aside from these two mothers, it is evident that both objective and subjective definitions are central to the mothers' understanding of social class. Objective definitions reflect the mothers' use of conventional systems of classification such as the Registrar General, occupations and those based on income levels to determine their class position. Subjective definitions are far more personalised and complex. It involves '*complicated mixture of the material, the discursive,*

psychological predispositions and sociological dispositions' (Reay, 1998: 257) and an understanding of the intersections of race, class and gender in determining class location.

Beverley Skeggs (1997) explores the intersections of race, class and gender in shaping women's experiences. Skeggs advances Bourdieu's theory that capital is intrinsic to society. This capital comprises 'properties capable of conferring strength, power and consequently profit on the holder' (Skeggs, 1997: 127). Four types of capital exist: cultural (made up of institutional, embodied and objectified capital); economic capital; social capital (social ties and networks that are used as a social resource); and symbolic capital (the legitimation of these three other types of capital). Race and class are significant determinants of women's access to the institutions, structures and processes of symbolic capital. Black middle-class women may be able to access economic capital (through, for example, a professional occupation with a high income) and cultural capital (through, for example, educational qualifications), but their black racialised and female gendered identities deny them access to symbolic capital, which is controlled by white middle-class men (Essed, 1994). White middle-class women have more potential to access by utilising their social capital (for example, 'old school tie' networks) to connect with individuals or networks that access symbolic capital. In this respect, as Skeggs suggest, white working-class women are similar to black women because they too have limited opportunities to use their social capital to same advantage as white middle-class women (ibid.).

The mothers in the study are aware of the intersections of class, 'race' and gender in structuring their daily mothering experiences, and in maintaining systems of inequality and disadvantage for black women. A number of mothers shared their views on this:

> If you're black middle-class or working-class, we have to all deal with the same racism don't we? I suppose if you're a black lawyer or doctor, then I suppose white people treat you differently to a black working-class person. They may still think they are superior to you, but I suppose they will try to show it less. They might still be racist but because you are educated then they can't talk down to you, they have to respect you.
> [Sharon, age 19, lone-mother, third generation]

When I visit my daughter's school I make the effort to dress up a little bit more. I will wear a smart skirt or pair of trousers, because appearances

still count. I've noticed that when they can see you dress smartly and you speak correct English, their whole approach changes and they treat you with respect. You're no longer the typical loud and aggressive black mother they expect you to be. During her first week, I had some time off from work and so I was looking a bit untidy when I took her to school. I could tell the teacher was a bit wary about approaching me. It was only when I told her I was a housing officer and she got to see me dressed smartly because of work that she relaxed. Now she makes a point of talking to me every day, she's different with me now.

[Zora, age 26, living with partner, second generation]

Middle-class white men will always remain at the top of the social ladder, white women benefit from this too. If they have the money then white parents take it for granted their children are going to be successful. Mothers nurture this by sending them to schools and encouraging them to make the type of friends with people that will help them later on in life.

We know our [black] children are seen as failures before they've entered the world, so we have to make sure they don't end up fulfilling these expectations. In a sense we're starting our parenting from two opposite ends. We have to work harder for respect and success that they automatically have. [Anita, age 43, married, first generation]

These quotations demonstrate the mothers' understanding that class differences between black women impact on the social resources and social capital the mothers have to respond to inequality and disadvantage. Sharon, for example, acknowledges that class divisions between black women do not shield them from racism or racial stereotypes. However, it does influence the way in which black mothers experience these on implicit and explicit terms. In Zora's case she believes that the teachers at her daughter's school use race and class judgements in their interaction with the children's parents and to differentiate black mothers. Zora reflects that middle-class mothers enjoy higher levels of interaction with teachers compared to working-class mothers. Her views are borne out by studies that illustrate class difference in parent-teacher interaction at schools (Reay, 1998). Zora adopts what she feels to be a middle-class appearance ('dress smartly') and behaviour ('speak correct English') to

challenge racial stereotyping of black mothers ('loud and aggressive'), and to establish greater contact with her daughter's teacher. Beverley Skeggs' (1997) study highlights similar behavioural patterns amongst working-class women who adopt certain middle-class signifiers, such as smart sophisticated clothing, to 'pass' as middle-class. Such behaviour does not necessarily represent a desire to be middle-class, but, rather, as in Zora's case, it reflects a strategic approach to securing a positive outcome in a society where white middle-class standards and behaviour are deemed to be superior to other cultural norms.

Anita's comments concerning the racialised context of class and gender reinforces the idea that white and black middle-class mothers are differentiated according to white mothers' greater access to symbolic capital. As her comments suggest, white middle-class mothers utilise their social capital to maintain their dominant position in society. In contrast, mothering practices by black middle women is primarily concerned with utilising their social capital to challenge the low expectations held of their children and finding ways to access symbolic capital. Anita's comments are indicative of the fact that white middle-class mothering is founded on race and class privilege. The mothers—Sharon, Zora and Anita—all draw on the notion of respect as something that is desired and as representing a white middle-class privilege. This desire (or demand) for respect is something that is deeply ingrained in Caribbean society (Goulbourne, 2001). With regard to these mothers, however, it encompasses a need for social recognition and yearning that their mothering is valued in its own right. This is because in the U.K. it is middle-class mothering norms and values that are celebrated as the universalistic ideal in mothering discourses (Williams, 1989; Woodward, 1997).

Over half of the mothers in the study are employed in jobs that are defined as middle-class occupations in the context of traditional classificatory systems: teaching, social work, housing management, and professional healthcare. Yet, the vast majority of mothers self identified as working-class and this is attributed to two significant issues. First, as a result of their black racialised identity, some of the mothers identify structural and psychological barriers that force them apart from the rest of the middle-classes. As a consequence they view their social status as similar to those groups with lower educational, income, and occupational levels. Second, there does not currently exist in the U.K. a readily identifiable black middle-class in which black middle-class individuals may develop ties of and collective membership. This is in direct contrast to the black middle classes in the Caribbean and the U.S.A. who have built strong affiliations

and networks of support and have a primary role in shaping political, social and economic agendas of black communities (see Omi and Winant, 1994; Baranov and Yelvington, 2003).

Conclusion

The various and contrasting issues selected for discussion—racial difference, diverse and adaptive family models, the cultural practice of child shifting, and social class divisions between Caribbean mothers—reveal that theories of difference are integral to understanding Caribbean mothering. Black feminism was one of the first to contribute to the development of theories of difference in feminist thought by exploring structural and racial difference between black and white women. This introduced a more complex and deconstructionist understanding of the term 'woman'. Post-structuralist conceptualisations of difference recognise that the term 'Caribbean mothers' itself is contextual and historically specific (Williams, 1996). The transitory and adaptive nature of Caribbean family models and household patterns show that mothers are not fixed into the static family structure of female-headed households. Instead female-headed households are one of many different family models through which they move in their lifetime. Yet female-headed households continue to represent a key aspect of Caribbean mothering. In the U.K. the racialised images of the *superwoman* and *babymother* underpin understandings of Caribbean female-headed households. The *superwoman* is blamed for the perceived breakdown in black male-female relations, whilst policy-makers characterise the *babymother* as 'undeserving' recipients of social welfare. Social class difference is implicitly assumed in these two racial stereotypes of Caribbean mothers.

Social class difference is also a third dimension of difference amongst the mothers, both in terms of their mothering experiences and social resources available to respond the differing manifestations of racism. Class cannot be understood in isolation from racial positioning. Indeed it is this intersection between class and 'race' that creates differences in black women's experiences and structural positioning in comparison with white women, who share similar social class positioning. Caribbean mothers desire a mothering identity where their mothering and child rearing practices are valued in contemporary mothering discourses. As the remaining chapters will demonstrate the construction of a collective Caribbean identity, established through a shared structural position and cultural values, does not diminish these differences. Rather, difference and diversity are celebrated features of this collective mothering identity.

Chapter 4
Mothering, collective memory and cultural identity
Introduction

Mothers have long been recognised as the 'gate-keepers' of culture and through their mothering activities they transmit specific cultural values and practices (Glenn, 1994). In this respect Caribbean mothers play a central role in developing ideas and understanding of cultural identity. This cultural identity that the mothers define for themselves, and which they in turn transmit to their children, combines cultural identification with their Caribbean origins and their continued links to the region with the cultural and social specificities of their lives in the U.K. In this chapter I explore the various approaches utilised by the mothers in celebrating and transmitting specific cultural values and practices. Celebrating a Caribbean cultural identity in their child rearing, the mothers employ processes of memory and re-memory (i.e. the re-working or reconstruction of individual memories) to generate a sense of cultural belonging and identity. They utilise memory to create a collective identity based on common experience. Cultural objects and signifiers are introduced by the mothers to shape and re-affirm collective memory. Collective memory creates the potential for new forms of political mobilisation where narratives of self, their family, and community are constructed to directly challenge pathological representations of black mothering.

However, the mothers are also developing new modes of cultural identity, values and practices that seek to move away from their Caribbean origins and reflect their particular social realities of being black and British. What the analysis tells us is that definitions of cultural identity are contextual. How the mothers choose to define themselves is continually shifting according to time, location and audience. Thus, the mother's understanding and identification of themselves as Caribbean or British is determined by their current location, and the context in which they are forced to, or wish to, define themselves. This chapter explores some of these issues.

Choosing cultural identity

Kenan Malik (1996) recognises that cultural identity is important to individuals because

> it is that [cultural identity] which gives a sense of attachment of belonging and of rootedness; that which links present with the past and creates a unique heritage (p. 186)

When I asked the mothers to define their cultural identity, they mostly identified themselves, ethnically and culturally, as Caribbean. The mothers' connection to a Caribbean cultural identity is facilitated by their 'outsider' location and their continued family/kinship networks and ties to the region. In reality, the English-speaking Caribbean is really a diverse set of islands; each with their own unique and distinctive sets of customs, values and traditions. Outside particular areas of trade and commerce (i.e. Caricom, the Caribbean Community and Common Market), academia (i.e. the University of West Indies) and cricket, the Caribbean does not really exist as a collective entity. Paradoxically, the construct and idea of a collective Caribbean region has gained strength and appeal through migrants living outside the region rather than individuals who reside there. James and Harris (1993: 255) acknowledge that:

> Caribbeans in North America and the U.K. have a better sense of and empathy for the cultures of the Caribbean as a whole rather than the majority of their counterparts who reside in the Caribbean itself

For the mothers in the study this 'outsider' location is crucial to the formation of a Caribbean cultural identity because it is through their 'outsider' location that they construct collective identity that subsumes, shares and generalises customs, traditions, values, language and food traditionally associated with individual countries in the region. Family/kinship ties and networks in the Caribbean are used to re-affirm this cultural identity and cement claims of cultural membership to the region. For the most part, this desire to re-construct a Caribbean cultural identity, affirming cultural ties to the Caribbean, stems from feelings of exclusion and marginalisation in British society. The celebration of a Caribbean cultural identity provides the mothers with a sense of 'belonging' and 'connectedness' which they feel unable to receive in the U.K.

I'm suppose I'm British on my passport, my citizenship is British so I suppose on paper I am [British]. But I'm not really British, I'm not accepted as British, so if I was ask to define my cultural identity, I would say I'm a black person of African origin, of Caribbean descent, living in Britain.

[Nizinga, age 31, lone-mother, second generation]

Britain defines my legal status but not my cultural identity; that's African Caribbean. [Jheni, age 35, lone-mother, second generation]

Michele: I'd say I'm black second generation West Indian because I know in my heart of hearts to a white person I will never be regarded as British. So I know I'll never class myself as British because I know I'll never be accepted regardless of being born here 28 years ago, it doesn't matter.
T.R.: Why do you feel you will never be accepted?
Michele: Simply because I'm a black person, they may not admit to it publicly but in their hearts of hearts they will never see a black person as truly British. [Michele, age 28, lone-mother, second generation]

This division between citizenship and cultural identity, as expressed by these second generation mothers, suggests that whilst they are bound by the same economic, political, legal and social order as the rest of the [white] indigenous population in the U.K., culturally they exist as a separate entity. The mothers' views are informed by racial ideology in society that positions black and minority ethnic groups as culturally and ethnically distinct from white British groups (Malik, 1996). The mothers' approach to race and cultural difference is a consequence of ideologies of race, racism and nationalism in contemporary U.K. (Solomos, 1989). In these ideologies racial difference is subsumed under and re-defined as cultural difference. In this way, cultural difference becomes a means through which individuals are differentiated according to 'authentic', i.e. white British and 'inauthentic' citizenship, i.e. black and minority ethnic groups (Gilroy, 1987). Furthermore, racialised minority groups are viewed as having a separate and distinct culture from an English or British one and consequently denied full citizenship rights. This view was best summed up by Conservative politician Enoch Powell in his (in)famous *River of Blood Speech* (1968). Powell proclaimed

Different people have different cultures, runs the argument, and it is
nigh on impossible for someone from one culture to acquire another. A
West Indian or an Asian does not by being born in England become an
'Englishman'. In law he becomes a United Kingdom citizen by birth; in
fact he is a West Indian an Asian still. Culture is something you are born
into, not something you acquire.

(Powell quoted in Malik, 1996:186).

While many disagree with the views expressed by Powell and view them as
racist and from a bygone era, it is clear that the central theme of cultural and
racial belonging is still irrevocably intertwined in current discourse around race
and nationhood. Those who conceive of culture in this way conceptualise it as
fixed, absolute, unchanging, and impenetrable. The mothers in the study, however,
are aware that cultural self-identification is a very fluid, transient, mobile act.
Defining themselves as Caribbean or British changes according to time, location,
context, and audience:

It's funny you know when asked here [Britain], if a white person asks me,
I would say that I'm West Indian, if a West Indian or black person wants
to know then I'm Trinidad, but when I went back to live in Trinidad, I
just thought of myself as a woman.

[Carol, age 50, widow, first generation]

I guess in Dominica, they don't see me as black and I wouldn't see me as
black either. I'm coloured or a brownin' there, but in England I would
definitely say I'm black. [Anita, age 43, married first generation mother]

When I'm at home [Antigua] I'm really aware of how British I've become,
although the British culture and way of life has always influenced the
West Indian way of life. But, in Britain, amongst the majority, I feel very
Antiguan, even after all of these years here.

[Doris, age 81, married, first generation]

As these viewpoints suggest the mothers are constantly re-defining themselves
according to specific racial and spatial contexts. New allegiances are continually
constructed and formed according to their audience. For example, in the company
of white women, racial identity is highlighted. Similarly, in the company of other

Caribbean people then cultural identification is formed around country of origin. In this context, identification is further broken down and new allegiances are formed on, for example, skin complexion, class, status, urban/rural divisions amongst other issues

There is greater willingness by the third generation, compared with the first and second generation mothers, to culturally identify themselves as British—or rather Black British—and regard this identity as culturally distinct from the Caribbean. The following quotation gives us some indication of this:

Sharon: I'm a British person who happens to be black. Here [U.K.] is where I'm born and here is where I live. All I know about the Caribbean is what my grandmum told me and she can't remember much really because she was only little when she came here. I think black people should stop saying they're from the Caribbean when they're born here because they're not. We've got to make something of ourselves here, make our own culture.

T.R.: What culture is that then?

Sharon: A black culture, a Black British culture

T.R.: What is a Black British culture?

Sharon: Well we're British and we're black so it's both of these things. We are different to white people so it would have to be a different culture but you can still say you're British. You can see a black culture on the streets, it's the clothes, the music, the way we walk, the way we speak, it's there, walk out of this door right now and you can see it.

[Sharon, age 19, lone-mother, third generation]

Denise: I'm Black British, this is my home no matter what those racists say.

T.R.: Why not just British instead of Black British?

Denise: We're British but we have our own style, our own way of being British that I suppose is different to white people's Britishness. Things like jungle [music] for example, that's our music, it's something we did for ourselves. England's not perfect and there are things like racism but I don't want to live anywhere else, it's my home.

[Denise, age 22, living with partner, third generation]

In contrast to previous accounts by first and second generation mothers, accounts by these third generation mothers highlight that 'blackness' and 'Britishness' are not understood as diametrically opposed and contested identities. Instead a Black British identity encourages the creation of new cultural spaces defined by their intersecting 'blackness' and 'Britishness'. This Black British collective identity tacitly acknowledges minority ethnic groups in the U.K., and similar experiences around racial inequality and exclusion. In this sense 'black' acts as political identity as well as a cultural one as it is the overarching factor for solidarity amongst minority ethnic groups.

Supporters of Black British cultural identity point to its potential for producing new modes of cultural creativity in [white] mainstream society. However, those who oppose this identity highlight three key criticisms. First, it has a narrow focus on working-class, urban, youth culture and ignores other social groups that do not fit into this category (e.g. the black middle-class, the elderly, mothers). Second, there are others who also claim that Black British cultural identity remains embedded in African and Caribbean roots (Young, 1994). For example, what is often referred to as 'street talk' in Black British cultural identity incorporates, adapts and stylises many aspects of Jamaican patois. Third, there is also the belief that it will harm cultural diversity in the U.K. because cultures, values and traditions that are unique to specific minority ethnic groups will be lost as they are subsumed under the umbrella term 'black'. Tanya, a mother in the study, also reflects on this and states:

> What does Black British mean anyway. OK, it says that you live or were born in Britain but it doesn't tell you much about your culture, your heritage, you could be from anywhere really, Africa, Dominica, Jamaica, Barbados, America, Cuba. All of these places have their own heritage and culture and I feel it is important to preserve all of these if you say we're Black British then it's all lost. It's like saying all black people are the same. It's just another excuse for white people to remain ignorant and not learn the differences between us.
>
> [Tanya, age 40, lone-mother, second generation]

It is clear that cultural identification is a complex issue and involves a combination of external constraints and agency. The mothers' understanding of a Caribbean or Black British cultural identity is crafted in a British context and it is constructed, and adapted to reflect their lives in the U.K. How the

mothers construct their cultural identity is facilitated by processes of memory and re-memory.

Memory, re-memory and cultural identity

The mothers' narratives emerge out of a collective memory of cultural belonging and identity. Understanding memory as cultural and social, collective instead of purely individual creates alternative spaces for marginalised groups to redefine and negotiate identities (Carter and Harshkop, 1997). Halbwach (1992) suggests memories are culturally and socially specific and there is a dialectical relationship between action and recall. Individuals view the past as having distinct phases and they use this understanding of one phase to deal with another or speak about a specific historical moment. Memories of past events and practices are selected and modified to 'fit' accounts of other groups and in this way their individual recollections contribute to group identity (Tonkin, 1992). For example, a common feature of the first generation Caribbean mothers' narratives is that they focus on recalling memories that highlight the collective experience of migration to the U.K. while down playing those that reflect differences between them such as ethnic diversity, racial/ 'shadeism'[2] and class divisions. Stories and events from the mothers' past were also selected to reinforce collective mothering traditions, values and practices in their family/kinship relationships.

Ken Plummer's work (2001) examines how memory works on a number of interconnected levels. He distinguishes between psychological/personal memory; narrative memory; collective memory and cultural memory. Psychological/personal memory looks at individual memory recall. Narrative memory focuses on the narratives people tell about their past and the underlying motives behind these stories. Plummer suggests both of these involve 'habitually told stories' that become 'memory habit' that in turn transforms into 'social fact' (p. 235). Collective memory is concerned with the social frameworks of memory. These memories can only be recounted after a framework is established and cannot be told if a framework for this does not exist. The mothers' narratives of their early years in the U.K. provide a clear example. For example, situations not initially experienced as institutionally racist by the mothers were now remembered in this context, once a social framework was established that enabled them to articulate an understanding of institutional racism. Past memories were re-visited and reconstructed by the mothers to reflect their new politicised understanding of gender and racial inequalities:

2 Discrimination based on small differences of colour e.g. light/dark/brown skin or other physical attributes.

When I first went looking for work in the 1950s this [white] woman said to me we have some supervisor jobs coming up but we can't give all to your people. I didn't see it as racism at that time but now I know that it is racism because over the many years I have lived here I have come to understand what racism is. I have been very involved in campaigns and have been asked to sit on committees to look for solutions to racism.

[Dolly, age 76, married, first generation]

When I remembered my treatment at school, I didn't used to think anything of it, certainly that nothing sinister was going on, but now I'm forced to look back on it differently mainly because of three things:

a) just talking to other women who really are no different to me but they went through the same things as me at school;

b) my eldest daughter has started school and I don't want my experiences of school repeated in her education;

c) work and certain, shall we say, negative things that have happened and the treatment of black people in general, so these things mean I see racism where I never remembered seeing it before, circumstances have forced me to look at the world like that. (sic)

[Zora, age 26, living with partner, second generation]

Both Dolly's and Zora's accounts reflect instances where their past individual experiences are later remembered and transformed into collective and politicised memories of race and racism. In Dolly's case she developed her awareness of institutional racism through the length of time she has lived in the U.K.—nearly 50 years—and her encounters with many others who have shared similar experiences of racial injustices. She has also developed understanding through her role as a community officer and her participation in local black voluntary projects. Similarly, Zora's current employment experiences and her daughter's entry into the education system encouraged her to revisit her childhood experiences and re-evaluate these from her mother status.

Personal memories are transformed into collective and cultural memories through the process of re-memory. Re-memory represents a political practice where memories are re-visited and reworked to 'give voice' to particular stories, particularly those of oppressed groups. It also reflects individuals' social, historical and cultural subject positioning. The idea that past memories are re-visited and transformed in this way—'re-memory'—is clearly expressed in Toni

Morrison's (1987) work of fiction *Beloved*. In this text Morrison describes how 're-memory' is *'not simply a re-collection of the past but its return, its re-presentation, its re-incarnation and thereby the re-vision of memory itself'* (p. 107). The dynamic process of re-memory transforms memories into political and consciousness raising actions whereby memories become 'voices of resistance' to the dominant discourse. *Beloved* tells the story of Sethe, who killed her daughter to free her from the bonds of U.S.A. antebellum slavery. Through re-memory, Sethe is able to re-visit her past and re-construct the murder of her daughter using her own words and on her own terms. In recollecting and revisiting the murder, *vis-à-vis* the ghost of her dead daughter, Sethe is able to reconcile her actions as an act of love instead of an act of infanticide because in the context of slavery, death was seen as the primary means of freedom. Historical data shows that during the slavery era in the U.S.A. and the Caribbean it was common for black mothers to take their children lives to prevent them from being forced into a lifetime of servitude, brutality, and exploitation. Their actions represented conscious acts of resistance against their slave masters and the commodification of human labour (Shepherd et al., 1988).

Despite this fictional narrative, *Beloved* is representative of the way black mothers utilise re-memory to re-articulate and document their pasts in their own voices. The opportunity to draw upon personal memories to re-tell stories of their past in a racialised and politicised context provided the impetus for many of the mothers to participate in this research. Many of the narratives remembered and re-told are not directly concerned with their daily experiences as mothers. However, their position as mothers is implicit in their re-structuring of these stories. These re-memories not only centre on childhood, familial experiences at home and wider racial experiences in the public domain, but also on self-identification with the collective 'Caribbean' cultural identity.

Cultural objects and cultural signifiers are also used to shape cultural identity and produce, what Plummer terms, *cultural memory*. In the second-generation mothers recollection of childhood the first televised showing of *Roots*, in 1977, was a key cultural memory. *Roots* was based on the fictional work of Alex Haley and traced the genealogy of an African American family from the slavery period onwards. The mothers culturally identified with this issue of black slavery and reinforced notions of collective belonging. *Roots* also opened up a dialogue around their own family narratives of slavery and revealed generational differences in attitudes to slavery. The following accounts provide some indication of this:

When *Roots* came out, it was all we talked about the next day at school. It united the black children in our year. We went to school angry and we felt really rebellious; like we wasn't going to take that shit from anybody. The teachers were wary and gave us a wide-berth during that time when it was showing on the TV. We used to do scenes from the show in playtime—we would pretend to whip each other, and it would always end with slaves fighting back and defeating the slave-masters; it was our way of fighting back. [Angela, age 29, married, second generation]

Michele: I remember coming back from J A [Jamaica] and then they showed *Roots*. I thought why did no-one tell me we were slaves, and my mum was like that was in the past, you don't want to worry about it, my parents never ever wanted to talk about it.
T.R.: Why did your parents not want to talk about it?
Michele: I think they were from the generation where it's in the past, forget about it I asked my mum if her grandmother was a slave and my mum was like 'no, no', she didn't want to talk about it at all.
 [Michele, age 28, lone-mother, second generation]

When the issue of slavery came up, I remember one afternoon some white children in my year [at school] told me that they watched *Roots* on television the night before. I was the only black one in my year and so naturally they tried to ask me questions about it. I was shocked because I never knew we were slaves, it was never talked about at home. After that I remember being really excited and going home and telling mum what I had learned, that we were slaves but she wouldn't talk about it.
 [Tanya, age 40, lone-mother, second generation]

From Tanya's and Michele's account it is clear that the issue of slavery was silenced in their homes and their experiences of silencing was common to other second generation mothers in the study. Why their parents chose to silence this issue must be understood in the social context of the 1960s and 1970s; an era when many second-generation mothers were themselves children. During this period, race relation theorists advocated assimilationist policies to deal with increasing numbers of migrants to the U.K. from New Commonwealth territories (CCCS, 1982; Solomos, 1988). Social welfare and educational

agencies focused on developing policies and procedures designed to encourage migrant children to quickly assimilate into the dominant culture. Therefore, it is conceivable that first generation mothers, firmly embedded in assimilationist policies of the time, believed that highlighting slavery would inhibit their children's integration into present society. Julia Fordham's study (1996) on black mothers in the U.K. during this era supports this viewpoint.

Cultural objects and signifiers in cultural identification

While the first generation mothers favoured mothering practices that supported an assimilationist policy, today second and third generation mothers regard teaching children their historical legacies, including slavery and migration, as an important feature of their mothering work. One way in which the mothers achieve this is by utilising cultural signifiers in their mothering so that they transmit perceived Caribbean cultural values and identity to their children. The mothers identify respect and good manners, as demonstrated by their children, the use of corporal punishment to maintain discipline of their children, regular attendance at church, and food, as key cultural signifiers of Caribbean cultural identity

Respect and good manners
 The mothers recognise the issue of showing respect to parents, family members and community elders as a Caribbean tradition clearly distinct from a British one as the following quotations illustrate:

> When your parents call you, you don't say 'yeh' or 'what', you've got to say 'yes mummy' or 'yes daddy', little things like that, you had to show respect. That's the way it is in the Caribbean and my parents raised me like that ... little things like you make your beds in the mornings, like when you come home from school you know that you have got to take off your school clothes and you put on your house clothes. Those kind of values I want to pass onto [my daughter] because I think those kind of values carry you through life and make you a better person.
>
> [Jamilla, age 25, lone-mother, second generation]

> Respect of elders, even if you're not related we call everyone aunt or uncle ... Coming to this country, I have never lost my West Indian background or culture. I have brought up my children with the same values I was

raised. Things like the respect of elders. Even if you're not related we [West Indians] call everyone aunt or uncle.

[Dolly, age 76, married, first generation]

We had it drummed into our heads that you had to respect your elders. Manners and respect are important. If you passed an elderly person on the street we had to tell them 'good morning' or 'good afternoon'. I remember that coming home from school with my mum and the bus was crowded then my mum would make me give my seat up to an adult and I would have to stand up for the whole journey home. She brought those values from home and try to teach it to us.

[Viv, age 40, married, second generation]

It is interesting that the mothers perceive these values of good manners and respect as intrinsically Caribbean traits. However, it could be argued that the the U.K.'s colonial legacy in the Caribbean meant that Caribbean families would have incorporated British value systems into their parenting and adopted British views around family values, respect and discipline. Furthermore, critics would also suggest that many other ethnic groups uphold these values of respect for elders; good manners and discipline. Therefore, and in contrast to these mothers' views, they cannot be viewed as exclusively Caribbean values or behavioural traditions.

Corporal punishment and discipline
The mothers also identify strong parental (family) discipline of children, mostly in the form of corporal or physical punishment as a Caribbean cultural signifier. In the Caribbean 'beating' or 'licks' (i.e. physical reprimanding of children primarily through belt, hand or shoe) remains a visible practice of discipline and punishment across the region, especially amongst the lower classes. Christine Callender (1997) claims that the roots of physical punishment as a common method of child rearing lie in pre-slavery African traditions, which have survived and are retained in Caribbean societies across the diaspora. Since the early 1990s various agencies were established in the Caribbean with aim of developing policy and legislation to address and control this mode of punishment, and also to educate parents in finding alternative methods of punishment (UNICEF, 2004). This ongoing work across Caribbean territories falls into line with policy initiatives in U.K. that are designed to regulate parenting and protect

children's rights such as the 1989 Children Act (Brannen and O'Brien 1996). So far Caribbean parents in the region and the U.K. have been resistant to these changes.[2] As Jane Ribbens (1995) observes, part of the resistance is because understandings of the term discipline are subjective and individualistic. As a result, individuals have different understandings of when discipline should be exacted and to what type of children's behaviour. The other reason is that parenting and child rearing practices are regarded as a private family concern. Thus, any state intervention into parenting is regarded as intrusive, restrictive, and highly authoritarian (Brannen, 1999).

A historical tradition exists in the Caribbean wherein 'good parenting' relates to parents ability to act as successful disciplinarians, and produce well-disciplined children who adhere to societal norms and values (Lowenthal, 1972). The onus is on parents to show others in their community that their children are obedient and respectful (Peters, 1988). Physical punishment is used to ensure their children's compliance. Elsie Leo-Rhynie (1997) reflects, 'these beliefs are founded, for the most part, on the biblical injunction not to "spare the rod and spoil the child"'. (p. 46). The mothers in the study, to varying degrees, grew up experiencing this form of discipline from their parents and they view it as a distinctive Caribbean tradition. While in a very small minority of cases there was little difference between discipline and abuse, for the most part, the punishment administered by their parents (usually the mother) was followed by shows of great physical affection and love. The punishment experienced by these mothers, as children, did little to damage close and loving bonds with their own parents. Certainly, the majority of mothers still persist in the belief that physical punishment is a culturally accepted method of parental discipline. However, there are class and generational differences in attitudes to, and experiences of, parental discipline. Generally, the mothers who were raised by parents who had more schooling and from the middle-class backgrounds were less likely to experience physical punishment. Grant et al. (1983) explains this is terms of 'the development of efficient communication skills that would permit them to reason with their children and explain the nature of misbehaviour to them' (p. 44). On a more practical note, these middle-class parents had resources

2 For example, policy attempts to ban parents 'smacking' children has sparked considerable debate in the black community. The *Voice*, one of the main black-based newspapers in the U.K., has reported on this issue (see Voice, 8th November 2004). The general consensus by black people who gave their opinions was that parents should be allowed to smack their children and that the government should not interfere in the way that parents choose to discipline their children. Interestingly, black parents justified their view by highlighting that smacking is part of black family cultural tradition.

that they could threaten to withhold from their children (e.g., removing toys and other privileges), so they had alternative ways to punish their children that were not options for low-income working-class parents. In discussing their own parenting methods, the first generation mothers acknowledged that physical punishment was the most common method of disciplining their children. However, the second and third generation mothers expressed greater caution about this practice. This is because increased state control and legislation in parenting to safeguard the rights and well-being of children—such as the Childrens' Act 1989—and general changes in societal attitudes to parenting, have influenced the mothers' views on parental discipline and punishment. For the vast majority of the second and third generation mothers any references to physical punishment of their children such as 'beating' represents a symbolic gesture to the Caribbean model of parenting and a re-affirmation its cultural significance rather than actual practice. In reality, the preferred methods of discipline by the mothers are 'grounding' (disallowing recreational activities and privileges outside of the home for an established period of time) stopping pocket money and restriction of use of telephone, television and internet, computer games. The social and historical context in which the mothers situate their own, and their parents, disciplinary practices provide a direct challenge to criticism levelled at disciplinary practices of Caribbean parents by those policy makers that portray their children as *'unfortunate recipients of repressive regimes'* (Callender, 1997: 100). It also re-affirms a Caribbean cultural identity by focusing on the perceived cultural significance of this parenting practice.

The Church

For many first generation Caribbean mothers during these early years, the black church acted as a primary site of resistance. black churches are not just something first generation mothers turned to upon migration, because historically the practice of churching-going and collective worship represents an important characteristic of Caribbean life. Across Caribbean territories black women are regarded as central to church participation and religious activities. Outside of the home and domestic sphere, the church acts as a primary site for the congregation of large numbers of black women. Valentina Alexander's (1996) study of black women's historical relations and participation in the church highlights the way black women established the black church in the U.K. as a strategic site of resistance. She comments:

They [black women] ... familiarised themselves with the language of resistance, although it had become so much a part of their spiritual lives that it was not necessarily recognised by them as such. Their tactics for resistance had been two-fold: they had implemented a religious life-style which changed an alien faith into their own and then utilised it in the general struggle for the ideological liberation of their people; second, they had created institutions where their specific needs as oppressed women could be met and dealt with. (Alexander, 1996: 90).

In my own research, the case of Dolly, a first generation mother, illustrates the way mothers use their participation in mainstream churches to challenge institutional racism:

In the church I was going to, there was a lot of black people that started to come, but there wasn't many black people taking part, so I got myself on the PCC [parish church council] and if anything disturbed me or worried me, I got my say. For example, there was seven ushers and there was not one black person taking part but there was a lot of black people who attend the church, so I had my say. From that day, they made sure that the ushers were not all white. So I fought, I fought a lot. In a quiet way, I got changes. [Dolly, age 76, married, first generation]

Dolly's action is indicative of the way that first generation mothers, during those early years, were not merely passive victims of racism, but were active agents in bringing about awareness of racist practices by dominant groups in society and in creating change.

Other first generation mothers, feeling excluded and marginalised in mainstream churches, turned increasingly to the black-led churches that were emerging in major cities throughout the U.K.

I was raised a Methodist but changed to Pentecostal. Growing up we was always led to believe that we share the same love and fellowship with other Methodists. I can't tell you how wrong I was. My very first Sunday in England I was really looking forward to it. Me and my cousin went to the Methodist Church on the high street. It wasn't nice. They didn't want us there. There was no love or fellowship expressed to you as a stranger. They were very cold and unfriendly. No-one spoke to us.

They're supposed to be Christians but to my mind they were hypocrites. I kept going back for a few months and I really tried to make the effort to be friendly but it was obvious I wasn't wanted. Then one of my friends from work invited me to her church. It was a black church and so different. It was so warm and inviting and they made me feel welcome. That's the church I've been with ever since.

[Donna, age 59, lone-mother, first generation]

Goulbourne (1989: 98) attributes the growth of black-led churches during this period to three key factors: (1) the rejection of white society and the congregation of black people, (2) class differences between practising white Christians (largely middle-class) and the majority of practising Caribbean migrants (working-class), (3) 'the evangelicism' of Caribbean Christians, (4) the strong feeling among many Caribbean Christians that they took their faith more seriously than white church-goers. Valentina Alexander notes that the black female church-goer is cast as:

Jemima; strong, resilient, matriarch, eyes lifted exclusively heavenward, carrying her race and all its woes upon her shoulders, bearing them through her unending prayers, her perpetual song and her faith in god-man Jesus. (Alexander, 1996: 85).

However, this image (like all stereotypes) does little to explain relations between black women and the church (Alexander, 1996). In particular it does not address the generational difference that affects this relationship. There are significant differences between generations in terms of the centrality of the church in the family lives of the mothers in the study. Virtually all of the accounts of the first generation mothers I spoke to document their participation in the church as an important part of their mothering, in a way that the second and third generation mothers' accounts do not. All of these first generation mothers are very active in their respective churches. For example, Dolly is a church steward and member of her church committee. Caro, Donna, Pearl, and Enid are members of their churches' choirs and Doris supervises her church's flower arrangements. These first generation mothers' involvement in and commitment to their churches, reflects experiences in the Caribbean. Here, church attendance and extra-curricular church activity is considered a traditional weekly ritual.

Pearl, a first generation mother reflects on the importance of the church to her life. She states:

> Without God's grace, I wouldn't have been able to raise my family and see them grow up into adults with families of their own. So my faith is very important to me, it's part of who I am. Those first few years were so hard. My children say "mum how did you manage? How did you cope?" The answer "I don't know". It was by God's grace that I kept going. God gave me the strength to carry on, so going to church, is my way of saying thank you. It gives me peace as well. No matter what is happening, I know when I leave church, I'm at peace, I have strength.
>
> [Pearl, age 61, married, first generation]

Pearl's account suggests that she drew strongly on her religious faith to assist her with her mothering especially during the early years in the U.K. when she encountered hostile conditions. Even today Pearl still considers the church a central aspect of her mothering identity.

Second generation mothers also remember the church as constituting an important part of their childhood experiences and childhood memories:

> *Nizinga:* I grew up in a typical West Indian family.
> *T.R.:* What's a typical West Indian family?
> *Nizinga:* A typical West Indian family, church on Sundays, followed by rice and peas. [Nizinga, age 31, lone-mother, second generation]

Attending church every Sunday is remembered by the second generation mothers as something which made them 'different' or 'other' to the white children with whom they grew up. It also binds them to a shared sense of a collective cultural past, as the church represents an important Caribbean tradition.

However, there is the sense that in comparison with first generation mothers, the church is not so central to their lives[3]. None of the second and third generation mothers in this study attend church on a regular basis, although, many attend church on special occasions such as Christmas, Easter and Mothers

3 I do not mean to presume here that the second and third generation mothers are less religious but rather that attendance of 'traditional' dominant Christian religious institutions (Church of England, Methodist and Catholic churches) has declined amongst adult women. However, there is evidence to suggest that there are high rates of participation by second and third generation women in black-led, and other evangelical churches (Alexander, 1996)

Day celebrations. Furthermore they place less insistence on their own children attending church. Only two second generation mothers, Zora and Jamilla, and one third generation mother, Denise, have young children who regularly attend Sunday School. Even in these cases, these mothers send the children with their own mothers instead of attending with them themselves.

Enid, a first generation mother, and Zora and Jamilla, two second generation mothers, best exemplify this generational difference in attitudes:

> T.R.: Did you go to church growing up?
> *Enid:* Of course I did, we all went to church, going to church was very important to us, not like now.
> T.R.: Do you still attend regularly now?
> *Enid:* Yes I go to the [local] Methodist church, every Sunday. I'm there, you'll see me sitting on the third pew on the right, that's my seat. I look forward to Sunday, so I can go to church, it's my special day. If for some reason I'm not able to go one Sunday, I don't feel quite right for the rest of the week, I feel like something is missing. There's this feelings of emptiness.
>
> [Enid, age 69, married, first generation]

Whilst Enid speaks of the church and her religious beliefs with passion and conviction, Zora and Jamilla express greater feelings of ambivalence:

> T.R.: Did you go to church?
> *Zora:* Yes, I was dragged out of bed every Sunday until I got to 12 and then I decided one morning that I wasn't going any more. She [mum] fussed for a while but then she left it alone
> T.R.: Why did you stop going?
> *Zora:* It was embarrassing, well no, not embarrassing but boring. My friends used to play netball, they never went to church, because the white families who lived round our way never really went to church, it was just [white] old people really. So my friends thought it was funny I had to go, and I felt it was ... well I just wanted to play too, so I stopped going. But I feel church is important, I'm still Catholic even if I'm not a practising one, and it is important to bring my daughters up that way. I send them to Sunday school with my mother, they're at the age where it's fun for

them, they love it. But I suppose if they didn't want to go any more, I wouldn't force them to, like we was forced to go to church.

[Zora, age 26, living with partner, second generation]

On a conscious level, church is not really a big part of my life, I mean I do go to church sometimes. My memories of church in my childhood is that I had to go every Sunday, I had to go to Sunday School. When I was 12 or 13 that was the stage when I really used to question what I was going for. When I was 15 they made us into members and we had to go to classes and study the bible. You just go through the motions because it was expected of you. There was a stage when I stopped going altogether because I thought I was a hypocrite. Now I go when I can but I'm not a regular church goer, but having a faith is important to me.

[Jamilla, age 25, lone-mother, second generation]

Both of these mothers, Zora and Jamilla, remember church as something they were obligated to attend as children, as a sense of duty, rather than through choice or any personal religious feelings. In Zora's case, attending church reinforced her difference, her 'otherness' to her white friends, and so she stopped attending church in an attempt to down play her difference. The decline in attendance at the mainstream churches, which many of the second and third generation mothers grew up in as children, does not necessarily mean Caribbean mothers today are less religious. The fact that there has been an increase in the number of young black people attending Pentecostal and other 'non-traditional' churches (Alexander, 1996) reveals the importance religion still maintains in the lives of young black people. One could argue that the decline in attendance at mainstream churches reflects wider social patterns where church attendance is generally declining. It could also suggest that as a result of greater diversity in sites of resistance and resources available to black women to challenge racism, the church is no longer dominant. The rapid expansion of black-led churches in the U.K. has led some commentators to claim that young black people today are moving towards a rejection of traditional western-influenced religious institutions, and their corresponding colonial, imperialist histories, and, that the racial, discriminatory, and exclusionary practices of mainstream churches contributes to this change (Coleman, 1992; Alexander, 1996).

Food

Food is an important part of cultural identity. But the obviousness and taken for granted nature of food has meant that until recently food has received limited critical attention outside anthropology and the health and nutrition research fields. Yet food is a cultural artefact imbued with meanings and values (Counihan and Esterik, 1997). The type of food goods chosen, the preparation and presentation of certain foods, all re-affirm cultural belonging. The mothers recognise the cultural significance of Caribbean food and they express a commitment to the preparation of this food as a means through which they can sustain links to the Caribbean and transmit Caribbean cultural identity inter-generationally. An important mothering practice involves them cooking Caribbean food for their children and in turn teaching their children how to prepare this food for themselves:

> My parents brought us up in eating West Indian food. My mother made a point of cooking West Indian food, teaching us learning how to do it. I like to cook rice and peas chicken curry and make Guinness punch. I make all of these and give it to my daughter. I also cook other types of food but it's predominantly West Indian food, so that when she grows up she can cook herself these foods. I feel it is important that this was passed onto me from my mum and now from me to her.
> [Michelle, age 28, lone-mother, second generation]

> In our home we may try a few English foods now and again but my husband was not too keen on it. Certainly when the boys were smaller I used to make things like fishfingers and chips, but there was always West Indian food—that's what they grew up with. I made sure all my children can cook. They all know how to cook. One of my sons is teaching his children. Now the next generation know about our food and the rich culture West Indian comes from. [Pearl, age 69, married, first generation]

> I know how to cook West Indian dishes, so that's an important cultural influence and I encourage my daughter to eat certain West Indian things. [Maxine, age 28, lone-mother: second generation mother]

Particular foods hold special cultural significance for families and they are often associated with family celebrations, 'get togethers', and cultural events.

Food therefore forms part of family rituals celebrating cultural identity (Sutton, 2004)

> It's our family tradition that the last Sunday of every month all of my aunts, uncles and cousins, go round to my gran's house. We have a big breakfast and then later we have our big Sunday dinner there. Usually, we have ackee and saltfish, breadfruit and green bananas for breakfast. She makes rice and peas with chicken and Guinness punch. She used to make all the traditional stuff that she had when she was growing up.
>
> [Sharon, age 19, lone-mother, third generation]

> Christmas is our big time. I stick to traditional West Indian food with one or two English dishes like potatoes. I start off with garlic pork and pepperpot on Christmas morning then I'll make rice and peas, spicy duck or lamb and of course a turkey.
>
> [Denise, age 22, living with partner, third generation]

Caribbean food is also used as cultural signifier by the mothers to revisit and re-member their childhood and construct a collective memory of cultural belonging. For example, the mothers commonly made reference to their experiences of the 'Caribbean Sunday dinner' consisting of chicken and rice and peas, the 'Caribbean Sunday breakfast' of ackee and saltfish with 'ground food' (i.e. green bananas, breadfruit, yam and cassavas) and also the 'dutchpot', a large cooking pot traditionally found in Caribbean homes. Caribbean food, as a cultural signifier, is perhaps one of the clearest manifestations how notions of a collective Caribbean cultural identity represent an 'imagined spatial collective' (Bakari, 1997) constructed by those residing outside of the region. Particular food types that are specific to individual territories in the region—such as the Jamaican cuisine, ackee and saltfish—are amalgamated and redefined as representing Caribbean cuisine.

Conclusion

Cultural identity is a highly politicised arena where subordinate groups can politically mobilise to challenge and resist external constraint. They also highlight individuals' agency in defining and choosing their identity. In this chapter I have attempted to show that Caribbean women, in their mothering, rely upon ideas of collective Caribbean cultural identity to challenge problematical constructions

of black mothering that I have identified in the previous chapters. A collective cultural identity that reinforces cultural belonging is socially constructed by the mothers through a combination of collective memory, cultural memory, re-memory, and cultural signifiers. Collective memory establishes the social and cultural frameworks for individuals to transform their personal narratives into collective narratives. Cultural re-memory also emerges from these collective narratives. The process of re-membering has a three-fold effect. First, the mothers' own memories are revisited so that past experiences are positioned in a politicised and racialised context. Second, the mothers are able to re-insert aspects of their cultural pasts, most notably the legacy of slavery, into their cultural identity. Third, a transnational Caribbean cultural consciousness is developed that emphasises 'rootedness' and 'connectedness' across successive generations.

Cultural signifiers are constructed to cement claims of a Caribbean cultural identity. This includes shared cultural attitudes and values around good manners, discipline, the church and food. These signifiers are employed by the mothers to give meaning to their mothering experiences and assert difference to white mothers. In formulating cultural identity the mothers recognise that cultural identity is not fixed and immutable but transitory and adaptable. The mothers express this in the way that they transform cultural self-identification according to changing contexts and audiences, as well as with generation difference. The remaining chapters consider how this collective Caribbean cultural identity informs Caribbean mothers' experiences in terms of child rearing practices, community activism, paid work and their relationships with men in their families.

Chapter 5
Mothering, child rearing practices, and strategies in resisting racism

Introduction

For Caribbean mothers in the U.K. a central aspect of their mothering work involves them developing coping strategies that enable their children to cope with and respond to racial discrimination which they, as black children, will most inevitably face. Research by Beverley Bryan et al. (1985) highlights the importance of black mothers' role in challenging racism as part of their child rearing:

> *'The cruel rejection of our children was something which black mothers had to respond to.* In some cases, hardened by similar daily experiences in the work place, some of our responses were clearly inadequate. Nevertheless, *many of us did find ways of supporting and reassuring our children as they learnt to cope ...'* (Bryan et al., 1985:92; emphasis added)

Of course differences between the mothers, such as social class and generation divisions, inform their perceptions of racism and how they respond to what they believe to be racist practices and experiences in their own and their children lives. These divisions also have implications for the strategies the mothers devise and resources available to them in this particular aspect of their mothering work. Despite these differences, this chapter identifies four main types of strategies that are commonly employed by the mothers. These encompass: first, psychological and emotional preparation of their children to resist racist practices in their everyday lives; second, the monitoring of their children's education; third, the celebration of black diasporic and Caribbean culture and traditions to promote a collective identity and a sense of 'cultural belonging'; and finally, the close monitoring and policing of children's activities in public spaces. Before we can begin to understand the significance and value the mothers attach to these strategies, it is important first to be aware of the particular ways in which the mothers conceptualise and experience racism in their own everyday lives, since this influences how they engage with these coping strategies in their mothering.

Understanding racism as lived experiences

In the study all the mothers stated that they had encountered racism in their everyday lives although the extent that they experienced this varied, as did the context. Social class and generation difference generally informed the mothers' experiences and their access to resources to respond and challenge racist practices in their everyday lives. In the following quotations three mothers from different generations—first, second and third generation—reflect on these issue of racism. Doris, a first generation mother, offers a retrospective account of the racial violence and harassment she faced during the 1950s when she first migrated to the U.K. Michelle, a second generation mother reflects on similar experiences of overt racial abuse during her childhood years, and growing up in East London during the 1970s. Susan, a third generation mother, and in contrast with the previous accounts, recounts a recent incident where the racial harassment she faced was less direct, more subtle, and insidious:

> Things were awful in those early days because they wasn't used to black people. We were like aliens from outer space and you could see the fear in their eyes. I was there for the 1958 [Notting Hill] riots because that time we used to rent a room just off Portobello Road. They chased us and threw bottles at us, but you see we were attacked and we were defending ourselves. But the newspapers reported it differently. They said that it was us black people who were rioting and looting. I'm sure you heard the stories from your parents about signs landlords used to put up in their windows 'no blacks, no dogs and no Irish'. I lived through that, that was how it was for black people back then. White people were really racist because they didn't know any better.
>
> [Doris, age 81, married, first generation]

> I'd be walking down the road and you have these nasty, vile people. They would have the nasty habit of spitting at you and calling you 'nigger' or 'black bitch'. East London was supposed to be a multi-cultural area but I still had to deal with that. You never knew what was going to get when you left your house. [Michele, 28, lone-mother, second generation]

> There's certain places in England that I don't feel comfortable going. Last summer we, me and my mum and my boyfriend, went to Shropshire

because my mum's work friend was getting married and she invited us. It's a lovely area, really pretty but I wouldn't go back there again because people were staring at us like they had never seen black people before in real life. We went to this restaurant and when we walked in the waiter quickly rushed over said that the all tables were fully booked even though we could plainly see empty tables. My boyfriend got vex [upset] and wanted to made a fuss but mum said 'no just leave it, it's not worth it' and we walked out. We decided to go and eat at the nearby pub and again it was the same thing. There was just this vibe that said 'you're not welcome here'. No-one said anything but you could tell they were wondering what we're doing out here. We ate our food quickly and didn't hang about. Then as we walking up the lane to the hotel, we saw a police car going in the opposite direction but when they saw us the car quickly reversed back and started following us up the hill. They didn't do anything but just stayed behind us until we got back into the hotel. So, because of things like that I feel black people are still not welcome in certain places and in certain parts of the country. They're not allowed to put up any signs like they used too saying 'no black people' but you still know that in certain places, in subtle ways they make it known that 'you're not one of us so you're not welcome'.

[Susan, age 20, living with partner, third generation]

Racist encounters and practices experienced by the Caribbean mothers are not just confined to (perceived) overt or direct racial actions such as racial abuse, harassment or physical violence. Instead the mothers recognise that racism manifests itself in more subtle 'invisible' and complex ways. Nizinga's comment is one of many viewpoints expressed by the mothers to support this claim:

I can't really give you a clear cut example because racism is so subtle that you can't put your finger on it and define it and say this is actually going on, but you know its there. You just can't articulate it but it's what's going on. It's no use ranting and raving because when you're talking to those people, they want facts. Their idea of racism anyway is name-calling. I can handle that but I can't handle the subtleness, where it is coming from. It did actually make me quite paranoid for a while but I just had to learn how to deal with it.

She then goes onto add:

> You know, we have it bad, our parents have it bad and our grandparents
> and great grandparents had it real bad. I don't think it's any worse, it's
> still just as bad as if we're still stuck on some plantation somewhere, but
> the situation and circumstances have changed.
>
> [Nizinga, age 31, lone-mother, second generation]

The above quotation reinforces Gilroy's (1987) view that racism is experienced as a 'changing sameness'. This reflects the fact that whilst the form and expression of racism has transformed over the years, it still continues to inform the daily lives of black people, and more specifically the lives of Caribbean mothers. The extensive literature documenting the racial inequality black people continue to experience in British institutions such as, for example, education, social welfare services, and the criminal justice system supports these claims of the 'changing sameness' of racism (Madood, 1997).

Caribbean mothers have a long-standing tradition of responding to racial inequality by actively, and in diverse ways, challenging racist practices at personal, individual and local, collective levels. For example, during the 1970s a group of Caribbean mothers collectively organised to successfully campaign for the abolition of Educational Sub-Normal [ESN] schools where Caribbean children were greatly over-represented (Bryan et al., 1985). My own research throws up similar stories of Caribbean mothers collectively and individually campaigning to improve conditions for themselves. Pearl, a first generation mother, recollected her experiences as a factory worker during the 1950s to recount how she collectively organised with the other female workers on the factory floor (many of whom were Caribbean mothers) to successfully lobby management into altering their shift working patterns so that working day now ended at 3.00 p.m. instead of the old time 4.00 p.m. Their new working patterns meant that the mothers were now able to take or collect their children from school, or arrive home shortly after their children's school day had finished. Pearl's success could be viewed as a small victory. But it was a large victory in the sense that these mothers were prepared to actively take on these larger institutions and organisations to secure better rights and working conditions for themselves and confront perceived incidents of racially and sexually unjust and unfair treatment.

Dolly's reaction to racist practices in her church, quoted in the previous chapter (p.63), is a similar example.

At individual and personal levels in their child rearing the mothers also implement strategies to respond actively to racism, thus subverting it, and minimising its importance in their children's lives. The struggle against racism, unites Caribbean mothers across the differences that exist between them.

Child rearing strategies to resist racism

Analysis will focus on four key strategies Caribbean mothers employ in their child rearing practices to encourage their children to respond to, and resist racism in their everyday lives. These strategies involve the psychological and emotional preparation of their children to resist racist practices, parental monitoring of their children's education, the celebration of black diasporic and Caribbean culture and traditions, and finally parental surveillance and policing of their children's activities in public spaces.

Strategy as a conceptual tool in child rearing practices
In suggesting that strategies are important mechanism through which the mothers respond to and struggle against racism it is important to clarify the meanings behind this term. Rosalind Edwards and Jane Ribbens (1991) explore the use of the concept 'strategy' in research defining women's—especially mothers' lives. They argue 'strategy' is a masculinist concept deriving from, and valorised as, male activities in the public sphere, and does not reflect the concentration on process rather than outcome in child rearing. However, in the case of Caribbean mothers' child rearing, I justify my use of the term 'strategy' to consider the way in which the mothers' individual battles against racism represent a collective experience than has a concern with outcome (see also Higginbotham, 2001). Traditional definitions of 'strategy' encompass having a plan of action or tactics. Despite the differences between the mothers, the common 'plan of action' concerns actively and deliberately seeking means through which elements of their child rearing can be used to respond to the effects of racism.

In a sense these mothers' child rearing actions are not merely 'coping mechanisms' but rather they signify conscious and deliberate acts of resistance. Yet, any implementations of such strategies in the mothers' child rearing practices are not without worries. Patricia Hill-Collins (1994) suggests that all black mothers living in western societies have to negotiate complicated and contradictory choices when developing child rearing strategies. The mothers' strategies encompass preparing their children to fit into systems of racial oppression whilst simultaneously resisting such systems. Hill-Collins recognises

that some mothers actively encourage assimilation so that their children fit into, and accept, the dominant ideology for reasons of survival. However, this can sometimes create unintentional costs to the children that are not usually felt until adulthood. In the analysis, the mothers' reflections of their childhood and their own mothers' child rearing strategies would certainly support this viewpoint. Generally speaking, the second generation mothers, when speaking about their childhood, revealed that their mothers' attempts to assimilate and not challenge perceived incidents of racism resulted in negative outcomes that still affect them as adult women today. There are also mothers who transmit to their children sophisticated skills that enable them to appear passive and submissive whilst at the same time they are challenging inequality and systems of oppression. Still other mothers encourage and teach their children to aggressively challenge racial inequality head on, as and when they are confronted with it. This approach can have similar unintended negative costs as the passive assimilation approach because black children do not learn to negotiate the delicate balance of resistance, submission and assimilation, generally required for them to successfully function in western societies (Higginbotham, 2001).

Black mothers are also faced with the task of balancing the need to expose and prepare young children for the various levels and forms of racism they will face, with the need to protect and shelter them from this information so that they can enjoy the innocence of childhood[1]. The following quotation gives us some indication of this concern expressed by the mothers:

> I want them to be children for as long as possible, so I suppose it's surrounding them in a comfort zone. I suppose I have been slightly smothering, I don't want them to experience that sort of thing [racism] yet. The school my son goes to is a black independent school and he'll never hear it here. But things will happen when he goes to secondary school, but I would have hoped that the foundation would be strong enough so that he's not rocked by it.
>
> [Jheni, age 35, lone-mother, second generation]

Psychological and emotional preparation of black children for racism
A central aspect of Caribbean mothering involves developing child rearing practices that psychologically and emotionally prepare their children for racism. The mothers in their child rearing practices teach their children to challenge

1 I recognise such a statement is a western cultural assumption of childhood. For debates on social and cultural constructions of childhood see James and Prout (1997).

racism in their lives and not view it as an obstacle for individual success and advancement. In order to achieve this, the mothers try to develop a particular mind-set in their children whereby societal racism is viewed as a motivating factor towards achieving their personal goals and ambitions. The following accounts by the mothers reflect this issue:

> I want her [daughter] to grow up to be proud of who she is because that way nobody can bring her down. I think I will do this by making her aware that she has to work a lot harder for what she wants, being aware that there are people out there who will try and stop you from succeeding, that there are people out there who don't expect anything from you, so for her to be aware of it and at all times I will encourage her to keep her head up, just be proud of who she is as a person and try to be strong.
> [Jamilla, 25, lone-mother, second generation]

> No matter how I do my best for my children as a mother, racism is out there. My responsibility as a parent is to make sure that my children do not allow racism to play such a big importance in their lives. They have to move beyond this. To be confident that they are bigger and better than racism and that they can do anything they want to do in life.
> [Camille, age 51, married, first generation]

And the following comments by Nizinga, a second-generation mother, clearly sum up the general attitudes expressed by all of the mothers when discussing how to encourage their children to approach racism:

> I'll tell my daughter not to let racism get you down, don't see it as an obstacle, just get on with it because you can do anything you want to in life, you can do it. [Nizinga, age 31, lone-mother, second-generation]

Caribbean mothers transmit a positive racial identity to their children in order to establish in their children self-worth, self-esteem and self-confidence, to challenge and resist racial inequality. These mothers' actions are particularly important because there are limited arenas in mainstream society in which black racial identities are valued and celebrated, outside of the contexts of sports, music,

and entertainment (Skellington and Morris, 1992). As Hill-Collins (1994: 57), in speaking about racial ethnic mothering generally, reflects:

> the racial privilege enjoyed by white, middle-class women makes unnecessary this complicated dimension of the mothering tradition of women of color. While white children can be prepared to fight racial oppression, their survival does not depend on gaining these skills. Their racial identity is validated by the schools, the media and other social institutions. White children are socialised into their rightful place in systems of racial privilege. Racial ethnic women have no such guarantees for their children.

In the study the mothers looked for ways for their children to celebrate black racial identity:

> I remember, maybe, they [children] had been called a name at school—I had to explain to them that, yes, they were black and that black was beautiful. When people try and get brown in the sun they associate it with health, well-being, and happiness. I had to show them it was truly wonderful to be a black person and not a negative thing to counteract the things children would be telling them at school.
>
> [Cara, age 50, widow, first generation]

> I tell her [daughter] she's a beautiful black princess all the time. I concentrate on all the positive things of being black.
>
> [Nizinga, 31, lone-mother, second generation]

The re-affirmation that 'black is beautiful' expressed by the mothers is rooted in discourse of the Black Power Movement that established itself in the U.S.A. and then the U.K. during the 1970s. Various commentators have examined the significance of this movement for black people worldwide (see for example, Davis, 1981). In the context of Caribbean mothers in the U.K., what was important about this movement is that the term 'black' was reclaimed from the dominant discourse in order to reflect a positive racialised identity. Black identities were now celebrated as beautiful and from this era onwards, influenced the mothers'

child rearing responses in countering pathologised images of black racial identities in mainstream society.

> When people say bad things about black people, that we're muggers and robbers for example, I tell them [children] to ignore it. You know they're not talking about you, you know what you're about. As long as you know that you have done nothing wrong, you can hold your head up high and have a sense of pride because black people have also achieved a lot of good things. [Beverley, age 48, married, first generation]

Parental monitoring of children's education
The monitoring of their children's education is a second strategy employed by the mothers to resist and respond to racism. From the 1960s numerous policy studies and government reports have acknowledged that the education system in the U.K. is a key institution in which black children continue to experience marginalisation and discrimination (for earlier studies, see for example, Goldman and Taylor, 1966; Select Committee, 1969). Successive Ofsted reports, published by the Department for Education and Skills, show that Caribbean children, in particularly young boys, continue to underachieve in schools (Gillborn and Gipps, 1996). While debates attribute this failing to a variety of reasons based on deficit models—such as, for example, a lack of black role models in schools, a lack of culturally relevant subjects in the school curriculum, a lack of parental involvement, the devaluing of education and learning in black youth culture—an overriding theme in the debate is that institutional racism and racist practices in the schooling system is a primary contributory factor in black children's underachievement and it remains a common cause of concern among parents, teachers and policy makers (see Wright, 1988; Mirza, 1992; Gillborn, 1995; Sewell, 1997).

The mothers in my study are themselves very familiar with these discussions concerning black children and the education system. As a consequence they have developed in their child rearing practices, increased monitoring of the education system. It is important to note, however, that the level and type of monitoring performed by the mothers varies. Furthermore, the mothers' own experiences of education in the Caribbean (primarily first generation mothers) or the U.K. (second and third generation mothers) also influence how they undertake this monitoring. For example, those mothers who were amongst the first minority ethnic children to be educated in the U.K. in the 1950s and 1960s, are very

anxious that their own largely negative schooling experiences are not repeated in their children's lives.

For many of these second-generation mothers, primarily from working-class backgrounds, the reality of their own schooling years in the U.K. was harsh. Racial, and to a lesser extent sexual, discrimination by teachers and pupils combined with limited resources in schools, concentrated in economically deprived areas, meant that their desire and ability for educational success did not match the realities which they faced and it was difficult for them to achieve this success (see also Wright, 1988, Mac an Ghaill, 1988, Mirza, 1992; Gillborn and Gipps, 1996).

> *Michele:* What I remember most about secondary school is being black and them having no faith in you whatsoever and when you produced a piece of work that was not so great the teachers would saying to you 'that's ok' [sic] instead of pushing you to do better. They was pushing them white kids but not us and you knew you were brighter than them. If I went to a school which gave more encouragement and gave me a push I would have achieved a lot more. My excuse is that at school the teachers said to me that I don't think you can achieve.
> *T.R.:* Why do you think they said that?
> *Michele:* Well I put it down to the 'race' card again. I remember one black girl and she said that she wanted to be a lawyer and the English teacher turn round and said 'well there's no way you're going to do that, quite frankly you're no good' [sic]. I don't think these people realise the damage they inflict when they tell a child that. When it came to exams it was your life in the teacher's hands and they'd decide CSE for you, forget 'O' levels, it was C.S.E.[2] [Michele, age 28, lone-mother, second generation]

Generally, second generation mothers who had similar negative educational experiences did not reject the system as a whole or the value of a good education. Rather the mothers who felt failed by the education system as children strategically secured an education for themselves as adult women:

2 The Certificate of Secondary Education (CSE), a lower level examination, and the General Certificate of Education at Ordinary level (GCE 'O' level), a higher level examination, were the two main levels of secondary school 16+ examinations in Britain before the General Certificate of Secondary Education (GCSE) was introduced in 1988.

When I left school I had to go to night school, that's what I did to get
my 'O' levels. [Michele, age 28, lone-mother, second generation]

I left school with hardly any qualifications. When I started working I built
up my qualifications. After I was working there for two years [housing
department] and they saw I was doing ok, they offered to pay for me to
do a housing management course and have half a study day. Even if they
didn't offer I would have paid to do it myself and gone to college two
evenings a week. [Zora, age 26, living with partner, second generation]

Nizinga: After I finished school, I went to college. The first college I went
to, this was [further education college] and everybody, about 90% of
students were black. We had all left school and it was like we were just
beginning our education now. A lot of black people have to finish school
and then go onto college to do their 'O' levels' or GCSEs then you go on a
do your degree in your mature years after you have worked for a while.
T.R.: Is that what you intend to do?
Nizinga: Yeh, I doing an Open University degree in Social Sciences but
I hope to switch to another university, and do it part time day release if
they allow me the time off.
 [Nizinga, age 31, lone-mother, second generation]

Heidi Mirza's (1993) study of black women in further and higher education
documents the way black women have utilised adult education to secure
educational qualifications that they were unable to obtain as schoolchildren.
These women have taken the 'back door route' into education as mature students.
Certainly, in the study, the vast majority of second generation mothers who left
school with limited qualifications used their current employment as a means
to pursue degrees and other professional examinations as part-time and day
release students. Interestingly these mothers who returned to education in adult
life, cite motherhood (impending or actual), being a positive role model, and
thoughts of providing a good life for their children as the catalyst in spurring
them back into higher education:

I decided to do the HND in Housing Management because I wanted to
make something of myself. If I'm honest then I would say that I'm really
doing it for my daughters, well for me too but more so for my daughters.

They're only five and nearly three [years-old] but I feel that even at that age they can see I'm doing other positive things in my life and they're seeing me doing things where I'm not just mummy.

[Zora, age 26, living with partner, second generation]

Nizinga, a second generation mother, similarly comments that it was raising her young daughter that motivated her towards studying for a social science degree:

Well people have been telling me that I should do a degree for years. Then when I had Keisha I just started to take stock, and you think well where's my life going to go from now, what can I offer my child? So I just did it.

[Nizinga, age 31, lone-mother, second generation]

It is interesting that in recollecting their childhood the second generation mothers recognise that their own parents equally valued the meritocractic ideal of education and regarded it as a means to secure inter-generation upward social mobility. However, newly arrived in the U.K. during the 1950s and 1960s, and lacking direct experience of schooling in the U.K., it is not surprising that they did not understand the day-to-day reality of racism which they faced as children at school and how this in turn directly impeded educational achievement and social advancement. The following quotation by a second generation mother educated in the U.K. reflects on first generation parental assumptions concerning this issue:

It doesn't matter how many 'O' levels you got, there's a lot of black people with degrees, masters even, and they are still be out there cleaning the streets, it's just disgraceful. In a way they [black parents] lied to us. A lot of people make the mistake of thinking that if they got the education, have a good academic background, then they're set up for life, but it's not like that at all. I know for a fact there's a lot of black people with really good degrees but they are still having to sign on or take shit jobs despite all that education. [Nizinga, age 31, lone-mother, second generation]

The criticism expressed by Nizinga towards first generation parents' attitudes to education does not acknowledge the historical and cultural rationale underpinning these parents' view of education and the educational system. First

generation parents' responses to their children's education in the U.K. from the 1950s through to the 1970s are based on their own experiences of education in the Caribbean just as second and third generation mothers' own experiences of being educated in the U.K. inform their attitudes and practices towards their children's education today. First generation parents newly arrived in the U.K., lacked direct experience of schooling in the U.K. Educated in the Caribbean, these parents were raised with the belief that working hard in school and showing obedience to the teachers equals educational success. It was commonly accepted that teachers had the children's best interest at heart, and teaching staff were greatly respected by parents and members of the local community (Senior, 1991). As a result of their schooling experiences in the Caribbean and the teachers' attitudes towards them, it was quite understandable that these first generation parents believed that (white) British teachers would also respond to their children and themselves as parents in a similar manner. This research shows that often these first generation mothers were not aware of the extent of the direct day-to-day instances of racial abuse and harassment by teachers that their children encountered during these early post migration years as Pearl's account suggests:

> I had no idea how vicious the teachers were to my children. I expected it from the other children who didn't know any better, but not the teachers. It was only years later as adults that my children really told me what they went through at school. I really had no idea.
>
> [Pearl, age 61, married, first generation]

Whilst it is accepted that some first generation mothers may not always have been aware of the day to day experiences of racial discrimination in schools, these mothers were aware of the wider experiences of institutional racism, of which the education system is a key site (Gillborn 1995). As such first generation mothers' encouraged their children towards studying 'strong' academic subjects at school, with the belief that qualifications in such subjects would enhance social and economic opportunities for them.

Not all of mothers educated in the U.K. as children during these early migration years encountered negative schooling experiences. Those mothers who as children came from an affluent middle-class background or went to school in suburban areas fared better than those mothers who as children were educated in inner London schools with limited resources. On the whole these women,

when recollecting their schooling years, remember experiencing less incidents of racism and racial harassment by their teachers and generally felt that good relations existed between themselves and the other children.

> In the 1970s my mother was one of few black teachers working in a school at that time and that created a bridge between her and the teachers at my school. She wasn't intimidated by asking them questions and she could talk to them on their level. She made them sit up and take note of her and I feel they respected her because she could relate to what they were trying to do with us at school
>
> [Anita, age 43, married, second generation]

It could be argued that by sharing a similar middle-class affiliation, the teachers could in many ways relate to these Caribbean children and their parents from middle-class backgrounds and thus judge them as less different to themselves. By seeing middle-class Caribbean children, such as Anita, as 'more like us', the teachers were less likely to apply stereotypical characteristics and notions of black racialised identities to the mothers and children. They were also less likely to discriminate against them on the basis of their racial cultural origin. This is not to suggest that teachers never expressed racist attitudes towards middle-class black children. Diane Reay's (1995) study of the classroom interaction of teachers and children in schools recognises that racism is displayed differently amongst the middle-classes. Racism, Reay argues, is often covert and manifests itself in a taken for granted attitude of superiority towards those perceived as 'others'. In addition, the teachers often ignore (or claim to ignore) black children's racialised identity, and instead they adopt a 'colour blind' approach to classroom experiences of black children. In doing so, black children's racial and ethnic identities are disregarded and instead they are defined in terms of their closeness in similarity to 'whiteness' or 'Britishness'.

Not surprisingly, these second generation mothers' own schooling experiences in the U.K. have had a fundamental psychological impact on the way they respond to the education system today and how they choose to educate their children. There appears to be greater pro-activeness on these mothers' part in having direct contact with the teacher regarding the educational affairs of their children. Whilst it could be suggested that the mothers' activities, attitudes and practices are part of a wider cultural shift in education towards greater parental involvement and parental choice and consumerism (Ball, 1993; David, 1993),

this should not diminish the fact that their greater involvement in schools is also a consequence of their own schooling experiences. One aspect of this involvement is concerned with monitoring their children's education and school curriculum in order to challenge and combat perceived incidence of racial (and also sexual) inequality in their children's schooling. The following quotations provide an indication of this:

> I saw that they wasn't moving my daughter onto another book, this despite knowing that she had done the reading as I would sit down with her every night to make sure that she was doing it—anyhow I saw that the teacher had moved these other white girls that my daughter plays with onto the next higher level book. So I went up the school and pulled the teacher aside to find out what was going on, after that they moved her to the next level book.
>
> [Zora, age 26, living with partner, second generation]

> There was this day I picked Malik up from school. He was around five or six years-old. When I asked him 'how was school today?' he started crying, saying that these children at his school kept calling him mud-face, and that he's made of mud. We immediately made an appointment with the headmaster to make him aware my son is being racially abused and that he had to deal with this immediately. The long and short of it was that a meeting was called between ourselves and some of the children's parents to talk things through and they got a warning. It brought it home that some things don't change because I was called names, racial names.
>
> [Tanya, age 40, lone-mother, second generation]

These mothers also closely monitor their children's curriculum and have greater involvement with their children's school on a day-to-day basis:

> I decided to become a parent-governor at the school because I feel that I can have a greater role in their education by doing that and my voice would be heard. One of the first things I got placed on the agenda was lack of books in library that promotes positive black people. It took me a few months to get my way but I kept on raising it at the meetings. I was

able to bring more books into to school that were more multi-cultural and that had black people that the black children could relate to.

[Anita, age 43, married, second generation]

Another mother, Michele recollects:

I remember when she was learning colours and she learnt every single colour except for the colour black. I went down to that nursery and said that's the first thing you should have taught her because number one that's what she is and number two, black is a dominant colour.

[Michele, age 28, lone-mother, second generation]

This incident initially appeared trivial to me but in listening to Michele it was clear that she saw wider underlying implications centering on the issue of racial identity. From Michele's perspective by failing to teach her daughter the colour 'black' this was one way of devaluing her daughter's racial identity, and at a very early age it is training her daughter to believe 'black' is of secondary importance.[3] These examples of involvement and intervention expressed by the mothers demonstrate their success in putting into place strategies that actively challenge perceived incidents of racism in their children's education.

In addition to greater parental involvement in their children's schooling, some Caribbean mothers are increasingly deciding to send their children 'back home' to the Caribbean to be educated. In the study one mother decided to do so with her children. Cara, herself a secondary school teacher, has had first hand knowledge of racism in the U.K. schooling system and the effects of this on Caribbean children's lives. Her experience directly influenced her to send her eldest children 'back home' to the Caribbean. Cara, in talking about the schools in which she has worked, states:

They are very negative towards the black children. That really opened my eyes, how some of the teachers are and the negative way in which they perceived our children. They say our kids are really disruptive, they don't want to learn, they're thick, they're slow. It made me think about my own children, what type of education they would receive, that's when we were

3 U.S.A. writer, Patricia Williams in her Reith Lectures (1997) also talks about a similar experience in relation to her son's schooling

saying yes, we have to go home to Trinidad. The children need to have an education where they will be loved and supported.

Cara took the decision to return home with her family to her island of origin, Trinidad, during the 1980s, where her eldest two daughters received a secondary school education. During the interview I asked her to address the difference this made to her daughters' education:

> *T.R.:* Do you feel your daughters received a higher standard of education, than they would have if you had remained in Britain?
> *Cara:* Most definitely. Education standards are higher in Trinidad, the expectations are higher and the culture of education is something that is accepted. You're not seen as goody-goody if you're doing it, or talked about, so they didn't have the negative peer pressure to think about. Getting a good education is an accepted norm.

So convinced is Cara of the value of a Caribbean education that she is considering sending her youngest son there to be educated too:

> I have particular concerns about my son, being a black boy, a black youth here in Britain. I really want him to do the best that he can and my concerns are if he goes to school here, the kinds of pressure he might have not to achieve might be great.
>
> [Cara, age 50, widow, first generation]

The idea of sending their children 'back home' (to the Caribbean) to be educated is an option being increasingly considered by mothers with school age children who still maintain strong family links to their Caribbean island of descent (Goring, 2004). This option particularly appeals to mothers with adolescent sons. Their views are supported by evidence that indicates Caribbean boys have the highest exclusion rates in schools and, from a young age, are negatively perceived by teachers as 'hostile', 'aggressive', and 'underachievers' (Sewell, 1997). In addition, in the U.K. amongst both black and white working-class boys there persists a popular viewpoint that academic achievement is effeminate or 'gay' (Mac An Ghaill, 1996; Sewell, 1997). Consequently, some

mothers believe that educating their sons in the Caribbean would free them from racial discrimination and other constraints, and reinforce, for their sons, an educational ethos that is commonly accepted in the Caribbean.

Yet recent research in the Caribbean challenges the widely held belief that sending their children, particularly sons, 'back home' will guarantee them educational success. In fact, educationalists in the Caribbean region are also grappling with a similar issue of educational underachievement amongst black boys (Bailey, 2000; Figueroa, 2000; Parry, 2000). In addition, teaching shortages in many Caribbean territories, a result of qualified teachers migrating to the U.K., U.S.A., and Canada to fulfil teaching shortages in these countries, mean that educational resources are increasingly limited (Caricom, 2004).

Celebration of a 'Caribbean' tradition and black racial identities

A third strategy developed by the mothers in their child rearing to challenge racism is to transmit to their children a cultural identity and notions of cultural belonging from which they can draw strength in times of difficulties. This is because the mothers question whether their children are fully accepted as British by the white population. They therefore return to Caribbean customs, values and traditions (some of which I identify in chapter 4) to foster acceptance and belonging in their children's lives. First generation mothers directly draw upon customs and traditions from their own upbringing in the Caribbean. Second and third generation mothers, in contrast, rely upon narratives and memories of their parents and grandparents to construct customs and traditions that frame a collective cultural identity.

The mothers also insist upon increasing their children's self-awareness and self-knowledge of black and Caribbean racialised identities in a global diasporic context. This is primarily achieved through the provision of toys, games and books, sculptures and paintings that advance positive self-images of black identities. Still other mothers are sending their children to black supplementary schools and Saturday Schools where subjects such as Afrocentric studies, black history and cultural studies complement the teaching curriculum. The following quotations provide us with some examples of this

> I intend getting her books which show black people's achievements, things like that, so that when she goes to school she won't feel like well 'what have we [black people] done', like I felt at school.
>
> [Pauline, age 25, lone-mother, second generation]

I actually go out of my way to find children's books with black people in it *[got up to show me a collection of black children books]* from all over the world. I think it is important to surround them with positive images.

[Jheni, age 35, lone-mother, second generation]

I'm teaching my son things now so that he knows who he is, where he is from, his history, so that he is proud of being black. I recently bought him a book that is about black inventors so that he is aware of the important contribution black people have made to the world outside of the usual images of singing, dancing and basketball. He learns these things at Saturday school, he looks at all the important historical events for black people here, the West Indies, Africa and America, so he's pretty aware of all the things black people have had to go through.

[Tanya, age 40, lone-mother, second generation]

Increasing globalisation and trans-cultural links mean that mothers raising children today have more resources available to self-educate their children about black racial identities. First generation mothers, bringing up their children twenty or thirty years ago and who wanted to teach their children similar ideas, did not have many of the resources that the mothers have access to today, as these were simply not available. For example, Cara, recollects that raising her daughters during the 1970s she was keen to open dialogue with her young daughters concerning the historical structural location of black people in the U.K., but there were scarce resources—such as black dolls and black books—and information available to her at that time. In addition, for many first generation mothers their migration to the U.K. was the first time many of them had extensive contact with people from other Caribbean territories and/or black people worldwide. The education they received at school would have taught them only about the U.K. and its colonial empire. Thus their knowledge of a black diasporic history was limited.

Today, in contrast, the emphasis is very much on black people fostering links with other black people transnationally and marking out black cultural identities that transcend national borders and notions of national citizenship (Goulbourne and Solomos, 2003; Reynolds, 2004). Paul Gilroy (1993) develops the idea of a transatlantic black consciousness in structuring a black British cultural identity. He points out that a black British cultural identity encompasses a range and fusion of cultural practices and signifiers that originate across the 'Black Atlantic'

(Africa, Europe, Caribbean and the Americas). This serves to unite black people globally irrespective of ethnic, geographical, and national difference. Interestingly, Gilroy identifies art and other forms of aesthetic expression as at the forefront of this cultural identity. This argument chimes with activities by the mothers who use art and cultural artefacts to foster a celebration of black identities in their homes.

Gilroy's arguments are useful in the analysis of the mothers' experiences. The mothers speak of actively encouraging their children to learn about the diverse cultures and ethnicities of black people around the world. In promoting positive self-images of black identities and black self-awareness, the mothers look to the histories and experiences of black people globally. They then adapt these experiences to suit their own ends. When I visited the mothers' homes for interview it was very common for me to see African artwork, photographs, masks, sculptures, paintings, and other black cultural artefacts, representing the 'fusion of influences' Gilroy identifies. Such cultural fusions establish hybrid links between past and present, and between the Caribbean, African nations, the U.K., and the rest of the world. The fact that we are also living in of era of advanced telecommunications, increased travel, and migration also facilitates greater links between black people worldwide.

Cynics have suggested that the mothers' (re)invention of positive self images of black diasporic identity is very much concerned with a 'utopian' (and static) ideal rather than any real desire to connect the black experience globally. This is observed by the way that the mothers valorize notions of a black diasporic identity. Yet, when questioned about their experience of this, most of them did not have (or desire) direct knowledge of black people across the European nations or African continent. The mothers' experiences were primarily limited to the Caribbean, and most typically their country of origin/descent. In fact, only seven mothers in the study had visited countries with their children that did not include the Caribbean, U.S.A., or Canada. One could suggest then that these new modes of racial solidarity and unity are more imagined than real. Paul Gilroy makes this very point:

> In conjunction with the pressures of economic recession and populist racism, this yearning has driven many older settlers to return to lands in which they were born. Amongst their descendants, the same desire to withdraw has achieved a very different form of expression. It has moved towards an over arching Africentrism which can be read as inventing

its own totalising conception of black culture. This new ethnicity is all
the more powerful because it corresponds to no actually existing black
communities. Its radical utopianism ... transcends the parochialism of
Caribbean memories in favour of a heavily mythologised Africanity that
is itself stamped by its origins not in Africa but in a variety of pan-African
ideology produced most recently by black America. The problems of
contemporary Africa are almost completely absent from its concerns.

(Gilroy, 1993: 87)

I do not suggest this 'imagined' unity should be dismissed, for it serves a
very real purpose. It represents a survival strategy through which the mothers
can provide their children with a sense of collective pride and racial belonging.
This 'imagined unity' enables new meanings to be found around blackness that
contest the negative images of black identities that are by-product of slavery
and colonialism (James and Harris, 1993). Thus, this notion of the 'imagined
community' (Anderson, 1983) has political value through its ability to develop
a transatlantic black consciousness uniting black people in the U.K. with the
rest of the world.

Close monitoring and policing of children's activities in public spaces

In public spaces, Caribbean and other minority ethnic groups are highly visible
and their actions constantly scrutinised (Hill-Collins, 1999). Not surprisingly,
Caribbean mothers are worried when their children enter the public domain.
Existing societal gender relations also exacerbate these concerns, determined
by Caribbean people's racial positioning in the U.K. To keep their children
safe from racial abuse and harassment (and also sexual abuse and harassment)
a child rearing strategy involves the mothers closely monitoring and policing
their children's activities in the public domain. Gendered relations lead to the
mothers monitoring and policing their son's, and daughter's public activities in
different ways. The Caribbean phrase *'tie the heifer and loose the bull'* succinctly
sums up parents attitude to boys' and girls' relationships to the domestic and
public spaces (Brown et al., 1997).

In terms of daughters, the mothers' concerns for their daughters' physical
safety centres on physical and sexual attacks and harassment. Their concerns
are by no means exclusive to black and other minority ethnic mothers and are
shared by mothers of all ethnic groups. However, in addition to sexual violence,
and other forms of violence, the mothers also fear their daughters experiencing a

particular form of sexualised racial violence as a result of the relationship between Caribbean's women's racialised status in the U.K. and the social constructions of black female sexual identity in western societies. Research indicates that historically black women have been socially constructed and positioned in society as 'sexual beings', 'sexual degenerates', and objects of white male sexual desires (Gilman, 1992). Hazel Carby (1999) claims that this has resulted in the moral policing of black female sexuality by white agencies and institutions, and the black middle-classes in order to establish 'morally' acceptable codes of behaviour by young black women. I also suggest that this sexual objectification of black women, pervasive in western societies, influences how the Caribbean mothers (as well as fathers), closely police their daughters' activities as they move through public spaces. The mothers are aware that their daughters may be perceived in a highly sexualised way as a result of these constructions of black female sexuality and this further strengthened their concerns about their teenage daughters' sexuality:

> I worry about my daughter out late at night. It's not that I don't trust her and she's pretty streetwise, but it's not safe especially in this area. 'Strathway' is known as 'red light' district. So men in cars will be coming to a crawl beside you, checking you out. They assume because you're black and it's late that you're a prostitute looking for trade. So when she's out late we'll arrange something so she's not walking these streets.
>
> [Anita, age 43, married, second generation]

A central aspect of this monitoring and control by the mothers, and also fathers, of their daughters' activities and movements in the public domain is also tied up with notions of 'respectability' and the desire to safeguard their daughters 'reputations'. Whilst, Caribbean women have high levels of economic activity and autonomy outside of the home, (Reynolds, 2001) additional activities that they undertake in the public sphere (with the possible exception of church related activities) are restricted, and the home/private sphere remains their primary location. Sue Lees' (1993) study of adolescent girls, which theorises young women's relationship to the public sphere, can help in analysing these mothers' experiences. Lees argues that, whilst women are visible in the public sphere, as a result of male control of this domain, women could only enjoy a restricted relationship to it. Central to women's restricted relationship are patriarchal constructions of feminine identity that position women in the private sphere.

The validation of constructions of female sexuality through the secure confines of heterosexual monogamous relationship or marriage is also implicated (Holland et al., 1998). Women who challenge these respective positions and identities are labelled as deviant, sexually promiscuous, and 'unfeminine'. Thus, surveillance and control exercised by the mothers and fathers of their daughters' activities and movements in the public domain are generally concerned with safeguarding their 'reputations':

> *T.R.:* What about your daughters, did you worry about them too as teenagers?
> *Pearl:* Yes—but worry in a different way. I suppose it's different for girls. I was quite strict with them and so they wasn't really allowed out late anyway. I think their dad worried more about them, but that worry was of a different type.
> *T.R.:* What was that?
> *Pearl:* Well it was worry about their reputation, about them getting a bad reputation. [Pearl, age 61, married: first generation]

Amongst the elderly first generation mothers, such as Pearl, concerns about teenage pregnancy centred on the fact that a stigma was attached to their daughters being young unmarried mothers. Feelings of the shame that unmarried pregnancies brought to the family, and the sense that these mothers would somehow be judged by others mothers in the black community as being 'bad mothers', was a common thought (see Wilson, 1969). The concern that fathers expressed towards their daughters' sexuality is associated with men's wider patriarchal control of female sexuality, which is explored further in chapter 9.

The mothers in the study worried less about their male children's physical safety in terms of sexual attack or harassment. However, this does not mean that they worry less about their sons in public spaces compared with their daughters. If anything, their concerns appear to be greater for their sons. This concern is primarily attributable to two interlocking factors. First, male identities are closely defined by their relationship to the public sphere. Caribbean boys are encouraged to have more freedom and independence than girls and to learn the requisite survival skills 'on the road' and in the local neighbourhoods. The great numbers of activities they perform in the public sphere make this sphere a highly masculine space. Second, in contrast to white males in the U.K., black men's ability to move about freely in this sphere is hampered by the interwoven

relationship of 'race', policing, and crime. 'Race' and policing are highly politicised areas, with street crimes (such as mugging) represented by the police and the media as being intimately tied up with black male identity (Gilroy, 1987; Runnymede Trust, 1996). On one side there are 'race' activists, the black press and academic commentators who cite and criticise the high incidence of police arrest and incarceration of young black men; they also emphasise the high incidence of police harassment, brutality and the deaths of young black men whilst in police custody. On the other side there are mainstream media and public policy discourses that focus on the issue of social exclusion and address the high incidence of crime, civil unrest, and public disorder amongst young black men in economically deprived areas.

These diametrically opposed debates on black men, policing and crime means that this relationship becomes fixed in the public's imagination and informs the concerns that the mothers have for their sons in the public domain. The fear of racial attacks and harassment from the police and racist members of the public, along with an increase in black-on-black violence, and negative male peer pressure, such as male street gangs are very real concerns for the mothers. Several mothers voiced their concerns about pressure and physical danger they felt that their sons faced in public spaces:

> Now that he's getting older, I fear the call of the streets, Is he going to continually harassed by the police and arrested for just walking down the street?' [Cara, age 50, widow, first generation]

> I live in constant fear for my son. Black men are killing black men and for what? Do you know what really scares me, it's the way these kids are just accepting of it, violence at school is an everyday thing to them now. I just pray to God it's not my home the school ringing to say one of my sons is hurt or dead. [Joy, age 39, lone-mother, second generation]

> I worry about him getting into the wrong crowd and finding himself in trouble. I don't want my son to end up a statistic whether it be a criminal, or murder one. [Camille, age 51, married, first generation]

At the time of the interviews the racially motivated murder of young black teenager Stephen Lawrence, of south east London in 1993 further increased this fear. Since this unfortunate episode there have been more highly publicised

cases of violence against young black men involving black-on-black violence[4]. The mothers recognise that they could not confine their sons to home as easily as they can their daughters. As a result, they incorporate strategies into their child rearing that enable them to monitor their teenage sons' activities in the public domain. Although these strategies vary according to each mother, broad patterns exist. These strategies consist of the mothers establishing expected patterns of behaviour from sons when they are out of the home, close monitoring of their sons' friends and activities, and practical advice to avoid problems. The following accounts provide examples of these three main strategies implemented by the mothers.

Establishing expected patterns of behaviour for sons:

I told my sons that I don't want no police breaking down my door looking for any of them. They knew from the start, that I wouldn't tolerate them getting involved with the police. Once they know how far they can go, what you will and will not tolerate, it keeps them in line. That's it really, that's how I kept my sons out of trouble when they were coming up.

[Enid, age 68, married, first generation]

Close monitoring of sons' friends and activities:

I try and keep him busy, I have made sure that he has a lot of extra-curricular activities to do when he is at home so he doesn't have time to get into trouble. Also, this way I know where he is and that he's not up to mischief. I have also always made it a point of knowing who his friends are by allowing him to have his friends over for weekends and his school breaks.

[Camille, age 51, married, first generation mother]

Practical advice to avoid problems:

We tell them all sorts of things. We have given them some basic rules which I hope will help keep him out of trouble when they're out there. For example, I say to them no loitering on the streets, just go straight to where you need to go quickly. When they're out shopping they're not to go into shops unless they want something and have the money to pay for

4 In 2001 the murder of an African young boy, Damilola Taylor, by a group of multi-ethnic youths and in 2002 a spate of black-on-black gang shootings in the Midlands that eventually led to the death of two Caribbean teenage girls sparked widespread media interest and public condemnation in the Caribbean community and wider society.

it on them. Also to keep themselves close to where shop assistants can see you and never to go into a shop with a large group of their friends.

[Anita, age 43, married, second generation]

All of these strategies are attempts by the mothers to minimise their sons' visibility and physical presence on the streets. However, some commentators have been critical of the strategies employed by the mothers (e.g. not going shop) because of the way in which black young men are positioned as passive recipients of racial inequality instead of active agents of change[5]. It has been suggested that rather than adopting such approaches the mothers would better off teaching their children to directly challenge and confront racial incidents. However, these mothers' actions bring me back to an earlier point where I highlighted that black and minority ethnic mothers are daily engaged in complex and strategic choices that involve encouraging their children to resist systems of domination, whilst at the same time teaching them to submit to racial injustice for reasons of survival. The mothers desire for their sons to adopt, at times, a more passive approach reflects their awareness and understanding that to directly challenge perceived incidents of racial inequality can sometimes result in situations where their sons' physical safety (even life) can be threatened. Thus, the mothers' passive approach reflects the very real fear for their sons' physical safety when they enter public spaces.

Conclusion

Racism is a conceptual tool that helps us to understand how social boundaries are established to include and exclude certain ethnic groups. Yet racism has very real consequences for people's daily-lived experiences. For example, racism has practical consequences for Caribbean mothers in the way that they choose to raise their children in the contemporary U.K. The success of Caribbean mothers has been to utilise their child rearing practices and skills to develop strategies that challenge and resist racism in their children's lives. The four strategies outlined involve: first, the psychological and emotional preparation of children for racism; second, parental involvement in education; third, the celebration of a Caribbean tradition and black racialised identities; and finally the close monitoring of children in the public domain. It is important to point out that these strategies are by no means exclusive to Caribbean mothers. Racialised

5 For example, I presented a paper on this issue at Caribbean Studies Association annual conference, in Belize June 2003. In discussions with my colleagues following my presentations criticisms were expressed of this 'passive' approach employed by the mothers in the strategies they employed.

'other' mothers belonging to other minority-ethnic groups, have similarly been successful in using child rearing skills to employ strategies in resisting racism.

Chapter 6

Paid work, mothering and identity

Introduction

Across many societies and ethnic groups economic provision for the family is largely regarded as the responsibility of men. In Caribbean families and households, historically and cross-culturally, whilst there exists the expectation that men should function as the economic provider, in practice, it is largely women who end up assuming primary responsibility for family economic provision (Senior, 1991). The experience of Caribbean mothers in the U.K. is no exception. There is evidence to suggest that work, in particular full-time paid labour, is intrinsic to these women's mothering. Figures suggest that as much as 77% of Caribbean women are employed in some form of full-time labour. This high rate of economic activity by these women has remained fairly consistent since the Labour Force Surveys during the 1970s first started to investigate black and minority ethnic women's labour market activity (CRE, 1997). Caribbean women's high work rate reinforces the viewpoint that Caribbean women's role as workers is valued over and above their maternal reproductive status (see Breugel, 1989; Lewis, 1993; King, 1995). Specific cultural, historical, and structural economic factors combine to determine a strong work status and specific employment experiences for Caribbean mothers.

Historical patterns of Caribbean mothers' work

Evidence suggests that historically Caribbean mothers have long been defined by their work status. If we look at the distinctive historical moments of European slavery, British colonialism, and economic migration to the U.K. in relation to Caribbean mothers, then what connects these events is that in each instance Caribbean mothers are socially positioned as workers. Regardless of their maternal status these women were expected to work alongside their men-folk. Of course, it would be an oversimplification to claim that all Caribbean mothers are defined by a work status. For example, under the system of European colonialism around which Caribbean societies organised from the mid 19th to the latter half of the 20th century, race and class modified Caribbean women's work status. In the colour-class system of the region, affluent Creole, brown, and black women did not work, their households were organised around traditional sexual division of labour and they relied upon their male spouses for economic provision. These women remained at home whilst employing poor black women,

in the role as 'helpers', to care for their children and undertake domestic work in their homes (Mohammed, 1983). Such practices mirror the long practised tradition of affluent white women in the U.K. (see Woodward, 1997) and the U.S.A. (Higginbotham and Romero 1994) who employ poor white, black and minority ethnic women from countries such as the Caribbean, the Philippines, the nation states in Eastern Europe, and Latin America to undertake a similar function in their homes.

With the exception of the privileged few, however, historically for the majority of Caribbean mothers there was a cultural expectation of paid work and labour outside of the home. As early as the 17th century British rule and the plantation system in the Caribbean brought female slaves from Africa to work as unpaid and unskilled labour on the sugar plantations alongside their menfolk. Olive Senior (1991) highlights the fact that field slaves were grouped according to their strength and endurance and not their gender. Slavery further stripped these women of their female identity by conceptualising them as 'mules' and 'workhorses' (Mohammed, 1988; Beckles, 1995). They were judged purely on their reproductive labour capacities and they were positioned as breeders whose role involved reproducing the future labour force. Studies exploring the context of U.S.A. slavery reveal how this historical moment deconstructed conventional gender relations and the sexual division of labour. The dichotomous relationship of man/woman, work/home and dominant/subordinate, dominant ideological patterns of western societies, were not applicable to the slavery experiences of black men and women (Gutman, 1976). Indeed, Angela Davis (1981), points to the relevance of slavery for understanding black women's defined work status in contemporary society. She contends:

> The enormous space that work occupies in black women's lives today follows a pattern established during the very earliest days of slavery. As slaves, compulsory labour overshadowed every other aspect of women's existence. It would seem, therefore, that the starting point for any exploration of black women's lives under slavery would be an appraisal of their role as workers. (Davis, 1981: 5)

In the historical analysis there is a strong argument for the case that slavery produced a cumulative effect for black people in the Caribbean. It is argued that following on from slavery, structural oppression and systems of inequality and disadvantage affected black men's ability to earn a sufficient wage for their

family. Caribbean families had to culturally adapt themselves to survive this and a primary survival strategy involved communities adapting themselves to accommodate the socio-economic need for Caribbean women (including mothers) to work outside of the home (Hillman and D'Agostino, 2003). Thus, as Christine Barrow (1996: 65) suggests, Caribbean women's actions as workers are regarded as a *'positive response to adverse circumstances of poverty and unemployment especially amongst males'*.

Migration, both internal and external, has also played a key role in emphasising and reinforcing Caribbean women's work status (Shepherd, 1995). During the latter part of the 19th century to mid 20th century, men, as migrant labourers, migrated from the region on a mass scale to work on agricultural and manufacturing projects in Latin America, Cuba, and the U.S.A. This left a labour shortfall in the region and women were actively recruited to urban industries from rural/farming areas to fill these posts. The next large scale migration from the region occurred shortly after the second world war when Caribbean men and women were actively recruited to the U.K. to act as a source of cheap and flexible migrant labour along with other members of the U.K.'s New Commonwealth territories (e.g. India and Pakistan). Caribbean women were recruited to key public services that suffered an acute labour shortage at the time, such as the National Health Service, public transport, public utility services, and also manufacturing industries (Breugel, 1989; Lewis, 1993; Bhavnani, 1994). One striking aspect of this recruitment pattern of Caribbean women is that a *'significant number'* of them who arrived in the U.K. to take up full-time paid work were themselves mothers with young children or women who became mothers in a few short years (Bryan, 1885: 43). My own findings in the study support this claim. For example, six of first generation mothers who migrated to the U.K. were full-time working mothers with young children. Caribbean mothers' entry into the U.K. as workers, primarily employed in semiskilled manual labour, directly contradicted the popular discourse of the time that advocated notions of the 'good mother' whose central location was in the home and their primary role as domestic homemaker, nurturer and carer (Kathryn Woodward, 1997).

Caribbean mothers work patterns in the U.K.

Caribbean women's cultural legacy as workers still continues today as evidenced by the number of studies that highlight the centrality of paid work in these women's lives (Bryan et al., 1985; Williams, 1988; Westwood and Bhachu

1993; Lewis 1993). Recent statistics by the Commission for Racial Equality (1997) show that black women work longer hours, and engage in higher rates of full-time employment (77% at a minimum 35 working hours per week) than white women (56% at a minimum 35 working hours). Importantly, for white women the number of women in full-time employment has more than doubled in rate over the last 30 years. Yet for black women working hours have remained virtually unchanged from the late 1970s where the figure was 74% (Jones, 1984). There is a far greater tendency for white women with children of school age and younger to work part-time, (40%) whereas the rate for part-time employment amongst black women is much lower (Dale and Holdsworth, 1998). Research findings by Owen (1994) suggest that the proportion of black mothers working part-time is as low as 12% in London and the south east of England.

Cultural expectations of paid work: continuities and tensions
In the study the mothers are themselves aware of the cultural expectation towards paid work and report that their labour market activities represents a continuation of an intergenerational cultural practice.

> I have always worked and will continue to do so because my mother worked, my grandmother worked and my foremothers before that, so I don't see why I should be any different. And I don't think what I'm saying about my family is that unusual. Certainly the Caribbean women that I know, their mothers and even their grandmothers have also worked.
> [Michele, age 28, lone-mother, second generation]

Michele works full-time hours (40 hours per week) as a legal secretary. Michele appears to accept her own work identity as part of a historical and cultural process linking Caribbean mothers of past and present, in her own family/kinship networks and wider community. In speaking with the mothers it was common for them to identify paid work and other domestic caring mothering practices (the emotional and physical care and nurturing of the child) as two interlocking and interdependent functions:

> I don't see them [paid and domestic work] as separate things. I work so I can be a better mother. If I didn't go to work full-time, I wouldn't be

able to take care of my children properly, or take care of their needs. So, I wouldn't be doing my job properly as a mother if I didn't go to work.

[Zora, age 26, living with partner, second generation]

Going out to work is part and parcel of being a good mother. It's very important to me, knowing that I'm out there working for my family.

[Joy, age 39, lone-mother, second generation]

The comments expressed by these second generation mothers, Zora and Joy, imply an understanding of 'good mothering' that is dependent on their ability to care and provide for their family through paid work. Their viewpoints reinforce the claim that for black women generally in the U.K. their 'mother/worker' status is an important aspect of 'good mothering' and their mothering identity (Duncan and Edwards, 1998; Reynolds, 2002; Edwards et al., 2003). This conceptualisation of 'good mothering' directly contradicts traditional westernised ideologies of 'good mothering' that requires mothers to remain at home on a full-time basis to care for their children and the home, especially during the children's formative years (Woodward, 1997). In conventional understanding, mothering and employment are typically presented as separate, contesting, and incompatible, gendered identities (Richardson, 1993). A range of contemporary debates address female and maternal employment, considering such issues as 'gendered moral rationalities' (Duncan and Edwards, 1999), work life balance, better employment and child care benefits for working parents. All are rooted in, or challenge, a discourse of morality that constructs working mothers as problematic where mothers who work full-time are perceived as 'morally wrong', whether or not economic considerations dictate that they work (see Brannen and Moss, 1991; Hakim, 1996; Dex and Smith, 2001; Lewis, 2002).

Caribbean mothers conception of 'good mothering' as constituting paid work and mothering as two interlocking functions provide an alternative to idealised and normative representations. However, this western idealised notion of 'good mothering' has influenced their views concerning the impact of employment on their mothering and family relationships. As a result tensions develop around the mothers balancing these western ideals of mothering alongside their own cultural expectations as well as practical considerations. For example, two lone-mothers interviewed questioned the mother/worker identity and the culturally accepted

practice of working mothers. They both voiced a desire to change their working practices in order that they can have more time at home with their children:

> I don't know where it says that black women are automatically expected to keep working all of the time. It just seems to be the done thing for black women to work until we drop dead. Given the chance I would stay at home with my baby son. Also I like the idea of my daughter coming home from school and I could be home when she's here. So, what I would like to do is set up my own nursery. Or if it costs too much maybe I could set up a child minding service at home. That way I'll be able to choose my own hours and have more time for them [children].
>
> [Marcia, age 33, lone-mother, second generation]

> There is that expectation and pressure that comes from the black community, that as a good West Indian mother you work to provide for your family. However, if I could afford it then I would be at home with my family. Although I would have to probably find something to fill my days. I could do some form of charity work and help other children who are sick or disabled. Or I could make things such as little arts and crafts and sell them to raise money for a charity. That would be really good
>
> [Lydia, age 28, lone-mother, second generation]

Two others mothers in the study also offer retrospective accounts of their own childhood in order to reflect upon the way that their own working mothers had a negative impact on their childhood:

> When we were younger my mum was at work all the time. She used to do shifts so it would just depend on if she was on early shift or late shift, but I do remember that she wasn't at home for four o'clock, or whatever time school finishes, and you sort of notice the difference. We missed out on a lot of things because our mum was always working. We didn't go anywhere. We didn't go brownies or anything. We even had to beg just to go to church.
>
> [Melanie, age 29, lone-mother, second generation]

> Going back to my childhood, I do remember thinking I wish my mum was there to take me to school and pick me up. I went to a child minder,

she used to take me to school. In the mornings my mum and dad used to leave for 7.30 a. m. and I used to go over there first to have breakfast, it was only when I got big that I could cater for myself. I did miss not having my mum there when I woke up in the mornings to make breakfast for me and send me off to school and be there when I got back from school. I want to have a kind of job where I could be there first thing in the morning and last thing, you know drop them off at school and pick them up. I just missed that in my childhood and I want to have that for my daughter.

[Jamilla, age 25, lone-mother, second generation]

The mothers I quote above appear to speak the language of the western 'gendered moral rationality' discourse concerning 'good mothering' and celebrate these ideals. However, despite the mothers' claims that they want to remain at home with their children, all of them in their accounts consider the option of doing activities that would take them outside the home. Lydia, for example, speaks of a desire to do charity work. Jamilla and Marcia want employment opportunities that offer flexible-working patterns combined with home working. The fact that these mothers are still considering the option of work (whether it be paid or unpaid voluntary work) suggests that they are not completely rejecting all elements of the Caribbean cultural practice of working mothers. Even in instances where mothers positively support the notion of working mothers and are keen to work full-time themselves, they still buy into the western 'child deprivation' stance with regard to working mothers (O'Brien, 1996).

Mum was always working. My dad was working just as often but I just more remember it with my mum. I remember dad there at home but not really mum. [Nizinga, age 31, lone-mother, second generation]

It is interesting that in Nizinga's reflections, she acknowledges her dad worked just as hard as her mother. However, her father was fulfilling the assumed societal expectations of fathers in the family: the male breadwinner.

Economic constraints and considerations

Despite the fact that some of these mothers express an idealised desire to remain at home full-time to care for their children, the intergenerational connection between Caribbean mothers arising from their mother/work status, and the

fact that Caribbean women continue to assume the breadwinner role leads to the conclusion that they have little choice to work for economic reasons. This suggests that the cultural expectation of paid work, regarded as central to Caribbean mothering, is an outcome of wider structural and economic constraints.

Various and contrasting explanations have been provided concerning structural and economic factors that have encouraged Caribbean mothers into full-time employment. One claim is that Caribbean men's structurally subordinate location in the labour market on account of racial discrimination has undoubtedly contributed towards the high uptake of full-time employment by Caribbean women (Bhavnani, 1994; Coleman and Salt, 1996; Dench, 1996). Recent findings highlight how Caribbean men have the highest rates of unemployment in the U.K. Nearly 25% of Caribbean men between 18-65 years-old are unemployed (Berthoud, 1999). Caribbean men are three times more likely to be unemployed in their lifetime compared with white men. This has created a situation where Caribbean women have been motivated to enter full-time employment in greater numbers than women of other ethnic groups in order to make up this economic shortfall in household income as a result of Caribbean male unemployment (Berthoud, 1999; Moyenda Project 1997). Two mothers in the study present their choice to engage in full-time paid work as a pragmatic and rational response to unemployment experienced by their male partners:

> At one stage both of us were unemployed. I decided it would be easier for me to find work and he would stay at home and take care of our son because I feel that it is a lot easier for a black woman than a black man in this country to get a job. Companies would rather take a black woman over a black man and that's the main reason why you have so many black men out there drawing dole money.
>
> [Denise, age 22, living with partner, third generation]

> How I found this job is that me and Wayne were both unemployed, so we started helping out at the centre doing clerical work and filing for free so we could get experience and build up our C.V. Then we got a new director and everything changed. The new director is white and that created a bit of hostility because it's a black organisation. Things calmed down after a while because she seemed really committed. She applied for

extra funding for the centre and we got it. They used the extra money to expand the centre and get extra staff. Luckily, I was taken on as one of the extra clerical workers but they didn't take Michael on although he had more experience and he was much better with all the technical stuff like spread sheets. She never said anything but I'm sure I got the job and he didn't get one because as a black woman I'm less threatening to her. She would go out of her way to avoid confrontations with them [black men]. Black women she's ok around but not black men

[Susan, age 20, living with partner, third generation]

Both of these mothers are aware of and demonstrate an understanding of constructions of black male marginality in the dominant discourse. In the U.K. official discourse on black male identities represent them as a threat to society in relation to crime and policing, sexual morality, and a psyche of violence and aggression. This discourse can create moral panic, and serves to identify black men as a challenge to white patriarchal authority and white hegemonic masculinity (Marriott, 1996). These constructions and representations of black men generally and Caribbean men specifically has negative impact on their employment opportunities and job prospects.

Alongside the perceived racial barriers that are understood as restricting Caribbean men's access to employment, in recent years wider structural changes in the labour market have generally facilitated greater employment opportunities for women at the cost of male employment across all racial and ethnic groups. There has been a decline in 'traditional' male sectors of employment and increasing 'feminisation' of the labour market based around employment in un/semi skilled labour in clerical/administrative and service industries (Phillips, 1999; Bower, 2001). Even in instances where Caribbean men are in full-time employment, lower earnings and greater job insecurity compared with their white male counterparts, across all sectors of the labour market, ensure that Caribbean men's financial contribution cannot always on its own adequately sustain family and household expenditure (Modood, 1997)[1]. The working mothers in conjugal relationships (married/living together) identified that one of the main reasons that they are in full time employment is to cover the financial deficit of their partner's salary.

1 There was strong variation in this group according to individual circumstances such as level of educational attainment. Those Caribbean men with degrees have far less risk of unemployment compared with those men with only a secondary school education and little or no formal qualifications. However, overall as a group the average risk of unemployment was high and those Caribbean men with degrees had a considerable higher risk of unemployment in comparison with white men with similar academic qualifications (Berthoud, 1999).

His wages are not enough for all of our bills and so I feel I have no choice
but to go out to work so that all of our bills can be covered.

[Zora, age 26, living with partner, second generation]

We depend more on my salary if not more than his because I earn a little
more than 'David'. His money covers most of the household expenses like
the electricity, gas, his car repayment for example and my money goes
on the mortgage, shopping, my car repayment, nursery fees and buying
things that the children need. I have thought about staying at home but
that's a dream. Realistically speaking there's no way that his salary alone
the money would be able to do everything.

[Anita, age 43, married, first generation]

Caribbean women's structural position is the labour market also influences
their decisions and choices around full-time and part-time paid work. In
comparable jobs across all sectors of the labour market, black (African and
Caribbean) women earn disproportionately less than their black male and
white male and female counterparts (Bhavnani, 1994). Whilst it is true that an
increasing minority of black women are entering professional and managerial
occupations (5%), the vast majority of black women (69%) are positioned at the
lower rungs of the occupational ladder (Modood, 1997). Moreover, the jobs they
are concentrated in tend to be administrative and other non-manual posts that
offer lower pay and little opportunity for career (and with it salary) advancement
(Bhavnani, 1994). One primary outcome of black women's subordinate location
in the labour market is that black women have to work longer hours (hence
greater rates of full-time employment) or remain in a post for longer continuous
years in order to earn similar rates of pay to other social groups. Appendix 3
provides a breakdown of the mothers' employment characteristics and their
market activity.

Lone-mothering and employment
Undoubtedly, the high proportion of lone-mother households, prevalent
amongst Caribbean families in the U.K. has also contributed towards Caribbean
women's mother/worker status. Recent Census figures identify that over half
(51%) of the total number of Caribbean families in the U.K. are lone-parent
households (Modood, 1997; Goulbourne and Chamberlain, 1999). In the study
all but one of the lone-mothers decided to work full-time instead of working part-

time hours because it presented to them the only viable option for maintaining some degree of economic freedom and financial independence. The following quotation gives us some indication of this:

> I am determined not to rely on welfare because it's a trap. They only give you so much money and they expect you to live on that but of course you can't live on the pittance they give you, and so you go into debt. Getting up and going to work every morning is hard and putting in 36 hours per week, every week, is exhausting but it's the only way I know to have a comfortable life and to be able to afford the things that I want to do and you're not dependent on handouts from the state.
>
> [Jamilla, age 25, lone-mother, second generation]

Financial contributions from 'absent'[2] spouses towards child rearing and other domestic costs in some instance provide single mothers with an alternative source of income. However, the level of financial support that the lone-mothers in the study receive from these men varies according to individual circumstance, and it was also largely dependent on the father's current relationship, his employment status and the level of contact he had with the mother and his children. In 1991 the Child Support Agency (CSA), was set up to increase the financial contribution of 'absent' fathers towards their families. One mother used the CSA to approach her 'absent' partner for child maintenance as a final option after other attempts for payment had failed:

> I went to the CSA because it wasn't right that he wasn't doing anything for them [children] and it's what he owes me. So I went to see them [CSA] and I filled in the all the paperwork and they calculated what he owes me. They decided a set amount that he has to pay me each month, and then its automatically deducted from his wages. I just felt it wasn't fair that he was neglecting his duties as a father. Here I am slogging my guts out, working to make ends meet and he wasn't contributing anything. I know he's not happy about it but he didn't leave me any choice. I tried to speak to him before and I tried to make the maintenance arrangements between us. But Tracey it just wasn't working. He agree to pay, and he would give me money one month, but then three or four months would

2 The men who shared a 'visiting' relationship with mothers in the study (i.e. not living in the household on a full-time basis) also come under this category.

pass and he wouldn't give me anything. He would always have excuses about why he couldn't find the maintenance. At least this way with the CSA I know that I'm getting something for them [children] every month and I don't have to keep begging to do something that he automatically should be doing.

[Lydia, age 28, second generation, lone-mother]

However, for the majority of lone-mothers in the study the CSA has had little effect on their household income. These mothers chose not to use the CSA because they were reluctant to involve the CSA in their financial arrangements with the 'absent' father. The mothers perceived financial provision for children by the fathers as a private family matter. The quotations below suggest that these mothers preferred to make their own private financial arrangements with their children's fathers or not receive any financial support from them at all. Instead they decided to work full-time to make up this economic shortfall. Their reluctance to report their children's fathers to the CSA is based on the justifiable fear that societal institutions (of which the CSA is one example) pathologise and criminalise black men.

I think fathers should support their children regardless of whether they got on with the babymother but I don't agree with going down the route of the CSA to force men to pay. CSA does more harm than good. I don't want them prying in my affairs and you know how they're quick to label our [black] men as criminals, gangsters or just plain 'wotless' [worthless]. I don't want any part of that. We came to our own agreement that he would pay £50 per week to help towards the nursery fees. My salary and other bits of money just about cover the rest of the bills and I do overtime occasionally if I want money for extras like birthdays and Christmas.

[Terri, 26, lone-mother, second generation]

T.R.: Does anyone help with household expenses?
Pauline: It's me who basically does everything but I don't mind that. I work full-time and it's a reasonable salary so that means I'm not entitled to benefits. His [son] dad helps out as and when he can but its not as good as it should be. I think he could do more. We really need to talk about him increasing his contribution. But if it doesn't happen I'll manage somehow. I wouldn't go to the Child Support Agency although I do

know friends of mine that have done this and it has created no end of problems for them. I'm sure the people at the agency go around saying 'all these irresponsible black men having all these children and they can't be bothered to care for them'. [sic]

[Pauline, 34, lone-mother, second generation]

The economic constraints facing Caribbean mothers, whether through black male and female marginality in the labour market or lone-motherhood, and the unwillingness to involve the CSA for additional family income again reinforces the notion that, regardless of whether Caribbean mothers support the 'traditional' western ideal of mothering (Richardson, 1993; Ribbens, 1995), these ideals take second place to the economic realities they encounter

Unemployment

Of course not all Caribbean mothers are in full-time employment. Increasingly, high rates of unemployment, traditionally the preserve of black men is now starting to affect young black women too (including young black mothers). Recent CRE figures (1997) place unemployment for all minority ethnic women between the ages of 16-24 years-old at 30% compared with 12.5% of white women. In this minority ethnic group of 16-24 years-old, black women represent 37% of unemployed women. One outcome is that the difference in employment activity between black women under 25 years and black women over 25 years is becoming more pronounced than ever. This leads to a tentative, and as yet unproven, suggestion that paid work at the centre of Caribbean mothering can no longer be universally assumed. Instead a 'bi-modal pattern' (personal correspondence, 2000) of Caribbean mothering is starting to emerge where there is a high commitment to full-time paid work and high employment activity for those mothers over 25 years and a much lower commitment to full-time employment (primarily determined by unemployment) for those mothers aged 16-24 years-old.

Those young mothers who cannot afford child care costs or are denied access to it as a result of unemployment or low incomes have no choice but to remain at home and are dependent on the state to look after their children financially even if they are keen to work. Sharon, a lone-mother who is unemployed encountered the barrier of a lack of available free nursery places when seeking employment.

I put my name down for a free child care place but there's a 2-year waiting list for places. I wanted to apply for a sales assistant job at Sainsbury. I filled out an application and they called me for an interview. But I didn't go because I didn't have a [nursery] place. The money they're paying [means] if I have to pay for the nursery that would use up all my wages. It's not worth it for me to work right now until I can get child care sorted. I don't want to be out of work but it's cheaper for me to stay at home
[Sharon, age 19, lone-mother, third generation]

Sharon's experiences chime with those studies that find that whilst the number of mothers in full-time employment is increasing, the numbers of low-income single-mothers in employment is declining as a result of high child care costs, (see Phoenix, 1991; Edwards, 1993; Silva, 1996). The current Labour government is to some extent working to redress this issue and also shift 'gendered moral rationalities' for welfare dependent single-mothers towards maternal employment instead of a moral reasoning that mothers should be at home with young children (see Duncan and Edwards, 1999). In 1998 the New Deal Initiative for Lone-Parents was introduced to encourage single-mothers away from welfare state dependency and towards self-sufficiency through paid employment. The initiative provides a range of services targeted towards single-mothers, such as training, work placements, flexible working hours, personal advisers and assistance with seeking child care to help them in seeking employment. Recent reports, (such as Millar, 2000) suggest that in the short term, the programme has been relatively successful, with nearly two-fifths of lone-parents on the scheme, but it is too early to measure the long-term benefits of this scheme for lone-parents. However, despite the introduction of such policy initiatives as the New Deal, there is still a shortfall in adequate and affordable child care provision for mothers on low incomes.

Mother/worker status and child care

Caribbean mothers' work status has important child care implications. The occupations that the first generation mothers who arrived in the U.K. shortly after the post-war period entered, such as nursing and manufacturing industries, employed shift systems. Elyse Dodgson's (1984) study of Caribbean women's family life during this period shows that the shift system of working perversely helped to facilitate these women's child care and domestic arrangements, despite the long and unsocial hours of work that they worked. Working on a

shift system meant that these mothers could arrange to work different shifts from their partner (and others involved with child care), leaving someone available to care for their children at different times of the day and night. The mothers were particularly forced to depend upon their own family members and social networks because white child minders would often refuse to care for black children (ibid.). The other forms of child care options available to these mothers included sending for relatives, usually the women's own mother, from the Caribbean to care for the children, or alternatively sending young children back to the Caribbean to be cared for by family members (see Goulbourne and Chamberlain, 1999). Caribbean mothers who could not afford the cost of sending their children back to the Caribbean or bringing a relative to the U.K. depended upon their husbands to play a key role in child care. Two first generation mothers in their discussions of their child care arrangements during the late 1950s give us some indication of child care in these early years:

> The jobs we did meant that I worked nights and my husband worked in the day. After work I would rush home to get my children's breakfast ready and then my husband would leave for work. In the afternoons we would eat together and then I would leave for work and he would care for them until the next morning when I arrived back home.
>
> > [Enid, age 69, married, first generation]

> In my days they [white child minders] were very hostile, not like now. They didn't want black babies to mind and they were quite clear in telling you that—I had to go to work because there was no question of me staying at home because he [husband] wasn't earning enough. So me and [husband] would make sure we worked different shifts so at least there was one of us at home to watch the children. My sister would help out at times where we were placed on same shifts. Those times were really hard, we hardly would get to spend time together, when he was going out I was coming in or it would be the other way round, but what could we do? We didn't have the choices that you young people have today.
>
> > [Pearl, age 61, married, first generation]

In the literature, Caribbean female kin's involvement in child care is well documented (Roopnarine and Brown, 1997). In contrast, Caribbean men's prominent position as carers is largely not documented, because of conventional

representations of them as 'absent' or marginal from family life. Research work by Goulbourne and Chamberlain (1999) and my own research are some of the few attempts to re-insert black fathers into constructions of the Caribbean family. In this study Caribbean men's participation in child care is still evident today. Denise, speaking of her unemployed partner comments:

> During the day, he looks after [our son], he takes care of everything so that when I get home I just really have to give him his bath, put him to bed and read him a story. The money we're saving on what we would have to put towards the child minders if he wasn't looking after [our son] during the day, we're putting towards a deposit for a small flat.
>
> [Denise, age 22, living with partner, third generation]

In comparing the child care options available to Caribbean mothers today with Caribbean mothers during these early post migration days, at a theoretical level, Caribbean mothers today have more child care resources available to them. Nineteen mothers in the study with preschool children or children of school age used some form of formal child care service, such as child minders, nurseries, work crèche, after-school club or holiday play schemes. The demand for child care provision far outnumbers the supply in the U.K. (Cohen and Fraser, 1991). Research findings by Burghes and Brown (1995) also indicate that the race, social class and occupational status of working mothers largely determine their access to child care. Social class and occupational status certainly influenced the mothers' child care choices and options in the study. Those Caribbean mothers with professional occupations and high levels of income had an easier time with their child care arrangements. For example, one mother employed as a director of a mental health trust on a relatively high income employed a live-in nanny to care for her children. Another high income working mother, employed as a lawyer, had a child minder who assisted in getting her children ready for school in the mornings, took the children and collected them from school and cared for them at the end of the school day until the parents arrived home. Unsurprisingly, those Caribbean mothers with lower incomes had a more difficult time accessing affordable child care. Their experiences mirrored those of many low-income mothers across all ethnic and racial groups (Daycare Trust, 1997). Child care costs comprise the largest proportion of monthly expenditure for all of the working lone-mothers in the study. One lone-mother, states:

Nizinga: At the end of the month she [daughter] is starting nursery. It's going to break my bank.

T.R.: Can I ask you how much it will cost you?

Nizinga: £347 a month but my mum is going to help me out otherwise I couldn't afford it on my own as its more than half of my salary.

[Nizinga, age 31, lone-mother, second generation]

In the U.K., Caribbean grandmothers are not the primary child care source for the working mothers. This directly contrasts with mothering experiences in the Caribbean where the grandmother, especially the maternal grandmother, is characterised as the primary carer. However, even in the Caribbean the grandmother as principal carer is starting to change as a result of recent migration and demographic trends where older women are migrating to the U.S.A. and Canada and becoming increasingly involved in labour markets activities (Scott-McDonald, 1997). The main reason for grandmother's changing child care status in the U.K. is that, demographically, the Caribbean population is a relatively young one with 75% of black women under the age of 65 years (Owen, 1997). As a result Caribbean grandmothers are unlikely to act as primary child care providers during the working week because they themselves are likely to be in full-time employment. However, during the times they are not working, grandmothers still provide the main child care support for working mothers.

'Mother-ism', racism and sexism

Despite Caribbean mothers long work history in the U.K. labour market, they have enjoyed a less than successful relationship to it. The intersecting factors of racism, sexism and 'mother-ism' have all had an impact on Caribbean mothers' relationship to work, along with other black women (see Westwood and Bhachu, 1988; Williams, 1989; Lewis, 1993). The term 'mother-ism', first introduced by Heather Joshi (1991) highlights the way in which employers discriminate against working mothers based on their mothering status and continue to remain sceptical in their attitudes towards them. The following comments by, Michele, who works full-time as a legal secretary in a large City law firm, and Zora, who is a local authority housing officer, clearly depict the way in which 'mother-ism', has combined with racism and sexism to constrain Caribbean mothers' employment choices:

I was the first black woman the firm ever took on. What made it worse was that I was a mother, a single-mother and so they made certain assumptions about me. When I first started the firm put me on three months probation. It wasn't probation to see if I could do the job, they wanted to see if I would dash home because my child care arrangements were not sorted. I never had to leave the office because of child care arrangements. When there was another vacancy going in our department, they got another mother. I gave them the incentive to choose somebody else who was a single-mother, another black girl, but her child care arrangements were not sorted and she left after a period of time. Then my boss went back to, 'I don't want another mother, I want somebody who hasn't got any children'. [sic]

> [Michele, age 28, single-mother, second generation]

Once you tell them you're a mother they automatically assume you're always going to be asking for time off work or to leave work early. It's a joke really because being a mother makes you work harder, so they can't tell me 'you're under performing because your mind's on your family and not the work'. In these so-called enlightened times people look at mothers like, 'yeh we're ok to do the dogsbody work', but when it comes to other things they think we're not up to it. [sic]

> [Zora, age 26, living with partner, second generation]

As the above quotations indicate traditional expectations of mothering still underpin employers' attitudes to working mothers. In many instances, being a mother, in particular a single-mother with young children, can act as a significant barrier to securing employment, or inhibit promotion prospects for those mothers already in work (Joshi, 1991). For Caribbean mothers (as Michele's comment, above, illustrates) there lies the additional burden of being the 'first' and 'only' black women in the organisation as well as being the 'first' and 'only' mother'. This is especially prevalent in professional and private sector employment.

Mothers in the study who are employed as the 'first' or 'only' black woman in their organisations express doubts (often justifiable) as to whether they are employed as a 'token'. These mothers believe that, as 'token' employees, their employment or career advancement is secured on the basis of their racialised gendered position. Caro, Anita, and Camille, are three mothers who discuss this issue of 'tokenism' in relation to their own work experiences:

They set up an interview and I got the job but I nearly turned it down because there was all this equal opportunities being bandied about. In speaking to the [head of dept.] he said being black and female I would fit in with the equal opportunity policy. I thought I don't want to take the job because I'm black and female. I went back to the Headteacher and said I hope I'm not being offered the job because I fit in with the gender distribution quota. He told me that wasn't the case and so that's why I took the job. I just wouldn't want to do something because they want you as a token for whatever reason.

[Caro, age 50, widow, first generation mother]

Anita: The month after I started there I was having a casual conversation with the Research Director and I asked him what was it which made me get the job, because I was told shortly after I started work here that it was between me and another man. He laughed and said I was amongst one of the strongest candidates at the interview but what swung it for me was that by employing me the research centre was getting three for the price of one, and so the equal opportunities people wouldn't be on their case about the way ethnic minority people were under-represented here.
T.R.: What do you mean three for the price of one?
Anita: That was exactly my thinking. Well what he was trying to say I think was that I am black, a woman and a mother.
T.R.: Did he actually say that to you?
Anita: Yes, that's exactly what he said. He passed if off as if he was joking but his meaning was serious. I don't think he realised how offensive he was, like he was doing me a favour by giving me the job. It certainly gave me food for thought I can tell you.
T.R.: How do you mean?
Anita: Well, I know that I'm damn good at my job but with all the other things that are happening like being passed over for that promotion, I was telling you about, it just makes me think am I a valued employee? Is my research valued? Or am I just there to meet statistics?

[Anita, age 43, married, first generation]

Having me working there the Trust benefits just as much from me as I benefit from the Trust. I can count the number of senior black women in a similar position to me on one hand. My posting as a Chief

Executive raises their profile, and makes them look good. I'm under no illusions about it but in the same way that they're using me to claim equal opportunities, I'm using them to further my career.

[Camille, age 50, married, first generation]

As the data suggests, the intersecting factors of racism, sexism and mother-ism inform the mothers' work experiences. However these intersection factors encountered by the Caribbean mothers in the work place make it difficult to determine which of these are most influential affecting their employment conditions and working practices. Evidence indicates that a 'glass ceiling' is also in operation for black women at work, which limits their promotion prospects and opportunities, as a result of their female gendered and black racialised location (Jones, 1993).

There's no pressure at work but then there's no promotion. With the promotion bit it's just not coming, you've got to prove yourself and it seems there's more to be proven when you're black and a woman. They always saying we can see you've got certain aspects to do the job but then they say you've got to prove yourself. Yet, you see the white ones getting promotions. [Melanie, age 29, lone-mother, second generation]

This perpetual shifting of the goal-posts to deny access to promotion is commonplace. Deliberately leaving unclear the necessary skills and experiences required to secure advancement successfully denies Caribbean women, and other minority groups and women, occupational mobility. Thus, the 'old boys' network remains intact, limiting opportunities for others to enter specific areas or senior posts. One mother, reflecting on her own employment experiences, observes:

It's like some sort of secret society and you're forever playing catch up, trying to find out what the rules are. They say you need supervisory experience, which I'm doing, then it's oh you need management training. I've done the in-house courses and I'm doing a diploma in Housing Management, when I've finished that it will be something else.

[Zora, age 26, living with partner, second generation]

For Caribbean mothers one outcome of this continual disadvantage in the work place is that they are increasingly feeling disillusioned and despondent

about their employment opportunities. This manifested itself across the broad spectrum of levels and employment areas in this sector. Earlier in the analysis I highlighted the fact that a few of the mothers support the western ideal of mothering that is to remain at home on a full time basis. The discrimination they face on the basis of their gender, 'race' and mothering status also represents another potential factor in encouraging Caribbean mothers towards this ideal.

Reena Bhavnani's (1994) study of black[3] women in the labour market supports the mothers' claim of racial and gender disadvantage at their place of work. Bhavnani arugues that black women's historical position in the labour market is characterised by patterns of horizontal and vertical segregation. It is horizontal segregation, because black women are continually concentrated in specific occupations and sectors of the labour market. In the early post migration years, for example, black women were concentrated in nursing or semi-skilled manual work in specific industrial services (such as catering). Today, the bulk of women are employed in public administration, central and local government, (40%) and retail and distribution (22%) (Bhavnani 1994). In these occupations vertical segregation also exists. Black women are over-represented in the lower paid and lower status posts across these employment sectors. For example, in the public administration sector, a large employer of black women, black women are disproportionately employed as junior clerical/administrative workers (69%) and their presence as senior managers is virtually negligible (a slight increase from 1% in 1982 to 4% in 1997) (Modood, 1997). In this study the high concentration of Caribbean mothers in semi-skilled, low level, clerical/administrative posts in the public and voluntary employment sectors and status certainly reinforce this viewpoint (see Appendix 2).

The 'glass ceiling' cuts across all sectors of the labour market to limit black women's promotion prospects and the opportunity to enter specific areas of employment (Phizacklea, 1988). For those black women in professional and managerial positions the career choices and opportunities for career advancement that they face are narrowly defined. For example, black women employed in management are concentrated in services that have a majority of black client users.[4] Chris Ham's (1991) analysis of race and gender in the National Health Service also points to the prevalence of black female senior managers in the least

3 In the context of this study black women are defined as defined as African, Caribbean and 'mixed' (black/white) women.
4 A case in point is the London Borough of Lambeth, England who appointed the first African-Caribbean woman as Chief Executive in the borough. Lambeth has the highest proportion of African-Caribbean people in a local population in Britain (Owen, 1997).

glamorous 'Cinderella' health care services such as geriatric care and mental health. To suggest, however, black women are always marginalised or even 'ghettoised' into making their employment choices denies their agency. For example, five of the mothers in the study who were employed in professional posts—teacher, lawyer, social worker, academic lecturer, and mental health director—stated that they actively sought out employment in predominantly 'black areas' or with a high proportion of black users. To some extent their employment choices represent a 'strategic' means of securing greater opportunity for professional mobility and career success. Nonetheless, their employment choices can also be viewed as a means through which to 'give back' to the Caribbean community and act as a positive role model for others. Three mothers, employed as teacher, teacher assistant, and community worker respectively, offer frank appraisals of their employment choices as a means of 'giving back' to the community:

> I teach at a school just down the road from where I live. As you can see it's a mainly a black area. When I heard about the vacancy, I thought I wouldn't mind teaching in a place like this because of the challenge there would be. It used to have a really bad reputation but they got a new headmaster, a black man, and he has done some wonderful things. I thought that I could also do some good, maybe make a difference here and make my contribution to the local community.
>
> [Cara, age 50, widow, first generation]

> I think the major issue faced being a black teacher is probably just being seen. As it is I'm not a teacher but a support assistant now and the children look at me as an adult in the school and therefore somebody who deserves respect. I'm also training to be a teacher because I think there aren't many of us [black teachers]. The school I'm working in now has a school roll of 325 children. There are only three black members of staff in the school but yet there are a large amount of black children from our background in that school. I think we need a lot more black teachers because I think they [school children] should see that they are represented, and as a teacher I would be able to do that. A lot of the teachers here tend to be from middle-class backgrounds and don't have much in common with the children here.
>
> [Jamilla, age 25, lone-mother, second generation]

Its hard work and it can be soul-destroying at times but I love what I do. The way I see it, I'm doing my bit for the black community. Ninety-five percent of my clients are black. What I also like about the job is that people round here know me, I feel part of the community. At least I am trying to do something to make people lives better.

[Georgia, age 39, married, second generation]

Conclusion

The research findings indicate that Caribbean mothers long employment history in the U.K. is shaped by interlocking cultural and economic factors. Historically and culturally, Caribbean mothers have been constructed as workers and their cultural expectation of full time paid work persists. These women possess a mother/worker status that has been shaped and informed by the historical experience of slavery, colonialism and economic migration, in a U.K. context. Economic circumstances and constraints are framed around black male and female marginality in the U.K. Lone-mothering and the mothers' reluctance to seek additional household income through statutory agencies such as the Child Support Agency also encourages these mothers toward full time paid work and reinforces the mother/worker status. Yet, despite Caribbean mothers' high rates of economic activity their general experiences have not been altogether positive because of the intersecting factors of 'mother-ism', sexism and racism which have generally disadvantaged Caribbean mothers in the labour market. For Caribbean mothers today a tension exists in balancing this mother/worker status against the discriminatory conditions that they face as part of their daily working lives and the desire for greater personal choice and freedom in their working practices. In the research this has translated itself into increasing numbers of black women considering employment options that would take them out of full-time paid employment (but not necessarily situate them in the home as full-time carers). Other mothers have sought to resolve this tension by actively looking for employment opportunities that allow them to 'give back' to the wider black community and act as positive role models for others. But economic constraints limit these options for many black mothers and they continue to work in work settings in which racism, sexism and mother-ism are an everyday aspect of paid work.

Chapter 7
Community mothering
Introduction

Historically, Caribbean mothers, through their role as 'community mothers', have collectively organised care for Caribbean children in the community. The analysis of 'community mothering' provides a new conceptualisation of the interacting nature of work, mothering, political and community activism, and spheres of social life which are usually analysed separately.

Traditional academic practices fragment social life and falsely separate paid work from social reproduction, activism from mothering, and family from community (Naples, 1996: 227).

The development of the concept 'community mothering' reveals first, the social and collective responsibility Caribbean mothers have for children (and other vulnerable members) in their local community, to whom they are not biologically or legally related (Barrow, 1996; Glenn et al., 1994; Reynolds, 1999a). Second, as part of their 'community mothering', these mothers are actively engaged in collective and political struggles that focus on the physical survival of their children and community (Hill-Collins, 1994). Third, and contrary to traditional definitions of mothering, 'community mothering' demonstrates caring and parenting which extends beyond the domestic sphere and familial/kinship ties into public, non-familial activities. In this sense 'community mothering' reinforces the interdependent relationship between mothering and the wider socio-cultural concerns that Caribbean mothers have for their community. For example the wide range of caring work Caribbean mothers provide at localised and practical levels—such as voluntary care and the setting up and running of educational programmes for black children—are understood as benefiting the black community in general. It is also regarded as another way through which Caribbean mothers are able to transmit cultural values to the next generation.

The social and political context of Caribbean community mothering in the U.K.

A number of studies indicate that a high proportion of Caribbean women in the U.K. are actively engaged in some form of ethnic specific community work and/or participate in similar black welfare based community organisations (Goulbourne, 1989; Sudbury, 1998; Davis and Cooke, 2002; Goring, 2004; Reed, 2004). In this study a total of eleven mothers worked as paid staff in

black or Caribbean welfare based community organisations[1] and a further eight mothers did some type of unpaid voluntary work. These women's caring work or 'community mothering' occurred in organisations, such as supplementary schools, mentoring schemes, health and social support groups, and youth programmes. It focused on addressing particular concerns in the black community, for example, the educational needs of Caribbean children; youth unemployment; teenage pregnancy; and health and social care relating to the elderly, disabled and the mentally ill.

The 'community mothering' undertaken by these mothers in these welfare based organisations might be viewed as representing a growing trend towards community based caring by black and minority ethnic (BME) groups in the U.K. Over the last twenty years there has been a steady increase in the number of these BME community welfare based organisations and recent figures indicate that in the U.K. today there are approximately 10,000 of these organisations[2] (Reed, 2004)[3]. This expansion of BME welfare based community organisations, where Caribbean mothers perform the bulk of their 'community mothering', is considered to be a direct outcome of three issues. First, it is viewed as a reflection of BME increased political and collective mobilisation in order to address locally based concerns in their communities. Their activities reflect their collective feelings of disengagement, disillusionment, and disaffection with municipal statutory 'mainstream' (i.e. white) organisations in meeting their needs in a culturally sensitive manner (Davis and Cooke, 2002). Second, the mothers' 'community mothering' is an outcome of the demographic trend of an increasingly elderly Caribbean population and the issue of 'return migration' to the Caribbean. In response to these concerns the Caribbean 'community mothering' represents a well established, and cultural historical tradition of individuals utilising the community for support with family care and provision. Third, Caribbean mothers' participation in rapidly expanding BME community welfare based organisations must be read as part of a wider cultural and societal paradigmatic shift in policy discourses concerning the roles and responsibilities

1 In addition to speaking with these mothers about their community activities I also had the opportunity to visit fifteen mothers at their organisations to observe them at work.
2 Harry Goulbourne's (1989) earlier study of Caribbean community organisations in the U.K. identified three types of organisations: (1) welfare—these organisations addressed the welfare concerns of people in the Caribbean community; (2) broker/political—organisations that primarily focus on advocacy work and political activism; (3) social—organisations that offer social/sporting events (e.g. cricket club)
3 This figure represents Caribbean community organisations and groups that are officially registered as a charity and receive some proportion of funding from local education authorities and other statutory agencies (e.g. National Lottery Commission). Reed (2004) suggests that there are as many as 3,000 additional organisations in existence that are not formally recognised.

of family, community and state in family care provision. The analyses discuss each of these issues in turn.

State, family, community and care

Caribbean mothers 'community mothering' in community welfare based organisations in the U.K. can not be understood outside the social and political context in which they operate. In terms of state rhetoric concerning notions of care, the post World War II period consolidated a form of collectivism that was initiated at the beginning of the century. During this period, whilst some elements of individualism were retained, largely policy approaches sought to re-establish notions of collective responsibility where the basic needs of its citizens were met by the nation-state (Williams, 1989). The introduction of the National Health Service and the development of the welfare state during the late 1940s, for example, stood at the very heart of this model.

This ideology of state-led collective responsibility for care continued for forty years up until the development of the 'New Right' ideology which emerged in the early part of the 1980s. This shift in ideology marked the introduction of the period known as the 'new age of welfare'. This period encouraged a shift in balance between the rights and responsibilities of the state and citizens and the rights of responsibilities of the state versus the family (Wright and Jagger, 1999). Whilst some forms of collectivism were not eroded during this era, the criteria and eligibility for welfare benefits and services changed (Williams, 1989). An understanding of individual responsibility emphasised both community and the family as committed sources of caring support for individuals in society. A primary outcome of this shift in ideology was the shift in the provision of care and welfare services towards community and family.[4] Local government's power in funding welfare services was increasingly eroded in favour of a rapidly expanding voluntary sector and quasi-statutory bodies. Coinciding with this changing ideology was a period from the late 1970s and the start of the 1980s marked by civil unrest and urban uprisings across many urban cities with large Caribbean settlements. The Scarman Report, 1981 that followed on from this period partly attributed the riots and uprisings to feelings of alienation and powerlessness of young Caribbean people living in economically depressed urban inner cities areas. One of the recommendations made by the report was that local communities become actively involved in the planning of their communities and that funding becomes available for the establishment of

4 See for example, National Health Service and Community Care Act 1990

community organisations, such as welfare based ones, to address the roots of the difficulty (Solomos, 1988). Caribbean welfare based community organisations utilised this period and subsequent support from municipal left organisations in supporting grass root organisations to seek funding. New Labour continued the Thatcherite policy of re-emphasising individualism (whilst maintaining some elements of collectivism) and its policy of centralising and eroding the power of local governments.[5]

Other societal ideological shifts have informed and had an impact on welfare-based organisations in the Caribbean community. Weeks' study notes that individualism, where individual needs and choices are primary, is a key indicator of today's society. Moreover, individuals are actively choosing fluid and adaptable non-familial networks in their relationships, over the constraining ties of family (Weeks et al., 1999). Weeks' argument supports the individualisation theories that suggest major changes in family relationships because family members start to think of themselves as self-sufficient individuals with their own identity; an identity that is rooted in their work life as opposed to embedded in their family life. Black feminist commentator bell hooks presents a similar argument in her discussion of the black family with her claim that '*the rise of narcissistic individualism among black people has undermined traditional emphasis on the family and with this a shared sense of moral obligation to care for family members*' (1993: 154). Such viewpoints offer a rather pessimistic and over simplistic conclusion concerning the way in which family relationships still continue to have a value and significance in individual lives. However, there is little doubt that people are increasingly turning to networks and sources outside their family for care and support. For example, some of the mothers interviewed identified elements of the individualisation thesis as a key factor in the development of Caribbean welfare based organisations and in influencing people's choice to use them. Janet and Charmaine are two mothers who both work in a community organisation for the Caribbean elderly. They comment:

> *Janet:* This time 30 or 40 years ago there wouldn't even have been a need for an organisation like ours. The family all pulled together and helped one another. I'm not just talking about your immediate family but uncles, aunts and cousins. They would all pull together and help. But now people

5 One consequence of this changing culture of the voluntary sector is that the voluntary sector has become increasingly 'professionalised' and 'bureaucratised'. Caribbean welfare based community organisations tend to be small scale organisations. They face increased pressure from funders as they are being gradually squeezed out in favour of larger, professionally run ones.

are so busy. They say they haven't got time for you and that's not even
your distant relations saying that but your own family. We've become
selfish because people who only care about ourselves, about our own
needs and we're not concerned with other people.

[Janet, age 48, divorced, first generation]

Charmaine: If our users could turn to their family more, then we wouldn't
be needed. Caribbean people's attitudes have changed. As a society we're
become much more self-centred and I feel that Caribbean people have
copied that. We're living in a 'me' generation [sic]. I'm sure if you asked
people who was important to them and who they'd really care for in time
of crisis them I'm afraid most of us would say, our children, our partners
and that would be it. No one wants that responsibility of caring for other
family members, especially if it is going to involve time and money.

[Charmaine, age 41, lone-mother, second generation]

Both Janet's and Charmaine's comments identify people's changing attitude
towards providing care for extended family members and how this has directly
led to a need for their organisation in their local communities. One reason for
this shift away from family responsibility in family care is that as Caribbean
people become more dispersed due to economic, geographical and social
mobility it could mean that there are less opportunities for them to share their
time, skills, and resources in family relationships (Allen, 1982; Cross, 1993).
Second, as previously noted, there is also the demographic trend of an ageing
Caribbean population. Studies indicate that black people of Caribbean descent
have the fastest growing rate of people reaching retirement age and the U.K.
is now experiencing its first real wave of Caribbean pensioners (Alexander,
1999). Whilst some Caribbean pensioners are choosing to 'return home' to the
Caribbean to live out their remaining years, many will continue to live in the
U.K. either because they choose to do so as a result of their family ties here or
because financial constraints force them to remain in this country (Goulbourne,
1999). Those Caribbean pensioners who either choose to or are forced to live in
the U.K. have important policy implications for statutory agencies because they
have to introduce 'culturally appropriate services' for this group (Stubbs, 1993;
L. B. Merton, 1997; Gunaratnam, 2001).

The increased rate of Caribbean elders also has social implications for younger
family members because they have to find ways to balance the meeting of their

own individual needs alongside the cultural expectation that they will meet the caring needs of their elder family members. To some extent the need for younger family members to care for elder family members is born out of a strong sense of moral obligation because they are aware that they are not the sole source of support; and their elderly relatives in the U.K. have greater access to state welfare provision, and welfare community aid for caring, financial, and practical support compared to other societies, such as for example, the Caribbean (Irwin, 1995).

Whilst these discussions provide useful debates concerning the rationale underpinning the rise of Caribbean welfare based community organisations in the U.K., it should not be assumed that these organisations represent a last resort for care, something that is forced upon individuals because they cannot obtain the necessary level of care and support from their family members. Indeed this study highlights the mothers' belief that Caribbean individuals in need of care, do not regard these organisations as the only option available in lieu of family care but rather at varying times choose to utilise these organisations and/or the family as their preferred choice of care. Individuals who are experiencing issues and problems that they consider to be 'shameful' and who do not want to reveal this to wider family members are more likely to utilise services provided by black community welfare based organisations. One reason for this is that in some Caribbean families openly discussing certain types of illnesses and forms of disability are frowned upon and some illness and disability, for example mental illness and cancer, are viewed as 'sinful', 'shameful', or 'self-inflicted'. A strong tradition of supernatural beliefs (such as 'obeah' or a curse) and a lack of awareness with the Caribbean community of some illnesses maintain the stigma associated with certain types of illnesses. Thus, individuals who are experiencing this may prefer to turn to relevant community organisations and sympathetic people for support and assistance rather than their family/kinship members. The following quotation by Lisa, a co-founder of a black disability organisation, provides some indication of this.

> There are many black people with a disability but in our community we're not open about disability or illness. Even now its always hidden, kept behind closed doors and you don't always know unless someone tells you. And you see in our [Caribbean] community there's still this stupid mindset that your disability is to do with someone putting a curse on you. Its either seen as punishment or someone has put 'obeah' [curse] on you. So you see with those beliefs in our community people prefer to

come to us for help. I set up 'WIDA' because my eldest son is deaf. He
has 30% hearing is his left ear and completely deaf in his right. My mum,
kept saying 'well I don't know where his [deafness] comes from because
we don't have sickness in our family' [sic]. So of course she's convinced
that when I separated from [son's] dad he obeah me for leaving him
because he didn't want me to leave and things ended badly between us.
Now, with that kind of attitude can you imagine the inferiority complex
she's giving my son. I don't want him to feel ashamed he has a disability;
its just make him extra special in my eyes. There's no shame in asking
for help. Your family, with the best will in the world, can make you feel
ashamed and try to keep you locked away in the house. Or worse yet,
just not talk about it and pretend its not there. I know that's why people
come to us because they can't deal with the stigma at home from well
meaning people

[Lisa, age 36, living with partner, second generation]

'Community mothering' as cultural practice

The experiences of the mothers in terms of their community work suggests that
'community mothering' does not merely constitute a response to paradigmatic
shifts in state and family ideologies. As I previously suggested Caribbean mothers
have a long-standing and well-established tradition of providing community
support and care for its members who are not blood, or legal, relations. As such
there is also a historical significance to Caribbean women's role as 'community
mothers'. Evidence of 'community mothering' is observed across Caribbean
communities in the U.K., the Caribbean, and the U.S.A. (Barrow, 1996; Glenn
et al., 1994; Reynolds, 1999). For example, Brana-Shutes (1993) study of
Caribbean women in Surinam from the end of slavery in 1836 up to the present
day illustrates that these women are strongly connected to their neighbourhood
and its development. Many of them live in female-headed households and they
have resided in their community for a number of years. Alternatively, they have
inherited their homes from parents. As a consequence not only do these women
have strong a emotional investment in their community but also decision-making
responsibilities in both domestic and community spheres. Organisations
and informal networks are formed by these women to collectively organise
around emotional support, the redistribution of wealth, exchange of food and
labour, child care, teaching/training, and entertainment. Activities undertaken
in these organisations and networks also link domestic and neighbourhood

concerns to national politics. For example, mothers responded to the national policy of raising the literacy rates of children in Surinam by setting up literacy programmes staffed by female volunteers in their local neighbourhoods.

Similarly, in the U.K. during the early migration years many Caribbean women migrants did not have extended family networks to assist them with child care and other welfare support (Reynolds, 2001). They therefore had to rely upon newly formed relationships and newly created community groups and welfare associations as a way to survive these early years (Goulbourne, 1989; James and Harris, 1993). During this period Caribbean people were often denied access to building societies and banks for financial loans, and so self-reliance in local Caribbean communities was an important way for people to function. The 'pardner' system was established as a means through which people could collectively save money. Primarily set up and run by Caribbean women in the local community, the 'pardner' system acted as an efficient community money lending scheme. Bryan et al. (1985) reflect that the 'pardner' system in these early years provided the only available and regular source of money when lump-sums were needed for outlays such as mortgage deposits and the cost of airline tickets to bring children in the Caribbean to join them in the U.K. The black led churches also provided Caribbean people with support, care and fellowship. It was in the church community that some of the earliest 'community mothering' as first established in social and welfare-based community organisations (Goulbourne, 1989 and 2002; Alexander, 1996).

My mum's church was one of the few black churches to own their own building in London back in the 1970s. They got it cheap because it needed a lot of repairs. But people all pulled together and when I was growing up it was an important part of our area. Lots of social events took place there because you couldn't rent other venues. So, the church became the focal point for social events. On Saturdays I remember there was always a wedding reception, party or something going on. People used that hall a lot. The church even organised a sort of after-school club, only it wasn't called that because this was back in the 1970s. The pastor agreed to let one of the church ladies, Auntie Joyce, use the hall in the afternoons. Every afternoon after school I collected my younger brothers and sister and we walked to the church. Auntie Joyce looked after us until mummy came from work. There was about ten of us that would go there. It was very informal, not like the after-school clubs they

have today, and we didn't do any activities. What mostly sticks in my
mind is that the building was cold and draughty. Auntie Joyce giving us
orange juice and biscuits, and helping us with our homework. I don't
think mummy paid anything for Auntie Joyce to mind us but I'd have
to check that with her. I don't recall Auntie Joyce being paid anything.
I'm pretty sure Auntie wasn't a qualified child minder, but I do know she
had older children 'back home' in Grenada. I think she just had a love of
children and wanted to help the community.

[Sarah, age 33, married, second generation]

Even today in the U.K., generally those mothers closely involved with
'community mothering' in their organisations regard this as merely continuing
an established cultural tradition. With two exceptions (for example see
quotations by Janet and Charmaine above) the mothers saw caring work as
working alongside and in conjunction with care provided by the family, instead
of replacing the family's caring function. In fact, there is evidence to suggest
the family caring function is very much intact, not just by immediate family
members but also extended kin. However, the way they provide care has changed
as a result of changing social circumstances and demographic shifts. The rising
elderly Caribbean population in the U.K.; return migration of retired family
members to the Caribbean; and the high rates of labour market activity, have had
important implications for this relationship between the family and community
organisations, and their respective role and function in care provision.

Goulbourne's (1998c) study identified that the retired elderly still constitute
the vast majority of return migrants to the Caribbean despite an increasing
minority of young 'returnees' who are of economically active age. This factor,
combined with Caribbean women's high economic activity, means that senior
female family members (such grandmothers, aunts) who traditionally assume
a central role in caring for other family members are increasingly likely to be,
themselves, still engaged in full-time employment (if they are of economically
active age) or they have 'returned' to the Caribbean (after retirement). Not
surprisingly these factors limit the time to provide caring support. The following
quotation reflects on this changing family support: in terms of its implications
for 'community mothering':

The grandmother used to be important in helping the parents with the
children. My grandmother, she was a marvellous woman. She taught me

to read and developed my passion for books. Growing up my parents didn't have the time because they were busy working and so every afternoon after school me and my youngest two brothers would go by my grandmother's house. We'd sit down with our books. I'd practice my reading, do my lines and we'd take it in turns to read to her. It was there that I became good at reading. If only the children now had that resource available to them but I know its difficult because granny's busy working too, and some of them [children] don't even have them here because they've gone home [Caribbean] We've tried to take on that role in the school. Every week the teacher sits down with one of the children and makes them read aloud. [Helen, age 56, married, first generation]

This is not to suggest grandmothers, (as well as grandfathers) and other older family relatives who have re-migrated to the Caribbean are not still on hand to provide care support. Goulbourne and Chamberlain's (1999) study, for example, comment on the 'flying grandmothers' syndrome to represent grandmothers and other senior female family members who regularly criss-cross the Atlantic in order to visit family members in the U.K. and the U.S.A./Canada and provide them with practical child care assistance and emotional support as and when required. Similarly, grandmothers who are in full-time employment remain a central child care and parenting resource during the time that they are not at work (primarily weekends), and many would organise their annual leave to coincide with their grandchildren's school holidays so that they can assist with child care.

Gender and children in community mothering

Traditionally it is the female family members who have provided much of the care in the family whether it is caring for children, the sick or elderly family members. The roles and functions undertaken in Caribbean welfare based organisations are also highly gendered. Davis and Cooke's (2002) study exploring black voluntary organisations illustrates that a disproportionate number of women are key workers, volunteers, trustee members and service users in black welfare based organisations. These women fulfil obligations in their community that are similar to the work they perform in the home/family sphere. In contrast, Caribbean men are much less involved in these organisations and where they do participate it tends to be at senior formalised levels in the organisations (i.e. senior manager or board of trustee member) and they are less likely to take

part in the day-to-day activities[6]. In this study the mothers noted that women dominated in the organisations in which they are involved. They observed that women performed many of the day-to-day activities and assume a variety of roles ranging from key workers, board of trustee members, volunteers and service users. The work performed in these organisations mirrored their domestic activities at home. For example, the female workers and volunteers would be responsible for cooking, cleaning, visiting and shopping for the sick and assisting the children with their educational learning. The research findings replicate the findings by Sudbury (1999) whose study reported similar high rates of involvement by women in key domestic functions. Whilst Caribbean men also participated in the work performed in these organisations, there were far fewer men involved. The following quotations provide some indication of the gendered dimension community work provided in these organisations:

> We have four paid workers—two full time and two part-time—all of us are women. Our volunteers on our books are mostly women too. We only have two men who'll come in. One who drives the mini-bus and the other who helps out from time to time in our drop-in session but its the women who take the lead here. I find that women are more willing to give their time and help out where they're needed.
>
> [Donna, age 59, lone-mother, first generation]

> The women get more involved. They're more likely to attend the keep-fit classes and craft classes where they can make little things. Black elderly women are more far active and want to fill their time doing things than the men. In this group the number of male users are declining. We used to have a small but core group that would attend the luncheon club but they weren't really contributing. They would never attend any of the classes that were put on for them and all that they want to do is sit and play dominoes or cards. Now they've stopped attending, some of them died or went back home and the others just stopped coming and so I would say that its mainly women who are the main users of the services.
>
> [Tina, age 49, married, first generation]

6 Of course there are exceptions to this. In one supplementary school, men were equally involved with women as teachers and in carrying out other day-to-day activities.

The mothers reflected that men's contribution occurred at committee level. Men would hold key positions, such as Chairperson and Treasurer and also other similar posts, which monitor the overall running of the organisation. The gendered dimension to these organisations mirror wider gendered division of labour patterns in society. Even in female dominated occupations, such as teaching, for example men continue to hold the senior posts (Beechey, 1986; Rees, 1992). The gendered nature of these Caribbean community organisations is also prevalent in other Caribbean-led organisations such as black-led churches where men by and large hold the key positions despite a largely female congregation, (Alexander, 1996). With the exception of a few studies, such Sudbury (1999) and Davis and Cooke (2002), the gendered division of labour and subsequent gender inequalities that comprise black community organisations have been virtually ignored. Most studies either choose not to highlight gender difference at all, or they focus on the views of Caribbean men since although their presence in such organisations is limited they are often in senior positions, and so more likely to be interviewed than the majority of the women who do the day-to-day activities. Analysis of the community work of Caribbean women gives us then the opportunity to celebrate the work of these women, often overlooked in studies of black community and political activism in the U.K.

Children and Caribbean community mothering
The centrality of children in creating and sustaining Caribbean women's community activism is a crucial aspect of Caribbean 'community mothering'. As Julia Sudbury, (1999) observes:

> Children represented the intersection of the individual and community
> … This view of children as a shared responsibility gives rise to a desire
> to create collective solutions to problems experienced initially at an
> individual and family level. (1999: 48)

Implied in this understanding of 'community mothering' is that Caribbean women feel and share a collective responsibility for children and other vulnerable members of the community, to whom they may or may not be biologically related. A similar study by Hill-Collins (1990) of black women's community activism in the U.S.A. identified that it was common for the female community workers to use 'family language' when referring to unrelated individuals in their community. Her observations mirrored my findings where key female workers

and volunteers used language that expresses emotional ties and connections to the children. So for example, it was very common for the mothers who worked in the Saturday schools and mentoring schemes to refer to the children they worked with as 'our children', or 'my children', this despite them not having kinship or biological ties to them.

Hill-Collins (1994) discussion of 'community mothering' and in a broader sense 'community parenting' is particularly useful in understanding these women's language of ownership and the way it represents a moral or cultural obligation to provide care for non-kinship children who are also community members. She argues that these women believe that the range of tasks and duties they performed at localised and practical levels benefits the black children in their local communities. At a psychological and emotional level the community work performed is viewed as a means to successfully socialise and transmit the cultural values of the community to the next generation. The mothers who are engaged in 'community mothering' practices expressed similar views

> You do form emotional attachments. That's why I keep coming back to the school every Saturday morning. I have a vested interest in our children. When one of them does well I feel really proud and I share in their success. When one of them fails, I feel like I have failed.
>
> [Helen, age 56, married, first generation]

> There's this saying 'it takes a community to raise a child' [sic]. It means that we all have to take responsibility for them. They're our children. If we don't care then how can we expect anyone else to care about them. We all have to play a part, no matter how big or small because they're our children. What happens to our children affects the community as a whole so it's all of our responsibility to get it right because they're the next generation.
>
> [Dolly, age 76, married, first generation]

Nancy Naples' (1996) study of 'activist mothering', also in the U.S.A., illustrates that over a third of black and minority ethnic women in her study initially became involved with community work as a response to individual concerns and problems that they had regarding their children, especially the

negative experiences of their children in the education system. This argument certainly accords with the responses I received from key workers and volunteers who worked with children in local Caribbean communities in the U.K. For example, Dawn, a mother, who founded a Saturday School comments:

It was when the National Curriculum was first introduced that I really became interested in my children's education. I attended this talk about the National Curriculum, what it would mean for schools and what they learnt at school. By chance my friend was training to be a teacher and she invited me along at the last minute to go to this talk with her. Anyway, after that talk I came away scared. I was frightened for my children's future because I was sure that there was no way that their school could deliver. The school is very overcrowded and you can see that the teachers can't cope. I knew that I couldn't afford to send them [children] to another school and so I was going to have to do something myself. I decided to set up a Saturday school and so after this the first thing I did was get my hands on everything about the National Curriculum and the sort of things that children would be expected to learn. I then went to the school and asked them if they could give me spare copies of things that they use in schools for the children. When I told them about my intention to set up a Saturday school they were more than happy for me to do so and I based the teaching around this with a little bit of teaching about Caribbean histories as well.

[Dawn, 36, living with partner, second generation]

Similarly, Heather, another mother who self-defines as a 'community mother' notes:

I didn't like the storybooks they would give my daughter to bring home with her to read. I felt the school hadn't moved with the times and from the material you wouldn't know that we live in a multi-cultural society. Rather than complain and know that nothing is going to get done I thought to myself 'well Heather, you have the skills and the contacts, so why not produce your own books that you would like to see'. And that's what I did. In 1994 I set up my own publishing company in my house and I started to produce children's books that featured black characters and stories that black children could relate to. I wrote five short stories

to start with and based it on a main character who was this black girl but I also had Indian, Chinese and white children in the stories. I asked my friend who's an artist to help me with the illustrations. When I had that first series I contacted my daughter's Headteacher and she was genuinely interested in helping to get the project off the ground. She bought the first books and put them in the school library. Then the local education authority took an interest and they said that they would buy 150 books and put them in schools around the area and then education authorities in surrounding areas wanted them for their schools. The business took off from there and I decided I need more resources to keep up to demand. I applied for small business grant and with God's grace I got the funding. With that funding I was able to set up small publishing company. I rented a small studio, brought some second hand publishing equipment and I employ two women whose children go to my daughter's school to come in part time to help me with the publicity, marketing and admin side of things.

[Heather, age 33, living with partner, second generation]

What these quotations also reveal is that it would be naïve to suggest that mothers who work tirelessly for the good of the community, are primarily motivated by altruistic concerns. In reality mothers who participate in community work have an interest which has developed from personal and family concerns, and the desire to develop collective support for individual concerns addresses very specific issues that they have personally encountered. The following quotations offer some indication of this:

All of this got kicked off after I became a mother. Before I was a mother I had a nice interesting wonderful life. I'm a qualified solicitor. I worked in the city, got a law degree from Oxford. It was all very nice being a yuppie in the city but after I had children I think my priorities changed more to—not so much how I can improve my quality of life—but how I can improve the quality of the world in which my children will be living. The Chair is male and another who has recently joined. We are very pleased to have him and I think his interest came through looking at strategies to deal with racism that he felt his young son was experiencing and so

he said he might be able to help and that he'd liked to get involved. His example is like many others who also joined our organisation.

[Georgia, age 39, married, second generation]

I first did this because there wasn't many black single-mothers living on the estate and we've got quite a small Caribbean community here. My family lived quite far out and I felt really on my own and I was really isolated and lonely really. I thought that there might be other single-mums out there who were going through the same things as me and saw that it would be nice if we could meet up to talk and act as support to each other. I'm not a get up and go person but I thought why not? There's no harm in placing a couple of adverts in the local library and also at the town hall. I was shocked at the response I got. The first meeting ten mothers turned up and it turns out that they were going through the same things as me. We built things up from there and the rest is history.

[Alison, age 21, lone-mother, third generation]

I'm disabled myself and I was working for the city council and I saw that the council wasn't doing much to help the Caribbean disabled in Manchester. People in the area know me because I've lived here all my life and when they heard that I was working with the council they would come to see me about their family member who was disabled or if they were disabled themselves they would ask me to fill out their forms to get the right benefits and sometimes I would be asked to represent them in hearings. It helped me because I got to know more about my rights as a disabled person and what sort of money and help that I could apply for. [Donna, age 59, lone-mother, first generation]

A second important element of Caribbean 'community mothering' in sharing a collective and communal responsibility for Caribbean children is to produce Caribbean children's politicisation through identity formation, such as Caribbean history classes and related to this, in developing effective strategies for Caribbean children to cope with the racism which they will encounter in life. This aspect of the mothers' 'community mothering' relates back to the previous chapter where I explored a range of child rearing strategies the mothers employ to challenge and respond to racism in their children lives. Sarah, a board of trustee member for a youth mentoring programme claims:

A very important part of our work is to teach our children important life skills that will take them through life. It is important that our children learn what is going to confront them and school and how to challenge what they see to be as unfair treatment positively and in a constructive way. It's no good children shouting down the teacher if they feel they are being racist. That only leads to them being excluded from school even if initially they are in the right. As mentors we work with the children in teaching them how to deal with authority and handle any issues constructively, and so far I it is working. The Headteacher at a school I visited yesterday said that they were very surprised and impressed with how one of our mentees, who had been previously excluded from the school, handled a disagreement he had with a teacher in a very calm and mature way.

[Sarah, age 33, married, second generation]

Even if we take into account the stereotypical assumptions that underpin the labelling of Caribbean boys in schools as aggressive, physical etc., which is discussed in depth elsewhere (see Sewell, 1998) and the teacher's surprise that the boy in question has reacted differently to these preconceived assumptions, (i.e. calm and mature) it is clear that an important element of mentoring work is not just concerned with the raising of educational standards amongst Caribbean children in our schools. It also marks a collective attempt in the black community to develop strategies for children to challenge their teachers on what they perceive to be racist practices without necessarily undermining the teachers' authority. The qualities learnt here would be required for children outside a school context and in later life. In a special edition on Caribbean mentoring schemes in the Voice newspaper (6th June 2000: 20) David Gillborn, an academic specialising in race and education, and Amanda Howell, a mentoring project manager in the Midlands offer similar arguments. Gillborn comments:

'mentoring can be useful especially in helping Caribbean young people to discover different strategies, in finding their way through an institution'
(*Voice* 6th June 2000: p. 20)

Howell notes:

'With some of our young people we see a development in confidence and improvement of skills in getting jobs and keeping them. We've seen improvements in school work, and generally young people have a chance to think about the consequences of their actions' (ibid.)

The mothers' discussion concerning their role as 'community mothers' reflects their desire for role models in the black community. They regard their role as facilitating contact between children and potential role models:

An important element of what we do at the school is our grounding day. We try to organise these three to four times a year. We invite past members of school that have gone on to do good things with their lives. We also ask the parents and members of the management committee to come to the day. It is important for the children to have role models and not just role models that they will never meet but people who have actually been to the school, who have been through the system and have achieved great success. The children can ask them about their experiences. It's all very well the children saying they want to be a scientist or a doctor when they grow up, but do they know any? Do you know what is needed in terms of qualifications to become a scientist? That's why at our grounding days we also invite people along who are already working in those jobs so that they can speak with the children. They can give them career advice and talk about their pluses and minuses of their professions so that the children have realistic expectations of what the profession entails. The children can identify with them and they can say that they have personally met a scientist, a doctor, whatever. Doing that gives them someone they can aspire to.
[Felicity, age 54, married, first generation]

There are a range of practices and activities Caribbean 'community mothers' working in welfare based community organisations undertake in order to influence identity formation and cultural awareness of the Caribbean children who live locally. During the time of my fieldwork organisations taking part in the study were holding activities for the children to celebrate Caribbean Diasporic identities. I was invited along to these events. For example the *Marcus Garvey* school in London held its annual African Liberation Day celebration where the children are invited to put on events such as dancing, poetry reading and

recitals, to celebrate Caribbean communities elsewhere and the achievements of Caribbean people worldwide, other than sporting and musical achievement, (e.g. Mary Seacole, James Baldwin, Martin Luther King, and Nelson Mandela etc.). In the past the school has attracted worldwide and well-respected visitors to speak to the children, such as Bishop Desmond Tutu, the Reverend Jesse Jackson, ex-Jamaican Prime Miniser Michael Manley, and Professor Cornel West. A second organisation, *Caribbean Family Club* organised a Family Day where all the Caribbean families in the north east region of England were invited to spend the day together undertaking a range of activities such as art and craft, a football tournament and a fun-fair. It has also been successful in organising other family activities such as the '*Walk in the Countryside Day*', which was filmed and screened for television by Channel 4, to celebrate and promote positive images of the Caribbean family.

Interestingly, the mothers assert that they have become well known figures in their local Caribbean communities as a direct consequence of their work in their organisations. On the one hand this has enhanced their prominence and visibility in their local community. However, on the other hand this 'community mothering' status reinforces the burden of care these mothers assume for family and community:

> Everyone knows me now. When I go out shopping it takes me about an hour to walk down the local high street because everyone is always stopping me to say hello. Even if they don't know they come up to me and say 'are you Sybil do you know my mum, sister, cousin, uncle, auntie who comes to your group' or 'can I come and see you because I have a problem I want you to help me with'. (sic)
> [Sybil, age 49, lone-mother, second generation]

> They all know me on the estate now. It can be a good thing or a bad thing. It depends on my mood because sometimes you don't want to talk to anyone and people will want you to acknowledge them and they'll want to ask your advice about a problem they are having and you're just not in the mood. It makes it difficult to switch off and I have to go away for a few days to visit friends and family to get away from it all but other times its very flattering that people value my opinion and they see me as a figure of respect in the local community.
> [Pauline, age 25, lone-mother, third generation]

In addition to 'community mothering' increasing the mothers public profile in their local community, as the following quotation indicates it also reinforces the mothers' connections between political activism, mothering, community work and paid labour, conventionally analysed as separate spheres of social life. Dawn, a manager of a voluntary organisation, comments,

> I'm quite well known around here. I'm a definite face in the community. Also since I got involved in this organisation everyone up at city council knows me. The other day the chair of the education trustees approached me to run for Labour councillor for my local ward. I'm not sure if I'll do it but I'm considering it.
>
> [Dawn, age 36, living with partner, second generation]

The fact that these mothers who act as community workers in these groups are perceived as figures for respect and authority by Caribbean people living in the local community is a noteworthy development because traditionally local Caribbean community organisations have been one of the main arenas through which Caribbean men have been able to achieved social standing and status in society (Fryer, 1984). In contrast for Caribbean women despite their continued dominance in Caribbean community organisations their contributions have received limited social recognition from both outside and within the local Caribbean communities (Sudbury, 1999).

Conclusion

The concept 'community mothering' in the analysis of Caribbean mothers' lives reinforces the idea that the self, family and community are irrevocably intertwined. Equally for Caribbean mothers connections and intersections are framed around paid labour, community and political activism, child care, and mothering work. Welfare based community organisations perform a vital role in the Caribbean community and they represent the primary arena where Caribbean women perform 'community mothering'. Various commentators point to the way that changes in state welfare ideology, changes in attitudes concerning the role of the individual in relation to the family, and demographic changes in the Caribbean community have influenced the expansion of welfare based community organisations and have expanded in terms of the variety of its caring and support functions. Care for the Caribbean elderly, sick, and the education and mentoring of Caribbean children, are all areas traditionally undertaken by

the family, in particular female family members. To suggest, however that such organisations are now replacing the family in the provision of care would be an oversimplification. Rather these organisations represent the way that people across local communities work alongside family members to find ways of seeking collective solutions to individual and family problems.

Evidence suggests that Caribbean welfare based community organisations and work around 'community parenting' are not new phenomena, and across the Caribbean Diaspora they have continued to work alongside (and not instead of) the family in caring and parenting of community members. Until the mid 1980s in the U.K., for example, many of the welfare community organisations that existed in the Caribbean community were completely self-financed and not formally recognised by statutory agencies. Gender divisions continue to operate in Caribbean community organisations and this is not often remarked upon in analysis. Caribbean men's participation is far less numerically compared with Caribbean women, yet they hold key management posts in these organisations. It is the women who carry out the bulk of caring work and responsibilities in these organisations. In many ways their roles in the organisation mirror their family life, hence the terms 'community mothering'. As the studies suggest Caribbean mothers' involvement in these organisations represents concern for their own children and for children living in the wider community. In essence, through their 'community mothering', the mothers conceptualise mothering practices as an extension of, and developing out of, their collective and individual concerns for family and community.

Chapter 8
Caribbean men and the family: mothers' views on fathering

Introduction

There is a growing body of literature addressing men and the family. Yet despite the developments in this subject area, there have been a limited number of studies that focus exclusively on Caribbean men and the historical, cultural and racial contexts that shape their family experiences. To further compound matters, Caribbean mothers have for many years acknowledged and praised the support female family/kin and community members have provided in their mothering and child rearing practices, (see Clarke, 1957; Sutton and Makiesky-Barrow, 1985; Powell, 1986; Bolles, 1988; Barrow, 1996). What is less documented is the supportive role Caribbean men have played in family life. Indeed there is a dearth of literature in both the Caribbean and the U.K. concerning Caribbean men in the family (Brown et al., 1997; Reynolds, 2001b). It is almost as if black men have been written out of discourses and debates on black family life. Generally speaking the analysis of black masculine identities is restricted to the specific realms of urban youth culture, sport, music, crime and entertainment, where black masculine identities are constructed as 'hyper-masculine', 'hyper-sexual', and 'hyper-aggressive' (Mercer and Julien, 1988; Back, 1996; Alexander, 1996; Blount and Cunningham, 1996; Sewell, 1997). Notions of black men as 'carers', 'affectionate', and 'loving' (behaviour and traits usually identified with family life) do not fit into traditional models and representations of Caribbean masculine identities.

Where images of Caribbean men in the family exist in the media and policy debates, stereotypical representations prevail (for examples of this see chapter three). These do little to engage a critical understanding of Caribbean men's familial experiences. Conventional constructions of Caribbean fathers by the media and policy-makers posit them as absent or marginal from the family home, 'feckless' and financially irresponsible (see Reynolds, 1997). Not only are these men supposed to be emotionally uncommitted to their female partners, they are also said to lack concern about, or to be uninvolved in, the care and well-being of their children. In this study, however, the mothers' perceptions of the Caribbean men in their families—such as their children's fathers, their partners, their own fathers

or other male relatives—challenge these representations.[1] First, they recognise Caribbean men as being actively involved in their family lives. Second, the mothers acknowledge that irrespective of Caribbean fathers' absence or presence from the home, these men inform their mothering identities and contribute to their social realities. Third, black fathers possess power and authority in 'the family', contradicting traditional claims that posit maternal household power and authority as a central characteristic of Caribbean family life. This chapter provides an analysis of Caribbean men in family lives by documenting these mothers' claims.

The literature on Caribbean men and the family

In the U.K. the emerging literature concerning men and the family has generally focused on role shifts and changes in parenting behaviour as men adapt to the changing roles of women, fathers' socio-psychological behaviour, and the changing constructions of masculinity in the family (Lewis and O'Brien, 1988). Whilst this analysis of men and the family is welcomed as an important contribution to understanding family relationships, it must be noted that in the literature minority ethnic men, and more specifically black men, are largely absent from the debates. For example there is a lack of substantive literature investigating Caribbean fathers' family experiences. Yet, this absence of Caribbean fathering literature is not exclusively confined to the U.K. context. A study by Brown et al. (1997) in the Caribbean reported similar gaps in the literature. They set out to rectify this matter by speaking to group of fathers in Jamaica about their family experiences. Their findings suggest that the fathers desired to be part of family life but instances of economic inactivity and breakdown in relations with their children's mothers sometimes precluded their active participation. The Brown et al. study (1997) is just one of a few in the region that explore Caribbean fathering outside of traditional negative characterisations. In the U.S.A. academics and policy makers have been much more successful in analysing black men and the family (for example see, McAdoo, 1986, 1998a, 1988b, 1993; Taylor et al., 1997). However, much of their analysis is guided by problematic and pathological assumptions. So for example, the focus is very much on highlighting and understanding black men's absence from the home

1 In challenging these negative representations of Caribbean men in 'the family', it is not my intention to present black men as a homogeneous group. Vast differences exist between black men and their relationship to, and with, their families. There are instances where black men provide a negative contribution to the family (see Mama, 1993 for example). However, there are also many more instances where black men's contribution to the family is positive. Nonetheless in the discourse of black men in the family, but especially black fathers, this is very rarely seen. Thus, the central aim of this chapter is to make visible this latter group of diverse black men who make a positive contribution to the family.

and the problems they have in fulfilling family responsibilities (Staples, 1985). In addition, many studies are concerned with establishing a causal relationship between black male absenteeism from the home and wider economic factors in order to justify and rationalise their perceptions of black male absenteeism (see Wilson, 1987; Wilkie, 1997; Bowman and Forman, 1997). Wilson (1987), for example, attributes the perceived marginalisation of black men in the family to the high percentage of black female-headed households. He suggests that the alienation of black men from the labour market produced alienation from marital and familial relationships, leading inevitably to black men leaving the home or being forced out by their female partners. In a later study Wilson (1996) explores the psychological effect of unemployment on black fathers. He summarizes that when the father's role as economic provider and breadwinner erodes, and the wife/mother assumes this position, black men struggle to find alternative ways to define their masculinity and role in the family, resulting in psychological distress and self-alienation. Black women, by going out to work, cause the emasculation of black men because these men are displaced as the main provider. To survive black men must leave the family home, taking with them the greater potential earning capacity. As a consequence of fathers not being at home to supervise them, children tend to fail educationally and to fall into a life of crime and other deviant activities (see Frazier, 1948; Moynihan, 1965 and Murray, 1980).

Studies that identify diversity among black fathers—beyond the stereotypical characterizations of absent/marginal, irresponsible, young, possessing multiple children by multiple women as illustrated by Wilson's studies—are few and far between. Yet those studies that have undertaken the research reveal interesting findings that challenge conventional and stereotypical characterizations of black men and the family. John McAdoo's work (1988), for example, compares fathers from different ethnic groups in the U.S.A. who share similar socio-economic backgrounds. His conclusive findings are that black fathers are no different to fathers of other ethnic groups. Indeed, black fathers are just as actively involved in child rearing and the majority enjoy warm and loving interactions with their children and families. Roopnarine et al. (1995), researching black fathers in the Caribbean, also claims that where there is diversity in fathers' attitudes and involvement in child care, it is factors such as class, age, location, family upbringing, the relationship with wife/partner or children's mothers that primarily inform these differences.

It cannot be denied that discussions of black men and the family in the U.S.A. and Caribbean are embedded in their specific historical, cultural experiences. For example, with regards to the U.S.A. context, it is argued that specific political agendas lie behind the social constructions of black fathering. By placing blame on black women for the plight of poor urban black men, attention is diverted from the social, political, and economic factors that cause societal inequalities. Similarly, in the Caribbean it is argued that black fathering debates that focus on fathers' financial responsibility and the meaning of fathering in a matri-focal society and in relation to black masculine identities, are framed around women's specific challenge to patriarchal structures and social organisation in the region (Rheddock, 2004). Nonetheless, I draw upon these debates to understand Caribbean fathering in the U.K. because first, as I previously suggest, there is a lack of substantive literature available in the U.K. investigating black fathering apart from the media and commonsense views. Secondly, despite the cultural specificity of black fathering to the U.S.A. and Caribbean, there have been many attempts to directly transplant debates to the U.K. For example, black and white based newspaper articles alike employ the '*babyfather* syndrome'[2] as a rationale for high rates of female-headed households and the perceived lack of male involvement in Caribbean families (see Edwards and Song, 1996; Reynolds, 1997). The term *babyfather* is a popular colloquial term in the Caribbean used by women to describe the men with whom they have children outside of wedlock.

The public discourse versus private experiences:
The mothers' perceptions of Caribbean men and the family

In my study the mothers' perception of Caribbean men in their family certainly support the findings by McAdoo (1988) and Roopnarine et al. (1995) that suggest black men are important and active participants in family life. However, it is important to highlight that whilst the mothers generally expressed positive views about the particular men in their own family, when speaking about Caribbean men generally, and to whom they were not related, they expressed negative views. To understand these divergent views expressed by the mothers concerning the public and private perceptions of Caribbean men and the family, it is important to identify the underlying factors that inform this difference. The

2 Both the black and the white press have appropriated this term (also *babymother*) to document black
 male-female relationships and the high incidence of single-mother households amongst African-Caribbean
 families. This notion of the 'babyfather' was further popularized in Patrick Augustus' bestseller Babyfather
 (1994). Over the years, however, the terms *babyfather* and *babymother* have increasingly been criticised
 by members of the black community for the negative way in which it stereotypes black familial relations
 and the way they resonate with slave images which confine black people to 'breeders'.

mothers' negative views of Caribbean men generally was largely influenced by the public discourse that presents black fathers' involvement in the family as marginal or absent. To some extent the negative public images of black fathering have filtered into the black mothers' perceptions of Caribbean fathers in family life at a general level. It is important, therefore, to document these debates (informed by the public discourse), before I go onto assess the mothers' discussions (informed by private experiences), of Caribbean men in their specific families:

> What I feel is that with the black man, if he can't get a job he's feeling frustrated because of how the system's treating him. He's taking it out on you [black woman] because the system is not giving him a chance to be a provider or whatever. The ones that are decent are either married, gay or into white women, so that's one of the reasons a lot of black women are on their own. They [black men] want the children but they don't want the responsibility that comes with it.
>
> [Nizinga, age 31, lone-mother, second generation]

> You see a black couple now and all you see is the children, no ring, no house unless she went out and got it herself. Anyone remotely decent, well they're snapped up long time ago. So if you're a single black woman much less a single-mother, well forget it. As for the rest, let me see who we're left with? Those who don't know the meaning of work, those on drugs, the ones in prison, men who have children scattered all over the place.
>
> [Maxine, age 29, lone-mother, second generation]

These comments by Nizinga and Maxine, which identify the bulk of black men as 'worthless', unemployed, in prison, on drugs, or with multiple children by multiple partners are reminiscent of those debates first propagated by policy-makers in the U.S.A. (such as Frazier, Moynihan, Wilson and Murray) in their attempts to establish a causal relationship between the absence of black men in the family and the rise of the black underclass in urban America. Thus, it is significant that the mothers should draw upon these debates in their general perceptions of black men in black family life. The fact that these U.S.A. policy models of black fathering emerge in the mothers' narratives is attributed to the influence of both the white and black media (especially newspapers). Evidence suggests that the media has appropriated these U.S.A. debates, to negatively stereotype black fathers in the U.K. For example newspaper reports by the *Voice*,

a black owned newspaper, which is targeted at the black community in U.K. and the *Guardian* and *Sunday Express*, two mainstream newspapers suggest of black men that:

> For far too long black men have failed to support women and our children, a reality that all black men and women must seriously reflect upon.
> (*Voice*, 24 August 1993:6).

and

> If today's black woman has brought credit to her race, the black man is a different story. Not only does he have a tendency to opt out when the patter of tiny feet comes along, he is over represented in prisons and the dole queue. (*Guardian*, 21 March 1995, section 9:3).

also

> The "Linford Christie syndrome" of one-parent families is now disturbingly ingrained in black society. Young black males have adopted societal norms and are a lot more care-free in their responsibilities.
> (*Sunday Express*, 13 August 1995:2).

These negative characterizations of black fathers construct them as a homogeneous group. The individualistic nature of these men and their familial relations are denied. Yet when the mothers' discussions turn to their private experiences and the actual men in their families quite a different image of black fathers emerges to that of the generalised public discussion of black men. Generally, the mothers in my study spoke of their own male familial members and the children's fathers with warm affection, and identified them as positive influences in their lives. Even Nizinga whom I earlier quoted as speaking so disparagingly about black men in general, presented quite a contrasting view when discussing her relationship with her own father and her daughter's father, who does not live in the family home but nonetheless assumes an active participant child care role:

> I'm the apple of my dad's eye. When I was pregnant with my daughter, it was my dad who was sort of fussing over me the most and I suppose Sean [daughter's father] dotes on her too, he does his bit.

And later on in discussions Nizinga confirms this active participant role of her daughter's father:

He buys her clothes. If I say to him she needs this, then he will buy it. I'm quite happy with him in that respect, she knows who her dad is, he takes her out places and he buys her clothes, he helps out. This summer he's taking her back home with him to Jamaica so she can spend time with his family there.

[Nizinga, age 31, lone-mother, second generation]

The negative viewpoints concerning black men expressed by Nizinga in an earlier quote is not evident in defining her personal relations. Her comments above re-affirm the argument that the mothers' own experiences in relation to Caribbean fathers often contradict the public discourse.

Caribbean men as active participants in family lives

There are many examples in the data of the mothers' recognition of the active role black fathers assume in 'the family' and child care. The four primary roles black fathers' assume in 'the family' involve: (1) economic provision; (2) child care; (3) guidance and advice; and (4) protection and security. Of course not all the Caribbean fathers' in the study perform each of these roles. Also the level of their participation in the family varies according to each individual circumstance. This supports Anne Roschelle's (1997) claim that despite there existing significant gender difference between men and women involving child care provision (women devote considerably more hours to this compared with men), there appears to be no significant ethnic difference between black and white fathers concerning the amount of child care they provide. Overall, the amount of time fathers give to child care has increased in the last ten years for both black and white men. The increased activity and participation in the family by men is seen by some commentators as representative of a new movement by all men, from all ethnic and racial groupings, towards 'greater psychological involvement in family life', (Taylor et al., 1997: 248). As a result of great insecurity in work, men of all ethnic groups are said to be placing increasing emphasis on family rather than work (ibid.). Ambiguity and confusion shrouds these men's attempts to balance and reconcile greater involvement in home life and child care with that of traditional normative constructions of father as 'breadwinner', workers, with non-involvement in child care (Furstenburg, 1988; Reynolds et al., 2003). Since the late 1980s the changing role of men in the family as they attempt to establish greater work-home life balance has been taken up and championed by the mass media as 'The New Man' rhetoric.

The concept of the 'The New Man' has been criticised elsewhere as little more than a media gimmick (Chapman, 1988). The idea that activity and involvement by black fathers in the home is representative of a 'The New Man' is also problematic for a number of other reasons. That fathers, as 'The New Man' desire and actively choose to place less emphasis on work in favour of home life, denotes white, male middle-class privilege and elitism (Taylor, 1997). For the vast majority of Caribbean fathers in the U.K. this privileged power position in which 'choice' arises does not exist because of their subordinate racial status. Furthermore, black fathers involvement in family life is not a recent phenomenon, caused by changing attitudes of fathers' role in the home. Rather as the data shows this involvement has always existed.

For example, as a result of the difficulties first generation mothers encountered in combining child care and full-time employment during early post-war migration to the U.K., as discussed in chapter six, first generation Caribbean mothers depended very much on their husbands to share in child care and other domestic activities:

> With my eldest boys, I worked nights and I would rush home to get their breakfast ready for them whilst my husband got ready for work. When [husband] came home in the afternoon we would eat. I would then leave for work and he would look after them until the next morning.
>
> [Enid, age 68, married, first generation]

Other male members of the family such as uncles, grandfather and brothers, also played an active role in child care during this period:

> My earliest memory was living in Wood Lands. My grandfather came to live with us for a while. I remember he used to look after me, because my mum and dad were working. Mum at nights and my dad late. My grandad used to have me during the day. I remember him feeding me soft-boiled eggs, and he taught me how to ride a tricycle. I just remember that he was always around, my being very spoilt by him and this feeling of safety.
>
> [Jamilla, age 25, lone-mother, second generation]

A first generation mother, Dolly, also remembers the influence her brother had in her family life when she first migrated to the U.K. with her young family

He helped me a lot when I first came to this country. He was my only relative in Britain at the time. He used to take the children and look after them when they was small [Dolly, age 76, married, first generation]

Similarly, another first generation mother, Felicity, reflects:

When they were babies, I was very sick. The doctors couldn't find out what was causing the illness and I would have go into hospital for weeks at a time while they did tests and to convalesce. Daniel [husband] took over the parenting and organised everything for them so he could work, look after them and visit me at the hospital. I know my mum wanted to come over [from the Caribbean] and help out with the children but he flat out refused, he kept saying 'no way, they're my children, so why should I hand them over to someone else to care for them when I'm here and can do it' [sic]

[Felicity, age 54, married, first generation]

Today, Caribbean men are portrayed as just as active in family life and child care as in the mother's accounts of earlier years. These men assume four key roles in the home, in their position as fathers. These are: economic provision; child care; guidance and advice; and protection and security.

Economic Provision

Economic provision has long been recognised as an important fathering function central to fathering identities (Lewis and O'Brien, 1988). This function is regarded as equally important for black fathering identities (Taylor and Johnson, 1997). The mothers claim that whilst the men in their lives believed that it was essential they contributed towards family and household expenses, they also expected the mothers to shoulder some of this economic responsibility for family income:

Both of our mothers worked, so we kind of assumed that I would do the same thing as none of us had any experience of doing things differently. I know my ex-husband just assumed I would return to work after maternity leave. He never asked me 'are you going back to work', but it was just 'when are you going back to work?' [sic]

[Tanya, age 40, lone-mother, second generation]

Both our mothers were very active outside the home. My mother was a headmistress, she's retired now but she was always very busy back home [Dominica] and my husband's mum used to have a cake shop, so she was there selling things like bread and cakes they'd bake on the premises, so he grew up with that. So he was never one to say to me, 'you're my wife, a mother to my children, I expect you to stay home and do the housewife thing', it just never occurred to him to say that.

[Anita, age 43, married, first generation]

The accounts by Tanya and Anita convey the implicit, almost taken for granted, expectation many Caribbean men appear to possess with regards to their wife/partner economically contributing to the family income. This expectation of women's role in 'the family', shared by Tanya's ex-partner/son's father derives from a combination of historical, cultural, and economic factors. Caribbean women have a tradition as workers both in the U.K. and across the Caribbean, that is determined by factors such as maternal status, class factors, urban or rural living. In the Caribbean a small minority of black affluent middle-class married mothers stayed at home as full-time carers. However, the vast majority of black mothers engaged in some form of paid labour, (Senior, 1991). Similarly, in the U.K. this tradition of Caribbean women as workers ensures that many second and third generation Caribbean men have been raised seeing their mothers in full time employment. As a result, they encounter less ambiguous expectations in terms of the mother's dual domestic and economic role in the family. In contrast evidence suggests that today for many white middle-class fathers their mothers did not contribute financially to the family when they were growing up, and so this was not part of their childhood experiences (Reynolds et al., 2003). Increasingly in today's society more white mothers are engaged in full-time employment and provide a greater share of economic provision to the family. In these circumstances it could be argued that concerns about interweaving work and family pose greater adjustments for white males than Caribbean men (Duncan and Edwards, 1998).

The experience of Caribbean women (including mothers) as workers is deeply ingrained in Caribbean identities through economic necessity as well as cultural expectations. In chapter six, I argued that the higher rates of unemployment among young Caribbean men and the fact that both Caribbean men and women are over represented in low security and low pay employment (Bhavnani, 1994; CRE, 1997; Madood, 1997) means that many Caribbean

mothers cannot realistically expect their male partners to act as sole economic provider. In comparing first generation mothers' accounts of raising a family with young children during the late 1950s with second and third generation mothers' experiences today, I found the lack of Caribbean fathers acting as the sole economic provider to 'the family' is a relatively unchanged phenomena. The following accounts by first and third generation mothers reinforce this:

> I had to go to work because there was no question of me staying at home because he wasn't earning enough.
>
> [Pearl, age 61, married, first generation]

> At one stage neither of us could find work and we didn't feel right just living hand to mouth on the dole. We decided that because I was a qualified hairdresser and being a woman, it would be easier for me to find work. [Denise, age 22, living with partner, third generation]

In Denise's case her partner, Michael, is currently unemployed and they depend upon Denise's salary as a hairdresser for family income. Denise's experiences represent a growing trend in younger third generation two-parent families. Higher rates of unemployment for black men as a result of racial inequalities in access to employment means that in some households Caribbean fathers play a limited role as economic provider. Consequently, as Denise's and Michael's experiences suggest, black couples have had to re-negotiate a fathering identity which moves away from traditional constructions of fathers as economic providers towards one where their contribution to the family is still highly valued:

> We couldn't afford nursery on just my wages. During the day Michael looks after [son], he takes care of everything so that when I get home I just really have to give him his bath and put him to bed. I don't know how I would cope if it wasn't for him, it would be a real struggle.
>
> [Denise, age 22, living with partner, third generation]

As the above quotation indicates, far from absenting himself from the home as a result of unemployment and his inability to contribute to the household financially, Denise's partner has built additional functions and areas of responsibilities into his fathering identity. Moreover, Denise perceives his

contribution to the family to be as important as her mothering. There appears to be an acceptance by black mothers that due to present economic conditions and racial inequalities in employment, the fathers of their children will in all likelihood encounter periods of economic inactivity. Therefore, as Denise's case suggests, the re-negotiation of black fathering identities allows for fathers to remain at home, and undertake some aspects of child care, whilst the mother acts as the primary/sole breadwinner.

The position of such Caribbean fathers directly opposes the claims that suggest that the impact of economic marginality for black fathers results in absence and marginality from the home and family, and diminished fathering responsibilities. As Denise's comments about her boyfriend, Michael, clearly illustrates, the inability to act as primary economic provider in the family does not make him any less of a father or less responsible and committed to his family or children. In order to move away from constructions that pathologise Caribbean fathers who are unemployed or on low-incomes, and which minimise their importance to the Caribbean family, an analysis needs to look beyond this narrow identification of fathering as economic provider, and investigate other valuable functions and roles they perform in the family. The mothers highlighted other activities and responsibilities that Caribbean fathers undertake, which are just as vital to the family, child care, guidance and advice, and protection and security.

Child care

Guidance and advice
The physical, emotional and psychological care of the child(ren) are identified by the mothers as a key responsibility undertaken by their children's fathers. I should stress that this is purely in a supportive capacity, as primary responsibility for child care remains with these women. Furthermore, the degree to which child care occurs among the men varies according to each individual family's circumstance. For example, Lydia claims that the child care her children's father provides is virtually negligible. However, fathers, who are actively involved in child care, can deputise for mothers as primary carer when these women are away from the home. They can also set aside specific time to spend with their children and carrying out activities with them. They can be involved in everyday matters relevant to their children's welfare or, where absent from the family, home kept informed of these.

In all child care tasks except one, the mothers in this study describe the fathers performing tasks parallel to those performed by white fathers in other studies (see Lewis and O'Brien, 1988). The one exception is guidance and advice. Guiding children through the everyday trials and tribulations of life as they learn to become adults is something with which parents of all ethnic and class groups have to contend. However, as parents rearing black children in the U.K. there is a racialised element to this guidance and advice, precipitated by existing systems of racial inequalities and systems of injustice. In chapter five I highlighted how important mothering functions involve developing strategies to prepare their children to resist and confront racism. Caribbean fathers are also actively involved in this too:

> We know our children are seen as failures before they've entered the world, so it's our job to make sure they don't end up fulfilling these expectations. He [husband] pushes them more than I do, motivating them to try harder, to try and be the best, he'll sit down and talk to them about why it is important for them—he says if he doesn't sit down with them and make them understand about the world then no-one else is going to bother with them. [Anita, age 43, married, first generation]

Anita's comments are specific to her husband and the way in which he perceives guidance and advice to his children as his most important fathering responsibility. Many of the mothers' views of the men in their families support Anita's claims. Whether it is their husband/partner, children's fathers, own father, brother, uncle, or even a close male family friend, these mothers recognise the important role Caribbean men possess in the family in terms of assisting them with guidance and advice around issues of 'race', racism and other systems of inequalities the children will encounter. This is especially so for their male children. As a result of the particular concerns facing young Caribbean males in the wider public domain—such as educational underachievement, school exclusion, police harassment and incarceration, racial violence and black on black male violence—there has been a particular concern in the parenting of an adolescent son. Providing them with the necessary guidance and advice to resist systems of racism and inequalities is seen as a central fathering as well as mothering role.

In addition to the role Caribbean men perform in the family, there is a need for them to provide guidance and advice in local black communities. In fact, this issue

of positive black male role models for black male youths has dominated community concerns[3] (see McCalla, 2003). Discussions have focused on identifying who is best placed to act as role models in home and community? Should it be fathers, male family members, black men in the wider community, or could black women successfully perform what is seen an exclusive task of black men? The mothers agree on the need for role models. However, opinions vary on the issue of who is best suited for this position. Two mothers, Michele and Maxine, both lone-mothers, to some extent buy into the popular discourse concerning the negative impact of black male marginality in the family, and also the viewpoint expressed by Spencer Holland (in Sewell, 1997) that lone-mother households disadvantage young black men:

> At the end of the day it would be nice if any child could grow up in a two tier family structure with mum and dad because you get both sides, but it would be nice to have a man around more. If I had a son how would I teach him to be a man, how am I going to tell him what to feel when his voice breaks and how he feels because of all the hormonal changes, and all that grief he's going to have to face as he gets older. Boys need male influences in the home, so that they can do things together and talk about things I don't understand as a woman.
>
> [Michele, age 28, lone-mother, second generation]

> Sometimes it's important to have a man around for a son, someone to look up to who's nearer to them, rather than just a mum. Yeh, they can see that a mum can do everything without a man around, but it might make them feel redundant themselves, like what's the point of being here. Having a man around gives them a different perspective.
>
> [Maxine, age 29, lone-mother, second generation]

Michelle's and Maxine's comments illustrate the mothers' desire for positive male figures in male children's home lives, and they question the absence of this in relation to the welfare of black male children. A third mother, Tanya in assessing her son's relationship with his father (her ex-husband) suggests that whilst fathers are needed as the positive male role-models in their son's lives, they do not necessarily have to be living in the family home:

3 The rapid expansion of Black Mentoring Schemes, where black professionals are recruited to act as role-models for black children in black areas, is a product of this concern.

One thing I can say, is that he's [ex-husband] a good father. Jordan [son] idolises him. He has been a positive influence in his life. Jordan talks to him much more than me about what's happening in his life. For example, the other day he and his best friend had an argument of some sort. I could clearly see that he was upset but he wasn't responding to me. When he came back from his dad at the weekend, he was much brighter, he said they had a long talk and that dad helped him sort it out. So I'm glad that he's around and makes himself available, if only for my son's sake.

[Tanya, age 40, lone- mother, second generation]

Similarly, Anita, a married mother with two teenage sons, comments that positive male figures in sons' lives need not be exclusive to fathers but they can consist of other male family or non-family members:

Because of the closeness I see developing between them [her husband and her sons] now, I feel that mostly for boys, well all children really, but boys especially, really do need positive male figures in their lives, men who can act as role-models. I suppose it does not have to be their fathers really because if you're on your own then that's not always possible, he might be no-good too, but they certainly need responsible adult male figures who they can turn too, who'll guide them in the right direction.

[Anita, age 43, married, first generation]

Paradoxically, these mothers (Michelle, Maxine, Tanya and Anita) by asserting the need for positive male role-models in black boys' lives—whether it be the father who is in the home, the father who is outside of the home, or another black male family or non-family member who is identified as the positive male influence—are undermining their own (and other black mothers) roles as mothers and the positive contribution they make to their children's lives. Other mothers shared in the viewpoint that children's role-models do not necessarily have to be immediate (nuclear) family members. Instead other male and female kin and community members can adequately perform this task:

T.R.: What's your definition of a good role model?
Lydia: Someone who has my son's best interest at heart, who he is close to, you know has a good relationship with and that person is leading a good, clean life. I don't care if it's a man or a woman, a woman can be just as

good a role-model for a boy as a man. The most important thing is that they have his best interests at heart and [son] look up to them and says 'yeh I want to be like that person and hold those same values.' Someone who encourages him towards achieving good things in life.

[Lydia, age 28, lone-mother, second generation]

What I think is that children should have a role model, not necessarily a father but a role-model as a man or woman. Good role models can be anybody, an uncle, good friend. I remember the children [her great grandchildren] saying to me that when they were asked, 'who they wanted to be most like when they grow up', they would say me and I wasn't their parent. I was admired and I was a role model for them.

[Dolly, age 76, married, first generation]

Lydia and Dolly are two mothers from different generations. However, they share the belief that any person can act as a role model for male and female children, irrespective of the gender of the role model. Whatever the opinion held, it is clear this pre-occupation by mothers regarding the need for male role models, especially in relation to sons and male youth, is in direct response to the negative images of black men that are dominant in this society (which has a greater impact on second and third generation mothers). Role-models, whether found in or outside the home or performed by males or females, act to challenge the dominant discourses about black men through creating positive self-images of black identities that children can learn from and aspire to.

Protection and Security
In the mothers' narratives fathers as a source of protection and security for the home and family constitute another element of Caribbean fathering identity. This involves protecting children from external threats and dangers and offering them security against such dangers. In terms of the protection and security provided to sons this primarily involves keeping them safe from physical violence, racially motivated or otherwise. Protection for daughters centres very much on her sexuality, whether it be protecting girls against sexual violence or securing and controlling (and thus safeguarding) her sexual virtue. In discussions about their own childhood and relations between their daughters and fathers today, the mothers identify the way that female sexuality underpins father-daughter relations, either explicitly or implicitly.

Anita: I've always felt closer to my dad than my mum. The only time I can remember coming into any real conflict with him when I was about 17. I met this young man at a church concert, when all of the churches in the district had a meeting. We started to meet outside of the church. I didn't want to be sneaking around or for my parents to hear from someone else that we we're out together. So anyway, after about a month I brought him up to the house to introduce him to the family. My mum was pleasant enough to him but dad barely acknowledged him that whole evening [...] For about a couple of month afterwards, dad was really cold towards me. Like that closeness had disappeared overnight ... it took about a couple of years to get back on track really.

T.R.: What do you think that was about?

Anita: Do you know, I've never sat down and asked him but I'm sure having another man in my life, outside of my brothers and him, which meant something to me had a lot to do with his coldness towards me. It was the shock. He had to come to terms with me no longer being his little girl. Also when I told him [husband] and me was getting married, he wouldn't come to the phone and speak to me for months. That was a strange experience and again I think it was to do with finally accepting that I was no longer his, even though I was a grown woman, when I got married. [Anita, age 43, married, first generation]

Sue Sharpe identifies issues of 'possessiveness, a desire to preserve her innocence, the implicit threat presented by male competition for their daughter's affection,' in her study of father-daughter relationships (1994: 85). Her analysis could help to explain Anita's father response to her male partners. Similar research by Valerie Walkerdine (1997) of father-daughter relationships touches on this issue.

Other mothers also reflect on father-daughter relationships in the families. For example, Zora, a second generation mother comments on her partners' response to his two daughters arriving at adolescence:

He's already really possessive towards them now, so I dread to think what he's going to be like when they get older and start wanting boyfriends. As far as he's concerned, they're his little girls and that's how it's going to stay, he's already said they're not allowed to have boyfriends until they're 25 [laughing]. It's a bit of a touchy subject, so I bring it up sometimes

just to wind him up because I know he'll gets annoyed and starts huffing
and puffing about the place [laughing].

[Zora, age 26, living with partner, second generation]

Although Zora talks about her partner's response to any mention of his
daughters' future sexuality in a quite light-hearted way, it is interesting to note
that she is aware that her partner perceives his daughters as his 'possessions',
even at their very young age. It could be argued that traditional constructions
of patriarchal relations, which incorporate issues of male ownership of the
female, are informing this relationship (Walby, 1990; Walkerdine, 1997). This
is significant in the context of fathering and the Caribbean family because typical
representations of Caribbean family forms posit them as female-centred or
'matriarchal', with Caribbean men very much on the periphery and possessing
little power in black family life.

Power and authority of Caribbean men in the family

In the literature on Caribbean families, the concept 'matriarchal' suggests
maternal female power and authority. It is claimed that the matriarchal family
structure has resulted in the emasculation of the black man and in his marginal
familial role (see Wallace, 1978; Davis, 1981; Staples, 1985). However, the
structurally powerless position, that Caribbean mothers occupy in society,
ensures that the notion of the 'black matriarch' is a problematic construction.
Hill-Collins (1991) suggests that this concept also acts as a controlling image
for dominant groups in society, where black mothers and their family forms are
rendered deviant. Nonetheless, some black feminist theorists have embraced this
term to celebrate their mothers (Ladner and Ladner, 1987; Bell-Scott, 1988).
The mothers in the study do so also. Ironically, while celebrating this traditional
image of Caribbean mothers as strong and powerful when describing their own
mothers, it is their fathers who emerge as possessing the greatest source of power
and authority in the mothers' accounts. The following comment by Jamilla, a
lone-mother, illustrates this:

She's [mother] the backbone of the family, she's the workhorse in the
family, she's knows what's what. If anything needs asking or doing, ask
mummy. I think my dad is there as her support, her backup.

She then goes onto reflect:

Having said that about my mum, growing up my dad was the disciplinarian in the family, I remember if I was getting into trouble, then he would punish me. It didn't reach the stage where he would hit me, all he would do is look at me and I would crumble. I can't recall much of it but I think what used to happen is that she [mother] would say 'go to your father' and then that would be it for me, I would be wetting myself. It was my dad that I was scared of, his physical presence.

She also remembers:

My mum would sit down and work out what bills were to be paid where, but all the major decisions and big things like moving house, buying a new car was joint. Well daddy had more input really.

[Jamilla, age 25, lone-mother, second generation]

Jamilla's thoughts are crucial in that they effectively sum up the contradictions and ambiguity in power relations between Caribbean mothers and fathers. The construct of the 'black matriarch', as centred to power relations in the Caribbean family, provides an inadequate framework to explore these contradiction and ambiguity. Jamilla acknowledges her mother as the 'workhorse' in the family and her father as the 'backup' in specific day-to-day domestic activities. Here, her mother is dominant and her father provides a purely supportive role. This mirrors traditional gender divisions in the home, where the father or male figure supports with child care and domestic duties but is not the primary figure. For other (perceived) major household issues, such as discipline, purchases of expensive household goods, however, Jamilla talks about power and authority remaining with her father. Nevertheless, Jamilla conflates her mother's role with the notion of 'black matriarchy', whilst overlooking her father's equally dominant position, and his physical presence. This raises questions about why this occurs in constructions of black male-female relationships? One answer might be that because the 'black matriarch' is widely recognised as the quintessential feature of black families, there is limited detailed interrogation and acknowledgement of diverse family patterns. In the analysis of the mothers' family experiences in this study it was noticeable that in most two-parent families, traditional gendered power relations inform household relations. In the home Caribbean fathers enjoy a dominant status even if they hold little economic power. Furthermore, their dominant position and authority in the family is not dependent on them acting

as the sole or primary economic provider (i.e. the breadwinner) in the family. Two mothers remembering family life growing up in their homes comment:

> They're [parents] old-fashioned, set in their ways even. My mother was very traditional, she revolved everything around my father and how his day was organised. When we came home from school, we had to wait for my father to come before we could have our dinner and he was always the first to have his food served, he was always served first before we can eat. My mother still believes the man should be put first today. When my first marriage broke up, she thinks it was because I didn't respect him enough. Even now with [second husband], she says that I need to respect him better.
>
> [Beverley, age 48, married, first generation]

> Definitely we had greater respect for dad than mum. He wasn't really there [at home] that much and when he was he was always very, I suppose very aloof would be the word. I mean he was there and everything and he would talk to us about things but he wasn't really there, if you get what I mean? He was a man who came and went, so he was part of the family but not really part of it, if you understand? When he was at home, everything was about him. We tiptoed around him and would be whispering to each other, to not disturb him if he was at home sleeping for example. And if it was anything major, like to go on a school trip, mum would always ask him and then she would tell us his decision.
>
> [Angela, age 27, married, second generation]

These mothers' reflections concerning black men's role and status in the family offers a direct contradiction between black family ideology (with its emphasis on matriarchal families) and social reality. Their recollections are also indicative of the fact that, disempowered in wider society, home is often the place black fathers can feel they have a sense of power and authority, and that they exercise this over their wives and children, despite the fact that the mothers also work and have a certain degree of financial autonomy (McAdoo, 1988; hooks, 1997). Whilst there would appear to be greater equity today between the second and third generation men and women in the home in terms of decision-making, the persistence of inequalities in the gendered division of labour in homes ensures that gendered power relations still remain.

Absent fathers in family lives

Despite my attempts in the analysis to re-insert black fathers into debates of black family life by focusing on Caribbean men's authority, power, and presence in the home, there is no avoiding the fact that a significant proportion of Caribbean families in the U.K. are female-centred (matri-focal). Recent figures indicate that 51% of Caribbean families are female-headed households (Modood, 1997)[4]. As a result of the high number of female headed households, and perceived male absence, the *babyfather* syndrome dominates characterisation of 'absent fathers' and constitutes a key representation of Caribbean masculinised identities. The *babyfather* syndrome champions the idea that black men have multiple children by multiple partners, without pause for care and responsibility of the child. Although attempts have been made to challenge this characterisation (see Edwards and Song, 1996; Reynolds, 1997), its commonsense appeal remains.

A substantial proportion of lone-mothers in my study (about two-thirds of them) did state that their ex-partners/children's fathers have additional children from subsequent relationships. However, most of these men exist at any one time in stable, conjugal relationships with their partner. In addition, despite this 'absence' it clear from these mothers' accounts, that their children's fathers still actively participate in child rearing and child care, and this shaped these women's mothering experiences:

> The children's father helps out. Even if you're single, the father can still be around, so they can help with the upbringing if they want to.
> [Maxine, age 29, lone-mother: second generation]

Maxine's comments are indicative of the way fathers' absence from the home does not automatically exclude him from child care and family life. In can be argued that 'absent' fathers in fact assume 'absent presence' in family life. They are absent in terms of no longer living in the households, but they are still present and very active in their children and mothers' lives. The majority of lone-mothers I spoke to had regular contact with their children's fathers. Only two mothers in the study have very limited contact with these men. Therefore, the majority of these 'absent' fathers are active in child rearing. They would either visit the family home or arrange to have the children spend time with them, primarily at weekends and during school holidays. Many of the activities and responsibilities

4 This figure also includes mothers who are living with male partners in a non-marital conjugal relationship. It is estimated that 32% of single-parent families are the sole adults in a household (Owen, 1998).

that these mothers describe as performed by these 'absent fathers' were identical to those where the father lives in the family home. Describing the relationship with 'absent' fathers and their involvement in child care, the following mothers note:

> Since I split up with him, yeh, he has become far more interested in our daughter. Before I left him, I was always doing the buying, doing the providing. Now he helps out. If he's not doing anything in particular he will take her overnight, and she stays with him some weekends. He buys her clothes—if I say to him, she needs this, then he will buy it. I'm quite happy with him in that respect. She knows who her dad is, he takes her out places and he buys her clothes, he helps out.
>
> [Nizinga, age 31, lone-mother, second generation]

> He's a good father, I can't really fault him on that. He has him over to stay every other weekend and he'll plan for them to do things together. Also he'll phone me to discuss how he's getting on at school and we'll talk about his end of term reports. He's good like that. He gives him money to buy clothes and those computer games. It's nice because it takes the pressure off me to provide everything for him. I'm glad he's there for [his son], that he's a responsible father.
>
> [Tanya, age 40, lone-mother, second generation]

What is so interesting about Nizinga's and Tanya's accounts is that they each identify these men as playing a more active role in child care and child rearing after the relationship with their children's fathers broke down and these men left the family home. Prior to separation, the men spent less time with their children. Neale and Smart (1997) and Smart and Neale (1997) in their studies of divorced fathers active participation in child care report similar findings. One could therefore argue that fathers' presence in the home does not guarantee greater time devoted to child care. In the same way 'absent' fathers can be said to assume a 'absent presence' in the family, fathers who live in the family household home but are away from it for long periods of time, can be said to assume a 'present absence'. Camille, a professional middle-class mother, recognises this. She comments:

Richard [husband] does not get to spend as much time as he would like with the children because he's away working. Well, we both are really. But for [my husband] because of the short periods of time he does get to spend with them, it's really intense and he gets frustrated with them quickly because he tries to cram a lot of things into a short space of time. This makes them [children] miserable and tired. The best time for us is the summer break when [our son] is home from [boarding] school and we're much more relaxed about doing things because we have more time—but the main thing is that the children know he is there for them even if he's not physically able to be around all the time.

[Camille, age 51, married, first generation mother]

Similarly, Diane Reay (1998) found that fathers, who are present in the home actually do very little child care and domestic tasks. Yet, it is ironic that whilst the latter type of fathering is celebrated as normative, the former is vilified.

As well as 'absent' fathers' active participation in their children's lives some of the mothers identified them as important members of the family:

Sometimes I want to rely more on [her daughter's father]—alright yeh, things didn't work out between us and he left. He's not here all the time but I still see him as family, as part of my family.

[Jamilla, age 25, lone-mother, second generation]

Melanie: He [son's father] doesn't want [our son] growing up and calling another man daddy, so he's always going to be around.
T.R.: And is that ok with you?
Melanie: Well he is his dad, so there's not much I can do to stop him. It's he's like family really, you're stuck with them. When you have a child with the man, if he decides he's going to be one of those dads that stick around then you're stuck with him too [laughing].
T.R.: Do you see your son's father as part of your family?
Melanie: Well I'm stuck with him in my life, the same like a brother or sister because you know they're there, they're popping up in your life, always there. So because of that he's family in a way because I can't get rid of him [laughing].

[Melanie, age 29, lone-mother, second generation]

To Jamilla and Melanie, both of their children's 'absent' fathers are perceived as family. Relatives of these fathers, such as parents, brothers and sisters, uncles and aunts, also provide support for these single-mothers reinforcing claims that these 'absent' men and their kinship networks constitute family. These 'absent' fathers also have a very real effect on the way the women experience mothering, since, the lone-mothers operate around the notion of men in their lives even if they are absent. They also question their position as 'lone-mothers' in relation to the normative yardstick of a 'present' father and husband. This is evident in the way they discuss their children's well-being in relation to the perceived benefits of a father's 'normative presence':

> Sometimes I wonder whether she's [my daughter] losing out, whether I'm enough. Sometimes when her dad comes round, even my dad or my brother, she's really clingy to them and I wonder whether she's bored with me, the female and if she's missing that male influence in her life, well [her father] is an influence in her life but I suppose I'm talking about that permanent influence, a father who is always here for her all the time.
>
> [Jamilla, age 25, single-mother, second generation]

Jamilla's discussion on the necessity of a male presence—and the earlier accounts by the second-generation single-mothers who expressed the need for male role-models in their children's (but especially their sons') lives—reinforces a normative 'yearning' for 'traditional' family forms, rather than recognising the value of their lived 'alternative family' forms. All of these factors negate the marginal influence 'absent' fathers are said to have on family life and child care, and which is usually not discussed in the discourse of lone-motherhood.

Conclusion

The mothers' analyses of men in their family relationships indicate that Caribbean fathers are active participants in mothering and child care. Traditional representations of Caribbean families fail to acknowledge this. In this chapter, from the mothers' accounts, I have identified four key functions performed by black men in the family. The first, economic provision is largely perceived as a 'traditional' fathering role. The others—child care, guidance and advice and protection and security—constitute a re-negotiation of fathering identities by these men to encompass other roles. Thus, those fathers who are unemployed and therefore unable to financially contribute to their families can

still undertake a significant role in family lives. Many of the fathers who live outside the home assume an 'absent present' position, rather than disappearing from the family household altogether. As in the case of the 'absent father' misrepresentation, it is also too simplistic to say that Caribbean family forms are matriarchal. If we take this concept to mean female economic independence and authority in the home, there are indeed examples where this does exist. Nevertheless, evidence also suggests that even in instances where mothers engage in paid work and they are financially independent, black fathers assume power and authority in the household. This factor is often overlooked in the analysis of Caribbean mothering and family relationships.

Chapter 9

Conclusion

In the past two decades the focus of mothers and mothering has assumed a central place in family policy debates. Generally speaking two areas have dominated concerns around meanings and identities of mothering.

One area has been mothers' relationship to, and participation in, the labour market. The National Childcare Strategy, the European Union's Working Time Directive, policy changes in parental leave and maternity benefits, as well as greater emphasis on flexible and part-time working, reflect the range of policies introduced to encourage mothers into the work place (Dex and Smith, 2001). Yet evidence suggests that successive government failures to meet the basic need of adequate and affordable child care provision for mothers with young children mean that there is a still good deal of disagreement over what it means to be a mother, or, indeed whether mothers should go out to work or remain at home as full-time carers.

A second area of policy focus has been the rise in numbers of lone-mothers in the U.K. and the implications for welfare policy provision, children and family stability. New policy legislation, such as the 'New Deal for Lone-Parents'—introduced as a compulsory programme in 2002—emerged to address the perceived welfare dependency of lone-parents (primarily lone-mothers). A range of programmes were developed around retraining, skills learning, work experience and child care to encourage lone-parents back into paid labour market activity and away from state welfare provision (DfEE, 1998). This legislation followed on from the Child Support Act 1991 which sought to return the bulk of financial responsibility for child maintenance to 'absent fathers' and decrease state input (Barlow et al., 2002). In attempting to re-insert fathers back into the family (albeit only through financial responsibility for their children) this legislation legitimated the heterosexual married two-parent family structure as the universal, and idealised family form. In the policy arena, the discussion of lone-mothering has been also tied to debates around 'family values'. For example, in his Prime Ministerial speech during the Labour party conference in September 1998, Tony Blair called for a return to 'family values'. The emphasis for what Tony Blair termed a 'strong family life' (see Guardian, 30 September 1998:2) rested upon the notion of a two-parent family unit wherein the father assumes responsibility for his family and child care support. Blair's very public endorsement of the two-parent family and the way this family structure has

been used in debates to spearhead a return to 'family values' has been criticised as representing a not so subtle attack on lone-parent families. By advocating a two-parent family unit as necessary for the well being of society, a connection is inferred between lone-mothering, children's underachievement and juvenile delinquency, as well as wider societal breakdown.

Lone-mothers are constructed as problems and stigmatised in the policy discourse. Caribbean mothers have high rates of lone-mothering and as such they are caught up in these policy debates. Of course, and in contrast to the U.S.A., policy and media debates tend not to explicitly refer to race in their moral panics about lone-mothering. Their negative racialised portrayal of such mothers is usually implied in debates especially concerning absent fathers and welfare dependency (Phoenix, 1996). These understandings of Caribbean mothers in policy debates are part of much wider discourse that construct Caribbean mothering and their experiences, identity and practices as problematic and deviant.

Mothering and feminist research

Feminist perspectives have contributed to shaping the policy agenda by opening up conceptualisation and research on mothering. Mothering represents dynamic and complex interactions and social relationships that are culturally and socially situated (Glenn, 1994). They assert that mothering is socially constructed rather than a natural and unchanging biological fact. A universal set of maternal practices involving nurturing, protecting and training their children underpin social constructions of mothering (Ruddick, 1994). Mothers' interacting beliefs about family, self-hood, perspectives on childhood and the nature of their child shape mothering actions (Ribbens, 1995). Also universal to mothering is a relationship of care that presupposes that children have a core set of basic needs and mothers attempt to meet these needs (Ungerson, 1990). In doing so children make emotional, physical and moral claims on the mother and this provides them with a sense of meaning, purpose and identity (Leonard, 1996). Western mothering ideology is grounded in the development of capitalist industrial society and the creation of a gendered public/private divide, where the male/father is primarily responsible for the economic provision of the family, and operates in the public sphere, and the female/mother is situated in the home/private sphere as the primary carer and domestic worker (Richardson, 1993). This is represented as the normative and universal family despite recent

social and demographic changes—such as lone-mothering and working mothers—that are highlighted above.

Black feminist research emerged to challenge this universalistic ideology of mothering and the family. A central element of their work was to push for more attention to diversity and specificity as a result of racial (and social class) variations. Black feminist were interested in analysing the intersectionality of race, class, and gender divisions in determining the socio-historical, cultural and economic factors that shape mothering experience, identity, and values. For example, black feminists argue that, because of their subordinate structural location in terms of gender and race the conventional approach to understanding gender relations as an outcome of the gendered public/private divide is not readily applicable to the experiences of black mothers and the black family; nor has this ever been the case (Phoenix, 1987; Glenn et al., 1994). In the black family 'the public and private spheres are tightly interwoven' and mothering occurs at the 'boundaries demarking these dualities' (Hill-Collins, 1994:48). This is why for Caribbean and other racial ethnic mothers paid work in the public sphere has always been integral to their mothering. Some writers claim that this interweaving of the public and private sphere and the boundary position in which black mothering occurs is rooted in slavery. During slavery black women, regardless of their maternal status, were constructed as workers and were forced to work alongside their black menfolk, yet their female gendered location maintained women's primary responsibility for child care and domestic work (Gutman, 1976; Davis, 1981). Other writers suggested that black mothers' boundary position emerged prior to the historical period of slavery and is influenced by the Africanist tradition of family organisation where the distribution of roles and labour in the family was determined by seniority and family status rather than gender (Sudakasa, 1996).

Despite the differing perspectives on the origins of black mothers' boundary status they share agreement on the fact that black mothers' public/private boundary location is a cultural practice that has been accepted and successfully transmitted down the generations. Evidence suggests, for example, that this ideological positioning of Caribbean mothers in the public and private sphere simultaneously continued with colonialism and then later migration to the U.K. The ideological remnants of plantation society, and the structural poverty of many (formerly British) Caribbean territories encouraged Caribbean mothers to occupy a dual location in the public and private sphere (Senior, 1991; Momsen, 1993). Migration to the U.K. from the post World War II period onwards, and in response to labour shortages in key industrial areas, reinforced Caribbean mothers

work status. In each instance their gender position meant that these women also assumed primary family and child care responsibilities in the home (see Dodgson, 1984; Bryan et al., 1985; Williams, 1988).

Black feminists regard mothering as equally 'raced' as it is gendered and they assert that feminist perspectives on mothering have largely ignored the race dimension and have concentrated on understanding mothering as a solely gendered socially constructed phenomenon, born out of women's biological reproductive capacities (see for example, Gittins, 1985; Gordon, 1990; Richardson, 1993). Through their analysis they continue to reinforce the idea that the intersections of 'race', gender, and social class result in different social and structural locations for black and white mothers. The differing structural locations, which are ultimately informed by racial positioning, ensure black and white women do not experience mothering in quite the same way. Race and racism influences how black mothers nurture, protect, and socialise their children and the resources available to them to do so. At the core of black mothering are issues of survival, power, and identity (Hill-Collins, 1994).

Race and racism also inform social constructions of black mothering and their mothering experience. For example, racial stereotypes underpin constructions of Caribbean mothering. The three images that have assumed a popular and commonsense appeal are the 'welfare mother' or *babymother*, the 'black matriarch' and the 'black *superwoman*'. The 'welfare mother' or the *babymother* popularised in the media denotes the experiences of largely poor young working-class black lone-mothers (Reynolds, 1997a). These mothers are characterised as women who irresponsibly have children, often by multiple fathers, with no economic means to support themselves and their children. As a consequence, they rely upon state welfare provision as their primary means of income and housing. In contrast to the 'welfare mother', the 'black matriarch' or 'Caribbean matriarch' is the 'workhorse' of the family and she represents the mother who takes care of her family independent of state welfare provision and male authority (Joseph and Lewis, 1980). However, instead of lauding her attempts to care for her family through independent means (e.g. full-time paid employment), the 'matriarch' has been criticised in social policy debates as causing the breakdown of the black family because her actions have left little room for black fathers to fulfil their role as economic providers, thus emasculating black men (see Moynihan, 1965; Wilson, 1987 and 1996). Then there is the 'black *superwoman*', characterised as the professional, educated and upwardly mobile woman. Her decision to 'go it alone' in terms of mothering and

child care, is said to be a consequence of the lack of available black men who can equal her social and economic status.

Each of these representations of black mothering has wider repercussions for the way in which Caribbean mothers are viewed in society. These images reinforce the assumption of lone-mothering is a culturally and racially specific to Caribbean families and that no other family structures exist outside of this family form. Yet, in reality lone-motherhood is one of many family forms that mothers move through in their life cycles. Middle-class mothers and older mothers tend to exist in conventional two-parent married households and younger and working-class mothers are more likely to start off in lone-mother households. However, in the analysis limited attention is given to these variations in Caribbean family structures because it does not 'fit' into traditional images of black mothering.

Caribbean mothers voices: from margins to the centre

In the U.K. today mothering and being mothered in a racialised society continues to have an impact on the daily lived experiences of Caribbean mothers. This study marks an attempt to document the social realities these mothers face. Analysis is centred around forty Caribbean mothers—first, second and third generation mothers—and it reflects on their mothering experiences from the early migration years of the late 1940s onwards up to present day. In documenting these women's experiences this study is part of a wider black feminist agenda to reclaim the 'silent' and often 'invisible' voices of black and minority ethnic mothers in the mothering literature (Glenn, 1994). Caribbean mothers' voices assume a central position in this study because the analysis relies upon documenting the daily experiences of Caribbean mothers as seen through their own eyes. In doing so the research is grounded in black feminist standpoint theory. As I discussed in chapter two, at the heart of this epistemological position is the claim of 'special ways of knowing' (Alcoff and Potter, 1993). Black women have a special perception of their social world based on their black female location black women's knowledge production occurs through the key sites of motherhood and family, education, employment, sexual politics and community activism (Hill-Collins, 1990). In the study the mothers' perspectives draw upon one or more of these areas. As an epistemological position, black women's construction of 'self' is embedded in an acknowledgement and naming of 'self' as the racialised 'other' (Mirza, 1997). As such this identification and naming of Caribbean mothering identity in the U.K. is determined by, and contingent upon their cultural, ethnic and racial, 'other' mothering location. Caribbean mothering depends upon

defining itself against a western ideological construct of 'normative' mothering, or in other words a white, middle-class, heterosexual construct of mothering.

Collective mothering and experiences that shape common identity and practices among Caribbean mothers does not mean that they are an essentialised and homogenised group. In recent years, black feminist (also feminist) perspectives have contributed to the development of conceptual and empirical work on difference and diversity between women (see Afshar and Maynard, 1994). As chapter three outlined, theories of difference are operationalised on three distinct but intersectional levels. The first level—primarily the focus of first-wave black feminist theorists—is around understanding how structural racial difference between black and white women continue to position black female identities as 'other', 'different', or 'deviant' to white female identities (for example, see Carby, 1982; *Feminist Review*, 1993). This racial homogenising of black women acted as the vehicle in which the black feminist movement could collectively and politically mobilise (see Mirza, 1997; Sudbury, 1998). The second level seeks to understand differences between black women in terms of structural variations, for example, ethnic, class, age, generation divisions and acknowledges the different issues facing black women living in the 'west' and the 'rest' of the world (Mohanty, 1988). The third level—utilising a postmodern approach—interrogates self-definitions of the self and the nature of individual subjectivities (Williams, 1996).

In chapter three these differing conceptualisations of difference were developed in the analysis of Caribbean mothering. The collective struggle around racism, and the implications of their structural location as the 'other' for their daily-lived experiences bound together all black and minority ethnic women into a collective identity. However, the mothers' cultural origins in the Caribbean mean that the social resources available to them in their mothering are sometimes culturally and ethnically specific (for example the use of Caribbean signifiers in their mothering practices). Furthermore, in the analysis I continuously and deliberately alternated between describing the women as Caribbean mothers and black mothers. This is a successful way to demonstrate that the mothers share racial sameness with other black women but it is important to also highlight the ethnic and cultural specificity of their Caribbean background and its influence on constructing a collective mothering identity. The recognition of difference and diversity between the mothers is equally important as highlighting racial, cultural and ethnic sameness. In the analysis I also focused on social class divisions between the mothers and my concern with understanding generation divisions is

an issue that runs throughout the study. Social and generation divisions produce diverse mothering experiences. For example, these affect the mothers' responses to racism and the resources (both financial and cultural) available to them with which to respond. As individuals we do not occupy a singular fixed identity. In reality, how we see ourselves and how others define us are constantly shifting according to time, location and audience. Consequently, it is also important to highlight that the mothers occupy multiple, fluid, fragmented and intersected identities that shift and adapt themselves to each social contexts.

Towards a collective Caribbean mothering identity

However, and despite the contingent nature of identities, and the difference and diversity that exist between the mothers; there are five crucial factors that shape this collective mothering identity. These involve: the mothers' cultural connections to the Caribbean, child rearing strategies to respond to racism, paid work, 'community mothering', and perceptions of men's role and participation in the family.

The mothers' identification with a Caribbean cultural identity draws on past memories of their lives in the Caribbean (first generation mothers) and also memories of their childhood in the U.K. (second and third generation mothers). The mothers' memories are revisited and restructured, through a process of re-memory to account for their experiences in the U.K. In utilising this process of re-memory the mothers restructure past memories so that they represent their current racial and gender positioning. Re-memory also enables the mothers to bridge the gap between their Caribbean cultural legacy and their current experiences. Through a re-constituted Caribbean cultural identity, aspects of the mothers' cultural pasts that were previously silenced—such as family memories, and the recalling of slavery—are re-inserted back into, and celebrated as important facets of their cultural identity. This re-constituted Caribbean cultural identity is imagined and it ignores the vast cultural and national differences of the countries in the region. A homogeneous model of the Caribbean is constructed to allow the mothers to collectively organise around a cultural identity and establish shared feelings of 'rooted-ness' and 'connected-ness' to a common culture. The first generation mothers' ideas as to what constitutes a Caribbean cultural identity is to a large extent fairly parochial and is restricted to their specific Caribbean country of origin and the distinct customs and traditions found in this territory. The second and generation mothers, in contrast, have limited direct experiences of the Caribbean region, and thus they have forged a much more 'pan-Caribbean' (Bakari,

1997) cultural identity where the inter-island differences that exist in this region are submerged. These younger mothers are also simultaneously engaged in process of formulating a cultural identity in which their Caribbean heritage is recognised but includes the fact they are black and British. A black British cultural identity recognises new forms of cultural spaces and new modes of cultural nationalism whereby 'black' becomes the over arching factor for solidarity instead of links and/ or affiliations to the Caribbean. However it is too soon to consider how far this new form of cultural identification will overtake notions of a collective Caribbean identity which is favoured by the vast majority of mothers in the study.

To cement the mothers' claims of a collective Caribbean mothering identity, the mothers incorporate in their child rearing cultural resources (such as black cultural artefacts) and perceived models of Caribbean cultural values and behaviours. The teaching and transmission of a Caribbean culture by the mothers to their children is regarded as an important function of their mothering work. The re-constitution of a Caribbean cultural identity—through a process of memory and re-memory—and the creation of a black British identity, which draws upon cultural connections to a black Diaspora, are cultural strategies. The mothers use these cultural strategies in their child rearing to resist and challenge racism.

Despite the changing forms of cultural identification, one thing that remains constant in the mothers' lives in the U.K. is their collective struggles around racism. Many of the concerns that black mothers have for their children is as a consequence of the way that black racial identities are problematised by dominant groups in society. At both collective and individual levels the mothers organise to challenge racial inequality and racial injustices in order to improve conditions for themselves and their families. One element in the mothers' fight against racism is their development of cultural strategies in which to challenge and resist racism in their children's lives. Black mothers also face the task of teaching their children how to cope with, and live with, the racism that they will inevitably encounter. One strategy involves the mental and emotional preparation of children for racism by valorizing black racialised identities. In so doing the racist stereotypes, which identify black people collectively as a deviant group, are undermined.

The mothers also encourage their children to mobilise around societal racism, motivating them towards the achievement of personal goals and ambitions rather than allowing racism to be a deterrent to success. The mothers regard the education system as one area where their children are first likely to encounter

racism. Many of the second and third generation mothers suffered racial injustices at school at the hands their teachers and the other white school children. Thus, in order to ensure that these experiences are not repeated in their own children's schooling, the mothers employ a strategy to challenge racist practises in education. They do this by increasing their involvement in and surveillance of their children's educational affairs. These Caribbean mothers' collective actions come at a time when there is a wider cultural shift in education towards greater parental involvement, parental choice and 'parental consumer-ism' (David, 1993) in their children's schooling. Other educational options that are increasingly being considered by the mothers with school age children is to send them 'back home' to the Caribbean to be educated. Thus they remove their children from racist educational environments, and place them in a society where the mothers feel that a supportive non- racial culture of education exists. In addition, the mothers are also sending their children to black supplementary schools and 'black-owned' schools in greater numbers as a way of actively subverting racism in their children's education (see Mirza and Reay, 2000).

Black people are most likely to encounter overt experiences of racism (such as racial harassment and racial abuse) in the public domain. Thus, a final child rearing strategy the mothers engage in is to closely monitor and police their children's activities in public spaces. The parental control that is exercised over their daughters' movement in the public domain is informed by concerns around their daughter's sexuality and the way in which young women's freedom of movement in public spaces is associated with sexual promiscuity and sexual immorality (Lees, 1993). To counter the racial treatment of their sons in the public domain, the mothers establish expected patterns of behaviour, such as discouraging their sons from loitering on the streets. The mothers also offer practical advise to their children which will enable them to avoid problems when they are in the public domain.

The Caribbean mothers' struggles, around racism and child rearing strategies to challenge racism, are an important binding aspect of a collective Caribbean mothering identity. The mothers' collective positioning is further reinforced by a shared work identity. A work identity is central to Caribbean mothering as is evident by the 77.3% of Caribbean mothers across successive generations who are engaged in full-time paid work (Modood, 1997). This work identity is determined by cultural historical factors (such as slavery, colonialism and

migration) and economic factors (such as physical survival), which have acted to define and sustain black women's position as workers.

In the workplace the combination of racism, sexism and 'mother-ism' (Joshi, 1991) inform the mothers' working practises. The racism and sexism that the mothers' encounter as part of their everyday working experience is further compounded by the negative way in which working mothers—especially working single-mothers—are perceived by employers. More often than not in acknowledging a mothering status, mothers across all ethnic groups, encounter significant barriers in securing employment or promotional prospects. This results in incidents where some women feel that they have to disguise the fact that they are mothers. In addition, the continued lack of affordable state child care facilities for working mothers suggests a certain reluctance on the government's part to intervene in attempting to change employers' attitudes towards working mothers (DfEE, 1998). For Caribbean mothers who have had a long work history in the U.K. (especially the first generation mothers who have worked since the 1950s), their child care arrangements often involved friends or family members in the U.K. However, often the children's grandmother is not the primary source of child care for working mothers. This contradicts previous research, which identifies the fact that in black families it is often the maternal grandmother who cares for her daughter's children whilst she, the mother, is at work (see Stacks, 1994). Ultimately, this continued high labour force participation and shared work experiences among first, second and third generation mothers in the U.K. forges a shared work identity between the mothers (e.g. the shared experience of racism, sexism and mother-ism). This work identity reproduces a collective mothering experience that is rooted in a socio historical-cultural past.

A consideration of Caribbean mothers work status is not confined to examining their experiences only in relation paid work. It also involves their community work; otherwise known as 'community mothering'. 'Community mothering' highlights the interacting nature of work, mothering and political and community activism, spheres of social life that are usually analysed separately. It also reveals the social collective responsibility the mothers have for children to whom they are not related. This reinforces Hill-Collins (1994) assertion that for black and minority ethnic women, mothering is intrinsically linked to 'socio-cultural concerns' for their community and their mothering work reflects their collective and political struggles over the physical survival of the children and community. The range of caring work they provide through voluntary and

community programmes and welfare based community organisations provides an alternative site where children are socialised into cultural values and group norms. They also act of 'sites of resistance' against dominant the discourse seeking to problematise and pathologise black individuals.

Caribbean 'community mothering' is part of wider changing notions concerning state and family responsibility towards community care. From the 1980s onwards the policy shift, away from ideologies of communitarism towards individualism, placed greater emphasis on the community instead of the state to meet individual and family needs. It was during this policy era that Caribbean welfare based organisations greatly expanded as formal structures in local black communities; although, prior to this period, they had a long standing historical traditional of informally based welfare and community care. With these new and expanding formal structures in place, they worked alongside the family in care provision for children and other vulnerable adults. Women are essential and integral to the community work performed in these organisations and in many ways their work and practices mirror the domestic and caring work women perform in the home. Men also have a marginal role in these organisations; yet where they are present they tend to hold key managerial roles where power and authority is concentrated.

Gender divisions that reflect the differing roles and responsibility of Caribbean men and women in welfare community work are often overlooked in analyses. This is true, equally, for Caribbean men's role and participation in the family. However, the majority of the mothers in the study identify that their children's fathers assume an active participant role in child care whether or not they are living with them. The areas of responsibility that these fathers provide include not only the role of 'traditional' financial provider but also other functions—child care, protection and security, and guidance and advice. This shows that the fathers' contribution to the family is not solely confined to the position of economic 'breadwinner'. The assumption about black fathers' participation that prevail in the media (primarily newspapers), (black) popular culture and black family debates construct black fathers as 'absent' and 'marginal' in black family lives.

Even when Caribbean fathers are absent from the household this does not automatically equate to their absence from family lives. From the mothers' perceptions, it is clear that many of the fathers who live outside the home assume an 'absent present' position in 'the family' as a result of their participation in child care. As I discussed in chapter nine, these fathers' degree of involvement in 'the family' is as engaged, if not more so, as the 'normative' white middle-class father

who occupies a 'present absent' position in the family but for whatever reasons (usually employment) is away from the household for long periods of time and thus limiting their involvement in child care and the family. Caribbean fathers in family lives forms the final part of the case for a new collective Caribbean mothering identity because their re-insertion into the debate challenges traditional and racial representations of Caribbean mothering that are premised on male absence or marginality.

A new model for mothering research?

This study of Caribbean mothering presents a model of mothering, which allows differences, both structural (such as 'race', social class and generation), and individual to unfold without undermining the collective experiences that exist between mothers. Past research on mothering has tended to marginalise the experiences of black and minority ethnic mothers in the U.K. In revealing the complexities and specificity of a Caribbean mothering identity, a new model for universal mothering emerges. This model moves away from homogeneous and stereotypical images of black and white mothering as separate and incompatible to one where the mothering experiences of all women are heard. Such a holistic model of mothering enables us to see that mothering occurs at the critical juncture of 'race', class and gender. Mothering is as much 'raced' (also social class based) as it is gendered for both black and white mothers. Mothers belong to different racialised (and social class) positions and as such encounter different mothering experiences, as the case of the Caribbean mothers demonstrate. Yet, mothers across racial difference are also united by similarities in experience.

The analysis develops themes around which a Caribbean mothering identity is constructed. White mothering, as well as mothering by other minority ethnic groups also share these themes. For example, there is the theme of memory and re-memory where the mothers draw upon their past, as well as their own experiences of being mothered to determine their mothering today. There is the theme of protection, advice, security and education that forms central elements of the mothers' child care practices. The theme of work reinforces the way in which work acts as an important definer for mothers; regardless of whether they are primarily positioned in the home or in part-time employment (as is the case with white mothers); or, whether the mothers are primarily located in full-time employment (as is the case with Caribbean mothers). Finally the theme of fathering assesses the effects of the father's absence and presence on

mothering and family life and is an important area of discussion for both black and white families.

There is a racialised difference between white and Caribbean mothers in terms of the discussions formed around each of these themes. Caribbean mothering occurs in the specific context of racism. Thus, memory and re-memory of the mothers is specifically formed around racism. The Caribbean mothers use memory and re-memory—alongside additional child care practices (e.g. protection, security, advice and education)—as strategies with which to challenge and resist racism. Similarly, the mothers' work identity and working experiences are formed around racial constructions of black womanhood (that are socio historically-culturally specific) and wider systems of racial inequality in U.K. society. Representations of fathers' absenteeism from the home as racially and culturally specific to black Caribbean fathers, and the pathologised images of black mothering which follow on from this discourse, is rooted in racist discourses and racist debates of the black family life.

The future agenda for mothering research must be to develop a framework for mothering which embraces the different and diverse mothering experiences of various social, racial and ethnic groups in society. Through a new understanding of Caribbean mothering a universal framework for mothering identity is achieved. By placing difference and diversity at the front of mothering discourses, this new model of mothering speaks for, and is representative of, all groups of mothers in society and not just a select privileged few.

Appendix 1
Summary of mothers

First generation mothers

Name	Age	Status
Anita	43	Married
Beverley	48	Married
Camille	51	Married
Caro	50	Widow
Diane	63	Married
Dolly	76	Married
Donna	59	Lone-mother
Doris	81	Married
Enid	69	Married
Felicity	54	Married
Helen	56	Married
Janet	48	Lone-mother
Pearl	61	Married
Tina	49	Married

Third generation mothers

Name	Age	Status
Alison	21	Lone-mother
Denise	22	Partner
Sharon	19	Lone-mother
Susan	20	Partner

Second generation mothers

Name	Age	Status
Angela	27	Married
Charmaine	41	Lone-mother
Dawn	36	Partner
Georgia	39	Married
Heather	33	Partner
Jamilla	25	Lone-mother
Jheni	35	Lone-mother
Joy	39	Lone-mother
Lisa	36	Partner
Lydia	28	Lone-mother
Marcia	33	Lone-mother
Melanie	29	Lone-mother
Michele	28	Lone-mother
Nizinga	31	Lone-mother
Pauline	25	Lone-mother
Sandy	32	Married
Sarah	33	Married
Sybil	49	Lone-mother
Tanya	40	Lone-mother
Terri	26	Lone-mother
Viv	40	Married
Zora	26	Partner

The mothers

First generation mothers

Anita, age 43, a married mother, was born in Dominica and has a professional middle-class background. Anita lives with her husband and three children in an affluent area of southwest London. Anita is a university lecturer/medical researcher at a London teaching hospital.

Beverley, age 48, a married mother, was born in Jamaica. Beverley came to the U. K. as a teenager to join her family living here. Beverley lives with husband and two children in south London. She also has an adult son from an earlier relationship and three adult step-children. At the time of interview Beverley was expecting her first grandchild from her adult son. Beverley is a social worker in a local authority social services' department.

Camille, age 51, a married mother, was born in St. Kitts and came to Britain as a young girl during the mid 1950s. Educated in Britain, Camille has risen through the ranks of the NHS to become a senior mental health executive of a mental health trust. Camille lives with her husband and two children in south London. Camille employs a live-in nanny to assist her with child care.

Caro, age 50, is a widow. Born in Trinidad, Caro came to Britain with her mother during the 1950s in order to join her father who was already working here. Caro re-migrated to Trinidad for a short spell during the late 1980s but her late husband's ill-health forced her to return to Britain. Caro has four children, two are adult daughters, and she lives with her two youngest children. Caro is an art teacher at a local comprehensive school, and a freelance artist.

Diane, age 63, is married with four children and one-grandchild. Diane left Jamaica in the early 1960s to study nursing in the U. K. Diane is a retired nurse. She now spends her time as a voluntary worker for a black elderly organisation, where she teaches keep-fit and art and craft to members. Diane is also an active member of her local church and she is responsible for the church's flower arranging. Diane, lives in Manchester.

Donna, age 59 is a divorced lone-mother with two children. Donna lives and works in Manchester. Donna migrated to the U. K. from Jamaica as a young girl and she attended secondary school in the U. K. In the early 1990s she established a black disability organisation in her own home. She then secured funding for the organisation to lease their own premises and employ paid staff, as well as volunteers. Donna is employed as the Director of the organisation.

Dolly, age 76 is Trinidadian. Dolly is the mother of Caro. Dolly and Carol live in close proximity to each other and Dolly assists her daughter with child care on a daily basis. Dolly, age 76, is married with four children (one has died). She is also a

grandmother and great grandmother. Dolly is retired but she has had a variety of jobs over the years. Her jobs range from a factory worker, a seamstress, a life model for the London art colleges, to a community worker. Dolly is an still an active member of her local church and her local community. Through her voluntary work, she presides on various church and community committees.

Doris, age 81 is a married mother (six children), grandmother (fourteen grandchildren) and great grandmother (five great grandchildren). Doris was born in Antingua to Antinguan and Cuban parents. Doris' parents separated when she was a young girl and her father returned to Cuba. Much of Doris' childhood was spent living between her mother in Antigua and her father in Cuba. Doris was one of the first Caribbean migrants to come to Britain. She arrived here with her husband and family in 1949. Doris has been retired for many years, she used to work as a school canteen assistant. Doris lives in south London.

Enid, age 69, is married with three adult sons and eight grandchildren. Two of Enid's sons (and their respective children) live in the U.S.A. Enid was born in Guyana and came to the U. K. during the mid 1950s. Enid is a retired auxiliary nurse, who is actively involved in local black community organisations. Enid divides her time between her homes in the U. K. (south London) and Guyana, spending up to six months at a time in each country.

Felicity, 54, is married with two adult children and two grandchildren. Felicity is a secondary school teacher. Felicity was born in Jamaica and came to the U. K. with her mother. She attended secondary school in the U. K. On weekends, she works as a 'Headteacher' at the local black supplementary school on a voluntary basis. Felicity lives in north London.

Helen, 56, is married with four step-children and a niece that she raised as her own daughter. Helen is from Dominica and came to the U. K. during the late 1970s after she married a U. K. citizen. Helen is a primary school teacher. On the weekends she does voluntary work at the local black supplementary school. Helen lives in north London.

Janet, 48, is three times divorced with seven children (this includes 3 adult children) and 'numerous' step-children. Janet came to the U. K. from Jamaica with her parents as a young child and she was educated here. Janet is the Director of black elderly organisation and also committee member of a black disabled group. Janet lives in Manchester.

Pearl, age 61, a married mother has four children and three grandchildren. Pearl was born in Antigua and accompanied her aunt to the U. K. during the early 1960s. Pearl later met and then married her husband in Britain. Pearl recently retired as a factory worker and she now uses her time during the week to look after two of her young grandchildren whilst their parents are at work. Pearl lives in south London.

Tina, 49, is married with three children. Janet was born and raised in St. Lucia and lived in the U. K. for six years. Tina is a community nurse. Once a week she volunteers as a health advisor at a local black elderly organisation. Tina lives in Manchester.

Second Generation Mothers

Angela, age 27 is a married mother of Jamaican parentage. She has three young children including nine months-old twins. Angela was born in a working-class area of south London, and she has lived here all of her life. Angela is currently on maternity leave but due to return to work in the next three months. When she returns to work the twins will be cared for by a registered child minder. Angela works in the retail/high street fashion industry.

Charmaine, age 41, is a lone-mother of Barbadian/Guyanese parentage. She has two children (boys age fourteen and nine). Charmaine is a co-director of a black youth mentoring scheme in Birmingham.

Dawn, age 31 lives with her partner. Dawn is of Jamaican/Panama parentage. She has two children (girl and boy age twelve and four years-old). Dawn is a co-founder of a black Saturday school in an area she lives in north London. Dawn is a local authority education officer.

Georgia, age 39, married with three children (seven and four years and fifteen months old). She is of Jamaican parentage. Georgia used to work as solicitor in a large city firm in London. However, after the birth of the first child she and her husband decided to re-locate to Huddersfield to seek a better quality of life. Georgia's husband has strong family connections in Huddersfield. Georgia is a committee member of a black family group. She also works as a legal advisor for a national charitable organisation.

Heather, age 33, lives with her partner and their two children (boys age four and two years-old). Heather has Indo-Trinidadian origins. She is a freelance graphic designer and has set up a small publishing group to publish black and multi-ethnic children's books. She is also a co-founder of a black family group in Huddersfield.

Jamilla, age 25, is a lone-mother. She was born to Jamaican and Anguillan parents and grew up in south London. Jamilla commenced a degree in teaching but she had to suspend her studies when she became pregnant. She has a two year-old daughter. The relationship between Jamilla and her partner has recently ended but they remain in regular contact with each other. Jamilla is currently working as a special needs assistant teacher in her local primary school, but she will be resuming her teaching degree in the next academic year.

Jheni, age 35 is lone-mother of Jamaican parentage. Jheni was born and raised in London. Her parents separated whilst she was very young and Jheni grew up in a female-

centred household, living with her mum, sister, maternal grandmother, aunts and female cousins. Jheni has two school age children, a son and a daughter (age six and three years-old), with two different partners. Jheni has travelled extensively and has lived in various parts of the world (including Jamaica) and in various parts of the U.K. Jheni is self-employed and combines her work as a freelance photographer, artist, and consultancy work with full-time higher education.

Joy, age 39 is a lone-mother of Dominican-parentage. Joy was born in Dominica but came to the U.K. as a baby. Joy lives in south London with her five children (age twenty two, twenty, thirteen, seven and four years-old) and one granddaughter. Each of the children has a different father and Joy works as a government clerical officer.

Lisa, age 36, lives with her son (from a previous relationship) and partner. Lisa is of Jamaican parentage. Lisa lives in Coventry and recently secured funding to work as a full-time officer for a black disability group she co-founded. Lisa also works part time as a retail sales assistant to supplement her income.

Lydia, age 28, is a lone-mother of Jamaican parentage. Lydia lives with her two children (age seven and two years-old) in south London. She has a 'visiting' relationship with her partner. Lydia is employed as a clerical assistant in a central government department. Her mother lives in the same street as Lydia and helps out a lot with child care.

Marcia, age 33, is a lone-mother of Jamaican/St.Vincent parentage. She lives with her two children (boy and girl age sixteen and three years-old). Her children are with two different partners. Marcia is in a 'visiting' relationship with her current partner and father of her youngest child. Marcia lives in south London. She works as a local authority administrative officer.

Melanie, age 29, is a lone-mother of Jamaican parentage. Melanie has two children (age seven years-old and three months-old) by two different partners, but she enjoys regular contact with each of the fathers. Melanie's immediate family are dispersed throughout the U.S.A, Jamaica and Britain, and so she has limited contact with them. Melanie is currently working as a Inland Revenue officer but she plans to set up her own private child care nursery in the immediate future. Melanie lives her children in south London.

Michele, age 28 is a lone-mother of Jamaican parentage. She has one daughter (age three years-old). Michele was born and raised in east London, and she now lives in south London. Michele works as a legal secretary for a large-city firm.

Nizinga, age 31 is a lone-mother of Trinidadian parentage. Nizinga lives with her daughter (age three years-old). However, she enjoys a very close relationship with her family members who provide regular child care and financial assistance. Her ex-partner also lives close-by and he provides a significant amount of child care

assistance (e.g. collecting his daughter from nursery) despite the fact that he does not live in the family home. Nizinga works as a university administrator.

Pauline, age 25, is a lone-mother. She is of Barbadian/Zimbabwean heritage. She has one child (girl age 3) and she lives in Birmingham. Pauline works as a secretary/ clerical officer in an accountancy firm. She does voluntary work as a mentor for black teenage girls in the local community.

Sandy, age 32, is married with two children and was 6 months pregnant with her third child at the time of interview. Sandy is of Jamaican parentage. She works as a community liaison officer in a local health authority. She lives in Coventry and is the sister of Lisa who also participated in the interviews.

Sarah, age 32 is a lone-mother with one child (son, age 10 years-old). Sarah is of Grenadian parentage. Sarah is a committee member and voluntary worker for a black mentoring programme in Birmingham. Sarah works as a senior policy officer Birmingham County Council. Sarah is also actively involved in her local black church.

Sybil, age 49, is a lone-mother with three adult children and two grandchildren. Sybil's parents migrated to Coventry shortly after the second World War ended in 1945. With regards to this 'new wave' of Caribbean migrants, Sybil was one of the first black children to be born and educated in the U.K. Sybil is of Jamaican parentage. She is a full-time officer for a black mental health organisation in Coventry and serves as a committee member for three other black organisations and is often called upon by the local media to speak about issues and interests affecting the black community in Coventry.

Tanya, age 40 is a divorced lone-mother who lives with her son (age 11). Tanya is of Guyanese parentage. Although Tanya was born in north London, as a child she was sent to live in Guyana with her maternal grandparents. Tanya returned to the U.K. to complete her university education. Tanya has a current partner who she does not live with. She is a solicitor who specializes in criminal law.

Terri, age 26 is a lone-mother with one child (age 6). She is of St. Lucian parentage. Terri is in a 'visiting' relationship with her current partner. Terri lives in south London. She works as a payroll clerk in a central government department.

Viv, age 40 is a lone-mother who lives in south London with her two children (girls 15 and 13). Her sister's son also lives with them. Viv is a social worker and works for a local authority.

Zora, age 26, is of Barbadian/Guyanese parentage. She was born in south London and has lived here all of her life. Zora lives with her long-term partner and their two daughters (age 5 and 2 years). Zora is employed as a local authority housing officer.

Third Generation Mothers

Alison, age 21 is a lone-mother with one child (age two years-old). Alison lives in Coventry and works as a sales assistant in a supermarket. Alison established a single-mothers group on the local estate where she lives. Alison is of Jamaican/Nigerian/British heritage but both her parents were born and raised in the U. K., as was Alison.

Denise, age 22 has a Barbadion/Grenadian/St. Lucian family history but, like Denise, both of her parents were born in Britain. Denise is engaged and she lives with her fiancé and baby son (age two years-old). Denise is a hairdresser and would like to own her own salon in the very near future.

Sharon, age 19, is a lone-mother, with a Guyanese/Jamaican/Welsh family back ground. Sharon has a visiting relationship with her partner but at the time of interview he was currently serving time in a young offenders institute and she was very unsure if the relationship would continue. Sharon is presently unemployed and lives in south London.

Susan, age 20, lives with her partner and their one child (age fourteen months-old). Susan works as a nursery assistant. She has an Indo-Trinidadian/ Afro-Chinese Jamaican heritage. She lives in south London.

Appendix 2

Caribbean mothers' employment status and labour market activity

Employment Characteristics	Total Number	Total %
Employment activity:		
Full time employment	29	72.5%
Full-time student only	0	0
Full Time student and part-time working	4	10
Full-time carer	0	0
Part-time employment only	0	0
Unemployed (registered and looking for work)	2	5
Retired	5	12.5
Total	40	100%
Employment Sector		
Public	22	55
Private	3	7.5
Voluntary*	8	20
Not applicable (e.g., retired and unemployed)	7	17.5
Total	40	100%
Employment by industry		
Banking, computing & finance	1	2.5
Community*	8	20
Food and catering	0	0
Public administration	13	32.5
Medical, nursing & health	3	7.5
Retail & sales	2	5
Teaching & education	3	7.5
Textiles & manufacturing	1	2.5
Transport and communication	0	0
Other	2	5
Not applicable (e.g., retired or unemployed)	7	17.5
Total	40	100%
Skills level		
Professional and managerial	6	15
Clerical and administrative	24	60
Skilled/semi skilled non-manual	3	7.5
Skilled/semi skilled manual	0	0
Unskilled	0	0
Not applicable (e.g., retired or unemployed)	7	17.5
Total	40	100%

* (This figure represents mothers who are employed as paid workers only; it does not include mothers who do unpaid voluntary work)

Bibliography

Afshar, H. and Maynard, M. (1994) (eds) *The Dynamics of 'Race' and Gender: some feminist interventions*, London: Taylor and Francis.

Ahmed, S. (1997) "It's a sun-tan isn't it?": Autobiography as an identificatory practice, Mirza, H. (eds) *Black British Feminism*, London: Routledge.

Alcoff, L. and Potter, E. (1993) Introduction: When Feminism Intersect Epistemology, Alcoff, L. and Potter, E. (eds) *Feminist Epistemologies*, London: Routledge.

Alexander, C. (1996) *The Art of Being Black*, Oxford: Claredon Press.

Alexander, V. (1996) 'A mouse in a jungle': the Black Christian woman's experiences in the church and society in Britain, Jarrett-Macauley, D. (eds) *Reconstructing Womanhood, Reconstructing Feminism: Writings on Black Women*, London: Routledge.

Alexander, Z. (1999) *Study of black, Asian and ethnic minority issues*, London: Department of Health.

Allen, S. (1982) Gender, Race and Class in the 1980s', in Husband, C. (ed.) *Race In Britain: Continuity and Change*, London and Melbourne: Hutchinson University Press.

Amos, V. and Parmar, P. (1984) Challenging Imperialist Feminism, *Feminist Review*, Special Issue, 17, July: 3-19.

Anderson, B. (1983) *Imagined Communities*, London: Verso.

Anthias, F. (1990) Race and Class Revisited: Conceptualising Race and Racisms, *Sociological Review*, 38 (2): 19-42.

Anthias, F. and Yuval-Davis, N. (1983) Contextualising Feminism: Gender, Ethnic and Class Divisions, in *Feminist Review*, 15 (1): 62-75.

Anthias, F. and Yuval-Davis, N. (1992) *Racialised Boundaries*, London: Routledge.

Arendell, T. (1999) *Mothering and motherhood: a decade review*, working paper 3, California: University of Berkeley.

Arnold, E. (1997) Issues of reunification of migrant West Indian children in the United Kingdom, in Roopnarine, J. and Brown, J, (eds) *Caribbean families: diversity amongst groups*, London: JAI Press Ltd.

Atkinson, P. (1990) *The Ethnographic Imagination: Textual Constructions of Reality*, London: Routledge.

Augustus, P. (1994) *Babyfather*, London: X Press Publishing.

Aziz, R. (1992) Feminism and the Challenge of Racism: deviance and difference, in Crowley, H. and Himmelweit, S. (eds) *Knowing Women: Feminism and Knowledge*, London: Routledge.

Back, L. (1996) *New Ethnicities and Urban Culture: racism and multi-culture in young lives*, London: UCL Press.

Backett, K. (1988) *Mothers and Fathers: A study of the development and negotiation of parental behaviour*, London: Macmillan.

Bailey, B. (2000) *Issues of gender and education in Jamaica: What about the boys?* in UNESCO Monograph series: *Education for all in the Caribbean*, assessment 2000, no 15.

Bakari, I. (1997) Memory and Identity in Caribbean Cinema, in *Cultural Memory: A Journal of Culture/Theory/Politics*, 30 (Winter): 74-83.

Ball, S. J. (1993) Education Markets, Choice and Social Class: the market as a class strategy in the U. K. and USA, *British Journal of Sociology of Education*, 14 (1): 3-21.

Bar-On, B. (1993) Marginality and Epistemic Privilege, in Alcoff, L and Potter, E. (eds) *Feminist Epistemologies*, London: Routledge.

Barkeley-Brown, E. (1991) Mothers of Mind, in Bell-Scott, P. (eds) *Double Stitch: Black Women Write about Mothers and Daughters*, Boston: Beacon Press.

Barlow, A., Duncan, S. and James, G. (2002) New Labour, the rationality mistake and family policy in Britain, in Carling, A., Duncan, S., and Edwards, R. (eds) *Analysing Families*, London: Routledge.

Barrett, M. and McIntosh, M. (1985) Ethnocentrism and Socialist Feminist Theory, *Feminist Review*, 20 June, 23-47.

Baranov, D. and Yelvington, K. (2003) 'Ethnicity, race, class and nationality', in Hillman, R. and D'Agostino, J. (eds) *Understanding the Contemporary Caribbean*, Jamaica; Ian Randle publishers.

Barrow, C. (1986) Male Images of Women in Barbados, Massiah, J. (ed.) *Women in the Caribbean (part II)*, Social and Economic Studies, Institute of Social and Economic Research, University of West Indies.

Barrow, C. (1996) *Family in the Caribbean: Themes and Perspectives*, London: James Currey Publishing.

Bassin, D., Honey, M. and Kaplan, M. (1994) *Representations of motherhood*, New Haven: Yale University Press.

Bayliess, C. (1996) Diversity in patterns of parenting and household formation, in Silva, E. (eds) *Good Enough Mothering?*, London: Routledge.

Beckles, H. (1995) Sex and gender in the histography of Caribbean slavery, in Shepherd, V, Brereton, B. and Bailey, B. (eds) *Engendering History: Caribbean Women in a Historical Perspective*, London: James Currey Publishing.

Beechey, V. (1986) Women's Employment in Contemporary Britain, in Beechey, V. and Whitelegg, E. (eds) *Women in Britain Today* Open University Press.

Bell-Scott, P. (1988) (eds) *Double Stitch: Black Women Write about Mothers and Daughters*, Boston: Beacon Press.

Benmayor, R, Vazquez, B, Juarbe, A. and Alvarez, C. (1993) Stories to live by: continuity and change in three generations of Puerto Rican women, in Samuel, R. and Thompson, P. (eds) *The myths we live by*, London: Routledge.

Benn, M. (1997) *Madonna and Child: Towards a New Politics of Motherhood*, London: Jonathan Cape.

Berleant-Schiller, R. and Maurer, W. (1993) Women's place is everyplace: merging domains and women's roles, in Barbuda and Dominica, in Momsen, J. (eds) *Women and Change in the Caribbean*, James Currey publishing.

Bethoud, R. (2001) 'Family formation in multi-cultural Britain: three patterns of diversity', paper presented at one-day conference, *Changing family patterns in multi-cultural Britain*, London: National Parenting and Family Institute.

Berthoud, R. (1999) *Young Caribbeans and the Labour Market: a comparison with other ethnic groups*, London: Joseph Rowntree Foundation.

Bhavnani, K. and Coulson, M. (1986) Transforming socialist feminism: the challenge of racism', *Feminist Review*, 23: 81-92.

Bhavnani, K. (1993) Tracing the Contours: Feminist Research and Feminist Objectivity, *Women's Study International Forum*, 16 (2): 95-104.

Bhavnani, R. (1994) *Black Women in the Labour Market: A Research Review*, London: Equal Opportunities Commission.

Bhopal, K. (1997) Women and feminism as subjects of black study: the difficulties and dilemmas of carrying our research, *Journal of Gender Studies*, 4 (2): 153-168.

Blair, M. (1995) 'Race', class and gender in school research, in Holland, J, Blair, M. and Sheldon, S. (eds) *Debates and Issues in Feminist Research and Pedagogy*, Multilingual Matters: Open University Press.

Blount, M. and Cunningham, G. (1996) *Representing Black Men*, London: Routledge.

Bolles, L. (1988) *My mother who fathered me and others: gender and kinship in the Caribbean*, working paper no, 175, Michigan State University.

Bower, C. (2001) 'Trends in female employment', *Labour Market Trends*, Feb: 107-118.

Bowlby, J. (1953) *Child Care and the Growth of Love*, Harmondsworth: Penguin Books.

Bowman, P. and Forman, T. (1997) Instrumental and Expressive Family Roles Among African American Fathers, in Taylor, R., Jackson, S. and Chatters, L. (eds) *Family Life in Black America*, California: Sage.

Boyce-Davies, C. (1994) *Black Women Writing and Identity: Migrations of the Subject*, London: Routledge.

Brana-Shute, R. (1993) Neighbourhood networks and national politics among working-class Afro-Surinamese women, in Momsen, J. (ed.) *Women and change in the Caribbean*, London: James Currey Publishing.

Brah, A. (1991) Questions of Difference and International Feminism, in Aaron, J. and Walby, S. [eds] *Out of the Margins*, London: Falmer Press.

Brah, A. (1992) Difference, Diversity and Differentation in Donald, J. and Rattansi, A [eds] *Race, Culture and Difference*, London: Sage.

Brah, A. (1996) *Cartographies of Diaspora: contesting identities*, London: Routledge.

Brannen, J. (1999) Reconsidering children and childhood: sociological and policy perspectives, in Silva, E. and Smart, C. (eds) *The New Family*, London: Sage Publications.

Brannen, J. and Moss, P. (1991) *Managing mothers: dual earner households after maternity leave*, London: Unwin Hyman.

Brannen, J. and O'Brien, M. (1996) (eds) *Children in families: research and policy*, London: Falmer Press.

British Broadcasting Corporation (BBC) (1998) *The 50th Anniversary Windrush Celebrations—Diary of Events and Programmes*, London: BBC.

Brodber, E. (1986) Afro-Jamaican women at the turn of the century, *Social and economic studies*, 35 (3): 19-31.

Brodber, E. (1974) *The abandonment of children in Jamaica*, Institute of Social and Economic Research, University of West Indies.

Bruegel, I. (1989) Sex and Race in the Labour Market, *Feminist Review*, Summer, 32: 49-68.

Brown, J., Newland, A., Anerson, P. and Chevannes, B. (1997) Caribbean fatherhood: underresearched and misunderstood, Roopnarine, J. and Brown, J, (eds) *Caribbean families; diversity among ethnic groups*, London: JAI Press ltd.

Bryan, B., Dadzie, S. and Scafe, S. (1985) *The Heart of the Race: Black Women's Lives in Britain*, London: Virago.

Bryson, V. (1992) *Feminist Political Theory*, London: Macmillan.

Burghes, L. and Brown, M. (1995) *Single Lone Parents: Problems, Prospects and Policies*, London: Family Policies Studies Centre.

Busia, A. and James, S. (1993) [eds] *Theorising Black Feminism*, London: Routledge.

Callender, C. (1997) *Education for Empowerment: the practice and philosophies of Black teachers*, London: Trentham Books.

Caricom (2004) *Our Caribbean Community*, Jamaica: Ian Randle Publishers.

Carby, H. (1999) *Cultures in Babylon: Black Britain and African America*, London: Virago.

Carby, H. (1982) White Women Listen! Black feminism and the boundaries of sisterhood, in Centre for Contemporary Cultural Studies (ed.) *The Empire Strikes Back: Race and Racism in 70s Britain*, London: Routledge.

Carter, E. and Harschkop, K. (1997) (eds) Special edition 'Cultural Memory', *New Formations*, 30, Winter.

Cazenave, N. A. (1981) Black Men in America: The Quest for Manhood, in McAdoo, H. P. (ed.) *Black Families*, Beverly Hills, California: Sage.

Castles, S. and Kosack, G. (1973) *Immigrant Workers in the Class Structure of Western Europe*, Oxford: Oxford University Press.

Centre for Contemporary Cultural Studies (1982) (ed.) *The Empire Strikes Back: Race and Racisn in 70s Britain*, London: Routledge.

Chamberlain, M. (1995) Gender and Memory: Oral History and Women's History, in Shepherd, V., Brereton, B. and Bailey, B. (eds) *Engendering History: Caribbean Women in Historical Perspective*, Oxford: James Currey Publishing.

Chapman, R. (1988) Introduction, in Chapman, R. and Rutherford, J. (eds) *Male Order: Unwrapping Masculinity*, London: Lawrence and Wishart.

Charles, N. (1996) *Practising Feminism: Identity, Difference, Power*, London: Routledge.

Chodorow, N. (1977) *The Reproduction of Mothering*, California: University of California Press.

Chodorow, N. and Contratto, S. (1982) The Fantasy of the Perfect Mother, in Thorne, B. and Yalom, M. (eds) *Rethinking the Family: Some Feminist Questions*, New York: Longmann.

Clarke, E. (1957) *My mother who fathered me*, London: George Allen Unwin.

Cobahee River Collective (1997) A Black Feminist Statement, in Nicholson, L. (ed.) *The Second Wave: A Reader in Feminist Theory*, London: Routledge.

Cohen, B. and Fraser, N. (1991) *Child care in a Modern Welfare State*, London: Institute of Public Policy Research.

Coleman, K. (1992) *Contemporary Developments in the Roles and Perspectives of Black Women in Mainstream Churches*, unpublished research paper.

Coleman, D. and Salt, J. (1996) (eds) *Ethnicity in the 1991 census: volume 1: demographic characteristics of ethnic minority populations*, London: HMSO.

Commission for Racial Equality (CRE) (1997) *Employment and Unemployment* Factsheet, London: CRE.

Commission for Racial Equality (CRE) (1997) *Racial Attacks and Harassment* Factsheet, London: CRE.

Counihan, C. and Esterik, P. V. (1997) (eds) *Food and culture: a reader*, New York: Routledge.

Cross, M. (1993) Black Workers, Recession and Economic Restructuring in the West Midlands, in Cross, M. (ed.) *Ethnic Minorities and Industrial Change in Europe and North America*, Cambridge: Cambridge University Press.

Dale, A. and Holdsworth, C. (1998). Why don't minority ethnic women in Britain work part-time?, in O'Reilly, J. and Fagan, C. (eds) *Part-Time Prospects*, London: Routledge.

David, M. (1993) *Parents, Gender and Education Reform*, Cambridge: Polity Press.

Davis, A. (1981) *Women, Race and Class,* London: Womens Press Ltd.

Davis, S. and Cooke, V. (2002) *Why do black women organise? A comparative analysis of black women's voluntary sector organisations in Britain and their relationship to the state*, London: Policy Studies Institute/Joseph Rowntree Foundation.

Daycare Trust (1997) *Child care Disregard in Family Credit, Who Gains?*, London: Daycare Trust.

Deacon, A. (2002) Paternalism, welfare reform and poor families in the United States, in Carling, A., Duncan, S. and Edwards, R. (eds) *Analysing families: morality and rationality in policy and practice*, London: Routledge.

Dench, G. (1996) *The changing place of men in changing family cultures*, London: Institute of Community Studies.

Dennis, N. (1993) *Rising Crime and the Dismembered Family*, London: Institute for Economic Affairs.

Dex, S. and Smith, C. (2001) *The nature and pattern of family-friendly employment policies in Britain*, Bristol: Policy Press.

DfEE (1998) *New Deal for Lone-Parents*, Consultation Workshop, October, London: Canonbury Academy.

Dill, B. T. (1988) 'Our mothers' grief: racial ethnic women and the maintenance of families', *Journal of Family History*, 13(4): 415-31.

Dinnerstein, D. (1979) *The Mermaid and the Minator*, New York: Harper and Row.

Dodgson, E. (1984) *Motherlands: West Indian Women in Britain in the 1950s*, Oxford: Heinemann.

Dubois, W. E. B. (1908) *The Negro family*, 1969 edition, New York:New America Library.

Duncan, G. and Brookes-Gunn, J. (1997) *Consequences of growing up poor*, New York: Russell Sage Foundation.

Duncan, S. and Edwards, R. (1997) *Single Mothers in International Contexts: Mothers or Workers?*, London: Taylor and Francis.

Duncan, S. and Edwards, R. (1998) *Lone-Mothers and Paid Work: Context, Discourse and Action*, Basingstoke: Macmillan.

Edwards, R. (1993) Taking the initiative: the government, lone-mothers and day care provisions, *Critical Social Policy* 39: 36-50.

Edwards, R., Callender, C. and Reynolds, T. (2003) 'Community or self-interest? A case study of mothers' work ethos in the hospital and the accountancy firm', *Journal of Community, Work and Family*, 17 (2): 309-330.

Edwards, R. and Duncan, S. (1996) Rational Economic Man or Lone-Mothers in Context?: The uptake of paid work, in Silva, E [eds] *Good Enough Mothering?*, London: Routledge.

Edwards, R. and Duncan, S. (1997) Supporting the family: lone-mothers, paid work and the underclass debate, in *Critical Social Policy*, 17 (4): 29-49.

Edwards, R, Duncan, S., Reynolds, T. and Alldred, P. (2004) Mothers and child care: policies, values and theories, *Children and Society*, 18: 254.

Edwards, R. and Ribbens, J. (1991) Meanderings around Strategy: a research note on strategic discourse on the lives of women, *Sociology*, 25 (3): 477-90.

Edwards, R. and Song, M. (1996) *Babymothers: Raising Questions about Perspectives on Black Lone-Motherhood*, paper presented at the Social Policy Association Annual Conference.

Ellis, P. (2003) *Women, gender and development in the Caribbean: reflections and projections*, London: Zed books.

Essed, P. (1994) *Everyday Racism*, California: Hunter House.

Farr, C. (1991) Her Mothers Language, in O'Daly, B. and Reddy, M. (eds) *Narrating Mothers: Theorising Maternal Subjectivity*, Knoxville: University of Tennessee Press.

Figueroa, M. (2000) 'Making sense of male experience: the case of academic underachievement in the English-speaking Caribbean, *Institute of Development Studies Bulletin on Men and Masculinities*, 31/2, Sussex: University of Sussex and Jamaica: University of the West Indies.

Firestone, S. (1970) *The dialetic of sex: the case for feminist revolution*, London: Jonathan Cape.

Fog-Olwig, K. (1999) Narratives of children left behind: home and identity in globalised Caribbean families, *Journal of ethnic and migration studies*, 25 (2): 252-266.

Foner, N. (1979) *Jamaica Farewell: Jamaican Migrants in London*, London: RKP.

Fordham, S. (1996) *Blacked Out*, Chicago: Chicago University Press.

Forna, A. (1998) *Mothers of all Myths*, London: Harper-Collins.

Fortes, M. (1956) Foreward, in Smith R. T., *The Negro Family in British Guiana*, (second edition) London: Routledge.

Frankenburg, R. (1993) *White Women, Race Matters: The Social Construction of Whiteness*, London: Routledge.

Frazier, F. (1948) *The Negro Family in the United States*, Chicago: University of Chicago Press.

Fryer, P. (1984) *Staying Power: The History of Black People in Britain*, London: Pluto Press.

Furstenburg, F. (1988) Good dads-bad dads: Two faces of fatherhood, in Cherlin, A. (ed.) *The Changing American Family and Policy*, Washington, DC: Urban Institute Press.

Gilbert, N. (1993) *Researching Social Life*, London: Sage.

Gilens, M. (1999) *Why Americans hate welfare: race, media and the politics of anti-poverty*, Chicago: University of Chicago Press.

Gillborn, D. (1995) *Racism and Antiracism in Real Schools*, Buckingham: Open University Press.

Gillborn, D. and Gipps, C. (1996) *Recent Research on the Achievements of Ethnic Minority Pupils*, London: Office for Standards in Education, HMSO.

Gilman, S. (1992) Black Bodies, White Bodies: Towards an Iconography of Female Sexuality in late Nineteenth Century Art, Medicine and Literature, in Donald, J. and Rattansi, A. (eds) *Race, Culture and Difference*, London: Sage.

Gilroy, P. (1987) *There Ain't No Black in the Union Jack*, London: Hutchinson.

Gilroy, P. (1993a) *The Black Atlantic: Modernity and Double Consciousness*, London: Verso.

Gilroy, B. (1993b) *Small Acts: Thoughts on the politics of black cultures*, London: Serpent's Tail.

Gittins, D. (1985) *The Family in Question*, London: Macmillan.

Glenn, E. (1994) Social Constructions of Mothering: A Thematic Overview, in Glenn, E., Chang, G. and Forcey, L. (eds) *Mothering: Ideology, Experience and Agency*, California: Routledge.

Glenn, E., Chang, G. and Forcey, L. (1994) (eds) *Mothering: Ideology, Experience and Agency*, California: Routledge.

Goldman, R. and Taylor, M. (1966) 'Coloured immigrant children: a survey of research, studies and literature on their educational problems and potential in Britain', *Educational Research*, 8(3): 163-183.

Gonzalez, V. (1982) The realm of female familial responsibility, *Woman and the Caribbean Project, vol 2*, Barbados: University of West Indies.

Gordon, S., Benner, P. and Noddings, N. (1996) (eds) *Caregiving: reading in knowledge, practice and ethics*, Philadelphia: University of Pennsylvania Press.

Gordon, T. (1990) *Feminist Mothers*, London: Macmillan.

Goring, B. (2004) *The perspectives of U.K. Caribbean parents on schooling and education: change and continuity*, unpublished PhD thesis, London South Bank University.

Goulbourne, H. (1989) 'The Contribution of West Indian Groups to British Politics', in Goulbourne, H. (ed.) *Black Politics in Britain*, London: Avebury.

Goulbourne, H. (1990) *Black Politics in Britain*, London: Avebury Press.

Goulbourne, H. (1998a) *Race Relations in Britain since 1945* London: Macmillan.

Goulbourne, H. (1998b) 'The participation of new minority ethnic groups in British politics' in Blackstone, T., Parekh, B. and Sanders, P. (eds) *Race relations in Britain: a developing agenda*, London: Routledge.

Goulbourne, H. (1998c) *Exodus?: some social and policy implications of return migration to the Commonwealth Caribbean in the 1990s*, discussion paper presented at the International Conference on The Caribbean family and living arrangements in Britain and the Trans-Atlantic World, March 1998, Cheltenham and Gloucester College, Cheltenham.

Goulbourne, H. (2002) *Caribbean Transnational Experience*, London: Pluto Press.

Goulbourne, H. and Chamberlain, M. (1999) 'Living Arrangements, Family structure and Social Change of Caribbeans in Britain', *ESRC Population and Household Change for Research*, Swindon: Economic Social Research Council.

Goulbourne, H. and Chamberlain, M. (2001) (eds) *Caribbean families in Britain and the trans-atlantic world*, London: Macmillan.

Goulbourne, H. and Solomos, J. (2003) 'Families, ethnicity and social capital, *Social Policy and Society*, 2, (2): 329-338.

Goulbourne, H. and Reynolds, T. (forthcoming) *A small scale study of black welfare based community organisations in the U.K.*, working paper series, Race and Ethnicity Research Unit, London South Bank University.

Grant, D. R. B., Leo-Rhynie, E. and Alexander, G. (1983) *Life cycle study: children of the lesser world in the English speaking Caribbean: volume 5*, Centre for Early Childhood Education.

Griffin, C. (1996) Experiencing Power: Dimensions of Gender, 'Race' and Class, in Charles, N. (ed.) *Practising Feminism: Identity, Difference and Power*, London: Routledge.

Guardian, (1995) *The Myth and the Mister*, 21 March, section p. 3.

Guardian, (1998) *The Prime Ministerial Speech in Full*, 30 September, p. 2.

Gunaratnam, Y. (2001) 'Eating into multiculturalism: hospice staff and service users talk, food, 'race', ethnicity, culture and identity', *Critical social policy*, 21 (3): 287-310.

Gutman, H. (1976) *The Black Family in Slavery and Freedom 1750-1925*, New York: Vintage.

Hakim, C. (1996) *Key issues in women's work: female heterogeneity and the polarisation of women's employment*, London: Athlone Press.

Halbwachs, M. (1992) *On collective memory* (ed. & trans., Coser, L. A) Chicago: University of Chicago Press.

Hall, S. (1991) The Local and the Global in King, A. (ed.) *Culture, Globalisation and the World System: Contemporary Conditions for Representations of Identity*, London: Macmillan.

Hall, S. (1992) New Ethnicities, in Donald, J. and Rattansi, A. (eds) *Race, Culture and Difference*, Buckingham: Open University Press.

Hall, S., Crichter, C., Jefferson, T., Clarke, J. and Roberts, B. (1978) *Policing the Crisis: Mugging, the State, Law and Order*, London: Macmillan.

Ham, C. (1991) *Health Policy in Britain*, London: Macmillan.

Haraway, D. (1988) Situated Knowledge: The Science Question in Feminism and the Privilege of Partial Perspective, *Feminist Studies*, 14 (3): 575-600.

Harding, S. (1991) *Whose Science? Whose Knowledge? Thinking from Women's Lives*, Open University Press.

Harding, S. (1993) Rethinking Standpoint Epistemology: 'What is Strong Objectivity?', Alcoff, L. and Potter, E. (eds) *Feminist Epistemologies*, London: Routledge.

Harley, S. (1997) Speaking Up: The Politics of Black Women's Labour History, in Higginbotham, E. and Romero, M. (eds) *Women and Work: Exploring Race, Ethnicity, and Class*, California: Sage Publications.

Hartsock, N. (1997) The Feminist Standpoint: Developing the ground for a specifically feminist historical materialism, in Nicholson, L. (ed.) *The Second Wave: A Reader in Feminist Theory*, London: Routledge.

Herskovits, M. J. (1941) *The myth of the negro past*, New York: Harpers and Brothers.

Hesse, B. (1997) White Governmentality: Urbanism, Nationalism, Racism, in Westwood, S. and Williams, J. (eds) *Imagining Cities: Signs, Scripts, Memory*, London: Routledge.

Higginbotham, E. and Romero, M. (1997) (eds) *Women and Work: Exploring Race, Ethnicity, and Class*, California: Sage Publications.

Higginbotham, E. (2001) *Too much to ask: black women in the era of integration*, Chapel Hill: University of North Carolina Press.

Hill-Collins, P. (1987) The Meaning of Motherhood in Black Culture and Black Mother-Daughter Relationships, *A Scholarly Journal on Black Women* 4 (2): 3-10.

Hill-Collins, P. (1990) *Black Feminist Thought: Knowledge, Empowerment and the Politics of Consciousness*, Boston and London: Unwin Hyman.

Hill-Collins, P. (1994) Shifting the Centre: Race, Class and Feminist Theorising about Motherhood, in Glenn, E, Chang, G. and Forcey, L. (eds) *Mothering: Ideology, Experiences and Agency*, California: Routledge.

Hill-Collins, P. (1997) Defining Black Feminist Thought, in Nicholson, L (ed.) *The Second Wave: A Reader in Feminist Theory*, London: Routledge.

Hill-Collins, P. (1999) *Fighting words: black women and the search for justice*, Minneapolis: Minneapolis Press.

Hillman, R. and D'Agnostino, J. (2003) (eds) *Understanding the Contemporary Caribbean*, Jamaica; Ian Randle Publishers.

Hirsch, M. (1990) Mothers and Daughters, in O'Barr, J. (ed.) *Ties That Bind: Essays on Mothering and Patriarchy*, University of Chicago Press.

Holland, J., Blair, M., Sheldon, M. (1995) (eds) *Debates and Issues in Feminist Research and Pedagogy*, Buckingham: Open University Press.

Holland, J. and Ramazanoglu, C. (1994) Coming to Conclusions: Power and Interpretation in Researching Young's Women's Sexuality, in Maynard, M. and Purvis, J. (eds)

Researching Women's Lives from a Feminist Perspective, London: Taylor and Francis.

Holland, J., Ramazanglu, C., Sharpe, S. and Thomson, R. (1998) *The male in the head: young people, heterosexuality and power*, London: the Tufnell Press.

hooks, b. (1982) *Ain't I a woman: black women and feminism*, London: Pluto Press.

hooks, b. (1989) *Talking Back: Thinking Feminism, Thinking Black*, London: Sheba Feminist Publishers.

hooks, b. (1990) *Yearning: Race, Gender and Cultural Politics*, Boston: South End Press.

hooks, b. (1992) *Black Looks: Race and Representation*, Boston: South End Press.

hooks, b. (1993) *Sisters of the yam: black women and self-recovery*, London: Turnaround.

hooks, b. (1996) *Killing Rage*, New York: Henry Holt.

Hylton, C. (1996) *Coping with change: families transitions in multi-cultural communities*, London: Exploring Parenthood.

Ireland, M. (1997) *Reconceiving Womanhood*, London: The Guildford Press.

Irwin, S. (1995) *Gender and Household Resourcing: changing relations to work and family,* GAPU working paper 12, School of Sociology and Social Policy, University of Leeds.

Jagger, G. and Wright, C. (1999) (eds) *Changing Family Values*, London: Routledge.

James, W. (1993) Migration, Racism and Identity Formation: The Caribbean Experience in Britain, in James, W. and Harris, C. (eds) *Inside Babylon: The Caribbean Diaspora in Britain*, London: Verso.

James, W. and Harris, C. (1993) (eds) *Inside Babylon: The Caribbean Diaspora in Britain*, London: Verso.

James, A. and Prout, A. (1997) *Constructing and Reconstructing Childhood*, second edition, London: Falmer Press.

Jones, T. (1993) *Britain's Ethnic Minorities*, London: Policy Studies Institute.

Jones, T. (1984) *Ethnic Minorities in Britain*, London: Policy Study Institute.

Joseph, G. and Lewis, G. (1980) *Common Differences: Conflicts in Black and White Feminist Perspectives*, New York: Anchor Books Ltd.

Joshi, H. (1991) Sex and Motherhood as Handicaps in the Labour Market, in MacClean, M. and Groves, D. (eds) *Women's Issues in Social Policy*, London: Routledge.

Kaplan, M. (1992) *Mothers' Images of Motherhood*, London: Routledge.

King, M. (1995) 'Black women's labour market status: occupational segregation in the United States and Britain,' *Review of Black Political Economy*, 24(1): 23-43.

Lal, J. (1996) Situating Location: The Politics of Self, Identity and 'Other' in Living and Writing the Text, in Wolf, D. (ed.) *Feminist Dilemmas in Fieldwork*, Colorado: Westview Press.

Lazreg, G. M. (1994) Women's Experiences and Feminist Epistemology: A Critical Neo-Rationalist Approach, in Lennon, K. and Whitford, M. (eds) *Knowing the Difference: Feminist Perspectives in Epistemology*, London: Routledge.

Lees, S. (1993) *Sugar and Spice: Sexuality and Adolescent Girls*, London: Penguin.

Lennon, K. and Whitford, M. (1994) (eds) *Knowing the Difference: Feminist Perspectives in Epistemology*, London: Routledge.

Leo-Rhynie, E. (1997) Class, race and gender: issues in child rearing in the Caribbean, in Roopnarine, J. and Brown, J, (eds) *Caribbean Families; diversity amongst groups*, New Jersey: Ablex Publishing Corporation.

Leonard, V. (1996) Mothering as a practice, in Gordon, S., Benner, P. and Noddings, N. (eds) *Caregivings: readings in knowledge, practice, ethics and politics*, Philadelphia: University of Pennsylvania Press.

Lewis, C. and O'Brien, M. (1988) *Reassessing Fatherhood: New Observations on Fathers and the Modern Family Life*, London: Sage.

Lewis, G. (2000) *'Race', Gender and Social Welfare*, London: Polity Press.

Lewis, G. (1993) Black Women's Employment and the British Economy, in. James, W. and Harris, C. (eds) *Inside Babylon: The Caribbean Diaspora in Britain*, London: Verso.

Lewis, J. (2002) Individualisation, assumptions about the existence of an adult worker model and the shift towards contractualism, in Carling, A., Duncan, S. and Edwards, R. (eds) *Analysing Families: morality and rationality in policy and practice*, London: Routledge.

London Borough of Merton, Department of Social Services (1997) *Operational Review of Day Care Services for the Elderly in Merton*, London: London Borough of Merton.

Lowenthal, D. (1972) *West Indian Societies*, London: Oxford University Press.

Luttrell, W. (1998) *Schoolsmart and Motherwise: Working-class Women's Identity and Schooling*, London: Routledge.

McAdoo, H. P. (1988) (ed.) *Black Families*, California: Sage.

McAdoo, H. P. (1988) Transgenerational Patterns of Upward Mobility in African-American Families, in McAdoo, H. P. (ed.) *Black Families*, second edition, California: Sage.

McAdoo, H. P. (1996) (ed.) *Black Families*, second edition, California: Sage.

McAdoo, J. (1986) Black fathers' relationship with their pre-school children and the children's development of ethnic identity, in Lewis, R. and Salt, R [eds] *Men in Families*, California: Sage.

McAdoo, J. (1988a) The Role of Black Fathers in the socialisation of black children, in McAdoo, H. P. (ed.) *Black Families*, California: Sage.

McAdoo, J. (1988b) Changing perspectives on the role of the black father, in Bronstein, P. and Cowan, C. (eds) *Fatherhood today: Men's changing role in the family*, New York: John Riley.

McAdoo, J. (1993) The role of African-American Fathers: An ecological perspective, *Families in Society*, 74: 28-35.

McCalla, D. (2003) (ed.) *Black success in the U.K. : essays in racial and ethnic studies*, London: Vision Learning Ltd.

McClintock, A. (1995) *Imperial Leather: 'Race', Gender and Sexuality in the Colonial Context*, London: Routledge.

Mckenzie, H. (1982) (ed.) Introduction: women and the family in Caribbean society, *Women and the family: women in the Caribbean project*, vol 2, Barbados: University of the West Indies Press.

McRobbie, A. (1982) The Politics of Feminist Research: Between Talk, Text and Action, *Feminist Review*, 12 (Summer): 46-57.

Mac an Ghaill, M. (1988) *Young, Gifted and Black: Student-Teacher Relations in the Schooling of Black Youth*, Buckingham: Open University Press.

Mac an Ghaill, M. (1993) *Understanding Masculinities: Social Relations and Cultural Arenas*, Buckingham: Open University Press.

Malik, K. (1996) *The Meaning of Race*, London: Macmillan.

Mama, A. (1993) Woman Abuse in London's Black Communities, in James, W. and Harris, C. (eds) *Inside Babylon: The Caribbean Diaspora in Britain*, London: Verso.

Mama, A. (1995) *Beyond the Masks: Race, Gender and Subjectivity*, London: Routledge.

Marriott, D. (1996) Reading Black Masculinities, Mac an Ghail, M. (ed.) *Understanding Masculinities*, London: Open University Press.

Massiah, J. (1986) (ed.) *Women in the Caribbean part I and II*, Institute of Social and Economic Research, Kingston, Jamaica: University of the West Indies.

Maynard, M. (1994) 'Race', Gender and the Concept of 'Difference', Asfhar, H. and Maynard, M. [eds] *The Dynamics of 'Race' and Gender: Some Feminist Interventions*, London: Taylor and Francis.

Maynard, M. and Purvis, J. (1994) (eds) *Researching Women's Lives from a Feminist Perspective*, London: Taylor and Francis.

Mercer, K. and Julien, I. (1988) Race, Sexual Politics and Black Masculinity, in Chapman, R. and Rutherford, J. (eds) *Male Order: Unwrapping Masculinity*, London: Lawrence and Wishart.

Mercer, K. (1994) *Welcome to the jungle: new positions in black cultural studies*, London: Routledge.

Minh-ha, T. (1989) *Woman, Native, Other: Writing Post-Coloniality and Feminism*, Indianapolis: Indiana University Press.

Millar, J. (2000) *Keeping Track of Welfare Reform: The New Deal Programmes*, London: Joseph Rowntree Foundation.

Millar, J. (1989) *Poverty and the Lone-Parent: The Challenge to Social Policy*, Aldershot: Avebury.

Millett, K. (1970) *Sexual Politics*, London: Abacus.

Mirza, H. (1992) *Young, Female and Black*, London: Routledge.

Mirza, H. (1993) The Social Construction of Black Womanhood, in British Educational Research: Towards a New Understanding, in Arnot, J. and Weiler, K. (eds) *Feminism and Social Justice in Education*, London: Taylor and Francis.

Mirza, H. (1995) Black Women in Higher Education: Defining a Space/Finding a Place, in Morley, L. and Walsh, V. (eds) *Feminist Academics: Creative Agents for a Change*, London: Taylor and Francis.

Mirza, H. (1997) Introduction: Mapping a Genealogy of Black British Feminism, in Mirza, H. (ed.) *Black British Feminism: A Reader*, London: Routledge.

Mirza, H. (1998) Race, Gender and IQ: the social consequence of a pseudo-scientific discourse, *Journal of Race, Ethnicity and Education*, 1 (1): 109-126.

Mirza, H. and Reay, D. (2000) 'Spaces and Places of Black Education Desire: Rethinking Black Supplementary Schools as a New Social Movement', *Sociology*, 34 (3): 477-499.

Modood, T. (1997) (ed.) *Ethnic Minorities in Britain*, London: Policy Studies Institute.

Moghissi, H. (1994) Racism and Sexism in Academic Practice, in Asfhar, H. and Maynard, M. (eds) *The Dynamics of 'Race' and Gender: Some Feminist Interventions*, London: Taylor and Francis.

Mohammed, P. (1983) Domestic workers in the Caribbean, in *Concerning Women and Development*, 11-83, WAND, Department of Extra-Mural Studies, Barbados: University of West Indies.

Mohammed, P. (1988) (ed.) *Gender in Caribbean Development*, Women and Development Studies Project, Trinidad; University of the West Indies.

Mohammed, P. (2004) Unmasking masculinity and deconstructing patriarchy: problems and possibilities in feminist epistemology, in Reddock, R. (ed) *Interrogating Caribbean*

masculinities: theoretical and empirical analyses, Kingston, Jamaica, University of the West Indies Press.

Mohanty, C. T. (1988) Under Western Eyes: feminist scholarships and colonial discourses, in *Feminist Review*, 30: 65-88.

Mohanty, T. P. (1992) Feminist encounters: Locating the Politics of Experience, in Barrett, M. and Phillips, A. (eds) *Destabilising Theory*, London: Polity Press.

Momsen, J. (1993) (ed.) *Women and Change in the Caribbean*, London: James Currey Publishing.

Morgan, P. (1995) *Farewell to the Family: public policy and family breakdown in Britain and the U.S.A.*, London: Institute of Economic Affairs.

Morrison, T. (1987) *Beloved*, New York: Alfred A. Knopf Inc.

Moyenda Project (1997) *Family and Survival Strategies: Moyenda Black Families Report*, London: Exploring Parenthood.

Moynihan, D. (1965) *The Moynihan Report: The Negro Family, the case for national action*, Washington, DC: Government Printing Office.

Murray, C. (1985) *Losing Ground: American Social Policy, 1950-1980*, New York: Basic Books.

Murray, C. (1994) *Underclass: The Crisis Deepens*, London: Institute of Economic Affairs.

Naples, N. (1996) Activist Mothering: cross-generational continuity in the community work of women from low-income urban neighbourhoods, in Chow, E., Wilkinson, D. and Zinn, M. (eds) *Race, Class and Gender: common bonds, different voices*, California; Sage.

Narayan, U. (1997) Contesting Cultures: 'Westernization', Respect for Cultures, and Third World Feminists, in Nicholson, L. (ed.) *The Second Wave: A Reader in Feminist Theory*, London: Routledge.

Nasta, S. (1991) *Motherlands: Black women's writing from Africa, the Caribbean and South Asia*, London: The Women's Press.

Neale, B. and Smart, C. (1997) Experiments with Parenthood, *Sociology*, 31 (2): 201-219.

Nettleford, R. (2003) *Caribbean cultural identity*, Jamaica: Ian Randle Publishers.

Nnaemeka, O. (1996) *The Politics of (M)othering: Womanhood, Identity and resistance in African Literature*, Routledge.

O'Brien, M. (1996) *Missing Mum*, television broadcast on BBC1 Panorama, Monday 3 February 1996, London: BBC.

Oakley, A. (1974) *Housewife*, Penguin Books Ltd.

Oakley, A. (1977) *The Sociology of Housework*, London: Robertson.

Oakley, A. (1979) *Becoming a mother*, Oxford: Martin Robertson.

OFSTED (1996) *Exclusion from Secondary Schooling in England*, London: OFSTED.

Olwig, K. (1993) *Global culture, island identity, continuity and change in afro-Caribbean community of Nevis*, London: James Currey.

Omi, M. and Winant, H. (1994) *Racial formation in the United States*, New York: Routledge.

Opie, A. (1992) Qualitative Research Appropriation of the 'Other' and Empowerment, *Feminist Review*, Spring, 40, 52-69.

Owen. D. (1994) *Ethnic Minority Women and the Labour Market: Analysis of the 1991 Census*, London: Equal Opportunities Commission.

Owen, D. (1996) Black-Other: The melting pot, in Peach G. C. K. (ed.) *Ethnicity in the 1991 Census vol. 2: The ethnic minority populations of Great Britain*, London: HMSO.

Owen, D. (1997) A demographic profile of Caribbean households and families in Great Britain, in Centre for research in Ethnic Relations *Living Arrangements, Family Structure and Social Change of Caribbeans in Britain: ESRC populations and household change research programme*, Coventry: University of Warwick.

Parmar, P. (1982) Gender, Race and Class: Asian Women in Resistance, in Centre for Contemporary Cultural Studies (ed.) *The Empire Strikes Back: Race and Racism in 70s Britain*, London: Routledge.

Parry, O. (2000) *Male underachievement in high school education in Jamaica, Barbados, St. Vincent and the Grenadines*, Kingston, Jamaica: University of the West Indies and Canoe Press.

Peach, C. (1991) *The Caribbean in Europe: contrasting patterns of migration and settlement in Britain, France and the Netherlands*, Coventry: Centre for Research in Ethnic Relations, University of Warwick, Research Paper 15.

Peters, Ferguson, M. (1988) Parenting in Black Families with Young Children: A Historical Perspective, in McAdoo, H. P. (ed) *Black Families*, second edition, California: Sage.

Phillips, M. (1999) *The sex change society: feminised Britain and neutered male*, London: Social Market Foundation.

Phoenix, A. (1987) Theories of Gender and Black Families, in Weiner, G and Arnot, M. (eds) *Gender Under Scrutiny: New Enquiries in Education*, London: Hutchinson.

Phoenix, A. (1988) Narrow definitions of culture: the case of early motherhood, in Westwood, S. and Bhachu, P. (eds) *Enterprising Women*, London: Routledge.

Phoenix, A. (1991) *Young Mothers*? Cambridge: Polity Press.

Phoenix, A. (1994) Practising feminist research: the intersections of gender and 'race' in the research process, in Maynard, M. and Purvis, J. (eds) *Researching Women's Lives from a Feminist Perspective*, London: Taylor and Francis.

Phoenix, A. (1996) Social constructions of Lone-Motherhood: A case of competing discourses, in Silva. E. B. (ed.) *Good Enough Mothering?,* London: Routledge.

Phoenix, A., Wollett, A. and Lloyd, E. (1991) (eds) *Motherhood, Meanings, Practices and Ideologies*, London: Sage.

Plummer, K. (2001) Documents of life-2: an invitation to a critical humanism, London: Sage.

Powell, D. (1986) Caribbean Women and their Response to Familial Experience, in Massiah, J. (ed) *Women in the Caribbean part I*, Institute of Social and Economic Research, University of the West Indies.

Pulsipher, L. (1993) Changing roles in the traditional West Indian houseyards, in Momsen, J. (ed) *Women and Change in the Caribbean*, James Currey Publishing.

Radkte, H. L. and Stam, H. J. (1994) *Power/Gender: Social Relations in Theory and Practice*, London: Sage.

Razoool, N. (1997) Fractured or flexible identities? Life histories of 'black' diasporic women in Britain, in Mirza, H. (ed.) *Black British Feminism*, London: Routledge.

Reay, D. (1995) Dealing with Difficult Differences: Reflexivity and Social Class in Feminist Research, in Walkerdine, V. (ed.) *Feminism and Psychology: Special Issue on Social Class*, 16 (3): 195-209.

Reay, D. (1998) *Class Work: Mothers Involvement in their Children's Primary Schooling*, London: Taylor and Francis.

Reay, D. and Mirza, H. (1997) Uncovering genealogies of the margins: black supplementary schooling, in *British Journal of Sociology and Education*, 18 (4) 477-499.

Reddock, R. (2004) (ed.) *Interrogating Caribbean masculinities: theoretical and empirical analyses*, Jamaica: University of the West Indies Press.

Reed, M. (2004) *The black and minority ethnic voluntary and community sector—a literature review*, London: The Council for Ethnic Minority Voluntary Sector Organisations.

Reynolds, T. (1997a) (Mis)representing the black (super)woman, in Mirza, H. (ed.) *Black British Feminism: A Reader*, London: Routledge.

Reynolds, T. (1997b) Class Matters, Race Matters, Gender Matters, in Mahony, P. and Zmorczek, C. (eds) *Class Matters: Working-class Women's Perspectives on Social Class*, London: Taylor and Francis.

Reynolds, T. (1999) *African-Caribbean Mothering: reconstructing a 'new' identity*, unpublished thesis, London South Bank University.

Reynolds, T. (2001). 'Black Mothers, Paid Work and Identity', *Journal of Ethnic and Racial Studies*, 24 (1): 1046-1064.

Reynolds, T. (2001b) 'Caribbean Fathers in Family Lives', in Goulbourne, H. and Chamberlain, M. (eds) *Caribbean Families in the Trans-Atlantic World*, London: Macmillan.

Reynolds, T. (2002) 'Analyzing the Black Family', in Carling, A., Duncan, S. and Edwards, R. (eds) *Analysing families: morality and rationality in policy and practice*, London: Routledge.

Reynolds, T. (2003a) The Success of Our Mothers: Caribbean mothering and Child rearing in the U.K., in D. McCalla (ed.) *Black Success in the U.K.: essays in racial and ethnic studies*, Cambridge: Vision Enterprise/Cambridge University Press.

Reynolds, T. (2003b) Black to the community: Black community parenting in the U.K., *Journal of Community, Work and Family*, 6 (1): 29-41.

Reynolds, T. (2004) *Caribbean Families, Social Capital and Young People's Diasporic Identities*, Families and Social Capital ESRC Research Group Working Paper Series, no. 12, London South Bank University.

Rhodes, P. (1994) Race-of-Interviewer Effects in Qualitative Research, *Sociology* 28 (2): 547-558.

Rhodes, P. J. (1992) The emergence of a new policy: racial matching in fostering and adoption, *New Community* 18 (2): 58-70.

Ribbens, J. (1995) *Mothers and their Children: A Feminist Sociology of Child rearing*, London: Sage.

Rich, A. (1977) *Of Women Born: Motherhood as Experience and Institution*, Virago Press.

Richardson, D. (1993) *Women, Motherhood and Child rearing*, London: Macmillan.

Roopnarine, J. and Brown, J., (1997) (eds) *Caribbean families; diversity among ethnic groups*, London: JAI Press Ltd.

Roopnarine, J., Snell-White, P., Riegraf, N., Crossley, D., Hossain, Z., and Webb, W. (1995) Fathers involvement in child care and housework in common-law, dual-earner, and single-earner Jamaican families, *Journal of applied developmental psychology*, 16: 35-52.

Rose, E. B. (1968) *Colour and Citizenship: A Report on British Race Relations*, London: Oxford University Press.

Roschelle, A. (1997) *No More Kin: Exploring Class, Race and Gender in Family Networks*, California: Sage.

Rowlands, M. (1997) Memory, Sacrifice and the Nation, in *Cultural Memory: A Journal of Culture/Theory/Politics*, 30 (Winter): 8-17.

Ruddick S. (1994) Thinking mothers/conceiving birth', in Bassin, D., Honey, M. and Kaplan, M. (eds) *Representations of motherhood*, New Haven: Yale University Press.

Ruddick, S. (1980) Maternal Thinking, *Feminist Studies*, 6 (2): 342-367.

Runnymede Trust (1996) *This is Where I Live: Stories and Pressures in Brixton*, London: Runnymede Trust.

Russell-Browne, P., Norville, B. and Griffith, C. (1997) Child shifting: a survival strategy for teenage mothers, in Roopnarine, J. and Brown, J. (eds) *Caribbean Families; diversity amongst groups*, London: JAI Press Ltd.

Safa, H. (1986) Economic Autonomy and Sexual Equality in Caribbean Society, in Masssiah, J. (ed) *Women in the Caribbean part I*, Institute of Social and Economic Research, University of the West Indies.

Sanford, N. (1976) Child lending in Belize, *Belizean Studies*, 4 (2): 26-36.

Scarman, Lord (1982) *The Scarman Report: the Brixton disorders*, Harmondsworth: Pelican.

Schmidt, V. (2001) 'Oversocialised Epistemology: A Critical Appraisal of Constructivism', *Sociology*, 35 (1): 35-157.

Scott, P. B., Guy-Sheftall B., Jones-Royster, J., Sims-Wood, J., DeCosta-Willis, M. and Fultz, L. (1991) (eds) *Double Stitch: Black Women Write about Mothers and Daughters*, Boston: Beacon Press.

Scott-MacDonald, K. (1997) The status of child care supports for Jamaican families, in Roopnarine, J. and Brown, J., (eds) *Caribbean families; diversity among ethnic groups*, London: JAI Press Ltd.

Seguera, D. (1994) Working at Motherhood: Chicana and Mexican Immigrant Mothers and Employment, in Glenn, E., Chang, G. and Forcey, L. (eds) *Mothering: Ideology, Experiences and Agency*, California: Routledge.

Select Committee on Race Relations and Immigration (1969) *The problem of coloured school leavers*, Volume III Evidence, London: HMSO.

Senior, O. (1991) *Working Miracles: Women's Lives in the English Speaking Caribbean*, London: James Currey Publishing.

Sevenhuijsen, S. (1998) *Citizenships and the ethics of care: feminist considerations on justice and morality and justice*, London: Routledge.

Sewell, T. (1997) *Black Masculinities and Schooling: How Black Boys Survive Modern Schooling*, London: Trentham Books.

Sharpe, S. (1976) *Just Like a Girl*, Harmondsworth: Penguin Books.

Sharpe, S. (1994) *Fathers and Daughters*, Harmondsworth: Penguin Books.

Shaw, S. (1994) Mothering Under Slavery in the Antebellum South, in Glenn, E., Chang, G. and Forcey, L. (eds) *Mothering: Ideology, Experiences and Agency*, California: Routledge.

Shepherd, C. and Mohammed, P. (1988) (eds) *Gender in Caribbean Development*, Women and Development Studies Project, Trinidad: University of the West Indies.

Shepherd, V., Brereton, B. and Bailey, B. (1995) (eds) *Engendering History: Caribbean Women in a Historical Perspective*, London: James Currey Publishing.

Signe, H. (1986) *Daughters and Mothers: Mothers and Daughters*, London: Hutchinson.

Silva, E. B. (1996) (ed.) *Good Enough Mothering?*, London: Routledge.

Silva, E. and Smart, C. (1999) (eds) *The New Family?* London: Sage.

Skeggs, B. (1994) Situating the Production of Feminist Ethnography, in Maynard, M. and Purvis, J. (eds) *Researching Women's Lives from a Feminist Perspective*, London: Taylor and Francis.

Skeggs, B. (1997) *Formations of Class and Gender*, London: Sage.

Skellington, R. and Morris, P. (1992) *Race in Britain Today*, London: Sage.

Smart, C. (1996) Deconstructing Motherhood, in Silva, E. (ed.) *Good Enough Mothering? Feminist Perspectives on Lone-Motherhood*, London; Routledge.

Smart, C. and Neale, B. (1997) Good Enough Morality? Divorce and Postmodernity, *Critical Social Policy*, 17 (4): 3-27.

Smith, R. T. (1953) *The Matrifocal Family*, London: Routledge, Kegan and Paul.

Smith, R. T. (1962) West Indian family structures, Seattle: University of Washington Press.

Smith, R. T. (1996) *The Matrifocal Family: Power, Politics and Pluralism*, revised edition, London: Routledge.

Snitow, A. (1980) Feminism and Motherhood: An American Reading, republished in *Feminist Review*, 40, Spring, 33-51.

Solomos, J. (1989) *'Race' and Racism in Contemporary Britain*, London: Macmillan.

Solomos, J. (1998) *Black Youth, Racism and the State*, second edition, Cambridge: Cambridge University Press.

Spelman, E. (1990) *Inessential Woman: Problems of Exclusion in Feminist Thought*, London: Women's Press.

Stack, C. (1974) *All Our Kin: Strategies for Survival in the Black Community*, New York: Harper and Row.

Stack, C. and Burton, L. (1994) Kinscripts: Reflections on Family, Generation and Culture, in Glenn, E., Chang, G. and Forcey, L. (eds) *Mothering: Ideology, Experiences and Agency*, California: Routledge.

Stanfield, J. and Dennis, M. (1994) *Race and Ethnicity in Research Methods*, London: Sage.

Stanley, L. and Wise, S. (1993) *Breaking Out: Feminist Ontology and Epistemology*, London: Routledge.

Staples, R. (1981) Race and Marital Status, in McAdoo H. P. (ed.) *Black Families*, first edition, California: Sage.

Staples, R. (1985) The Myth of the Black Matriachy, in Steady, F. (ed.) *The Black Woman Cross-Culturally*, Rochester, Vermont: Schenkman Books.

Steady, F. (1985) (ed.) *The Black Woman Cross-Culturally*, Rochester, Vermont: Schenkmann Books.

Steier, F. (1991) *Research and Reflexivity*, London: Sage.

Stubbs, P. (1993) "Ethnically sensitive" or "anti-racist"? Models for health research and service delivery, IN Ahmad, W. (ed.) *'Race' and health in contemporary Britain*, Buckingham: Open University Press.

Sudbury, J. (1998) *Other Kinds Of Dreams: Black women's organisations and the politics of transformations*, London: Routledge.

Sudakasa, N. (1996) *The strength of our mothers: African and African American women and families*, New Jersey: African world Press.

Sulemain, S. (1985) Writing and Motherhood, Garner, S and Kahane, C. (eds) *The (M)other Tongue*, New York: Cornell University Press.

Sunday Express, (1995) *The Ethnic Time-Bomb*, 13 August, p. 2.

Sutton, C. and Makiesky-Barrow, S. (1985) Social Inequality and Sexual Status in Barbados, Steady, F. (eds) *The Black Woman Cross-Culturally*, Rochester, Vermont: Schenkman Books.

Tarlow, B. (1996) Caring: a negotiated process that varies, in Gordon, S., Benner, P. and Noddings, N. (eds) *Caregivings: readings in knowledge practice, ethics and politics*, Philadelphia: University of Pennsylvania Press.

Taylor, R. (1996) Adolescent's Perceptions of Kinship Support and Family Management Practices in African-American Families, *Developmental Psychology*, 32: 67-77.

Taylor, R., Jackson, S. and Chatters, L. (1997) (eds) *Black Family Life in America*, California: Sage.

Taylor, R. and Johnson, W. (1997) Family Roles and Family Satisfaction Among Black Men, in Taylor, R., Jackson, S. and Chatters, L. (eds) *Black Family Life in America*, California: Sage.

Titley, M. and Chase, B. (1996) Across Difference and Age: Young women speaking of and with old women, in Wilkinson, S. and Kitzinger, C. (eds) *Representing the Other*, London: Sage.

Tizard, B. and Phoenix, B. (1993) *Black, White or Mixed Race: race and racism in the lives of young people of mixed parentage?*, London: Routledge.

Tomlinson, S. (1983) *Ethnic Minorities in British Schools*, London: Heinemann.

Tonkin, E. (1992) *Narrating Our Pasts: The Social Construction of Oral History*, Cambridge; Cambridge University Press.

Unicef (2004) *The regional symposium on juvenile justice in the Caribbean: towards a right approach for children*, UNICEF.

Ungerson, C. (1990) (ed.) *Gender and caring: work and welfare in Britain and Scandinavia*, London: Harvester Wheatsheaf.

VanEvery, J. (1995) *Refusing to be a 'Wife': Heterosexual Women Changing the Family*, London: Taylor and Francis.

Vickerman, V. (1999) *Crosscurrents; West Indian immigrants and race*, Oxford University Press.

Vidali, A. (1997) Political Identity and the Transmission of Trauma, in *Cultural Memory: A Journal of Culture/Theory/Politics*, 30, (Winter): 33-45.

Virdee, S. (1997) Racial Harassment, Modood, T. (eds) *Ethnic Minorities in Britain*, London: Policy Studies Institute.

Voice, (1994) *The Silent Revolution*, 2 August, p. 12.

Walby, S. (1990) *Theorising Patriarchy*, Oxford: Blackwell.

Walker, A. (1976) Meridian, New York: Harcourt Brace Jovonavich.

Walker, A. (1994) *In Search of My Mothers' Garden*, New York: Harcourt Brace Jovonavich.

Walkerdine, V. (1997) *Daddy's Girl: Young girls and popular culture*, London: Macmillan.

Wallace, M. (1978) *Black Macho and the Myth of the Superwoman*, New York: Dial.

Wallman, S. (1984) *Eight London Households*, London: Tavistock.

Wallman, S. (1988) The Boundaries of 'Race': Processes of Ethnicity in England, *Critical Social Policy* 13(2): 200-217.

Wambu, O. (1998) *Windrush: 50 years On*, London: Virago.

Ware, V. (1992) *Beyond the Pale: White Women, Racism and History*, London: Verso.

Waters, M. (1999) *Black identities: West Indian immigrant dreams and realities*, Harvard: Russell Sage Foundation.

Watson, R. (1997) *Researching Asian Mothers Leisure Activities: Methodological Implications for a White Female Researcher Interviewing Asian Women*, paper

presented at Transformations: Thinking Through Feminisms conference, University of Lancaster, July 1997.

Weber, L. and Higginbotham, E. (1997) Black and White Professional-Managerial Women's Perceptions of Racism and Sexism in the Work place, in Higginbotham, E. and Romero, M. (eds) *Women and Work: Exploring Race, Ethnicity, and Class*, California: Sage Publications.

Weedon, C. (1987) *Feminist Practice and Poststructuralist Theory*, Oxford: Blackwell.

Weeks, J. Donovan, C. and Heaphy, B. (1999) 'Everyday Experiments: Narratives of Non-Heterosexual Relationships', Silva, B. and Smart, C. (eds) *The New Family?*, London: Sage Publications.

Weekes, D. (1997) Shades of Blackness: young female constructions of beauty, in Mirza, H. (ed.) *Black British Feminism*, London: Routledge.

Westwood, S. and Bhachu, P. (1988) (eds) *Enterprising Women: Ethnicity, Economy and Gender Relations*, London: Routledge.

Wilkie, J. (1997) Changes in U. S Men's Attitude Towards the Family Provider Role, *Gender and Society*, 7 (2): 261-279.

Wilkinson, S. and Kitizinger, C. (1996) *Representing the Other*, London: Sage.

Williams, F. (1989) *Social Policy: A Critical Introduction*, London: Polity Press.

Williams, F. (1996) Postmodernism, Feminism and the Question of Difference, in Parton, N. (ed.) *Social Theory, Social Change and Social Policy*, London: Routledge.

Williams, P. (1997) *Seeing a Colour Blind Future—the paradox of race—the 1997 Reith Lectures*, London: Virago.

Wilson, P. (1969) Reputation and Respectability: a suggestion for Caribbean ethology, *Man*, 3 (4)1-11.

Wilson, W. J. (1987) *The Truly Disadvantaged: the inner city, the underclass and public policy*, Chicago: University of Chicago Press.

Wilson, W. J. (1996) *When work disappears: the work of the new urban poor*, New York: Random House.

Wolf, D. (1996) (ed.) *Feminist dilemmas in fieldwork*, Oxford: Westview Press

Woodward, K. (1997) Motherhood, Identities, Meanings and Myths, in Woodwards, K. (ed.) *Identity and Difference*, Buckingham: Open University Press.

Wright, C. (1988) The relations between Teachers and Afro-Caribbean pupils, in Weiner, G. and Arnot, M. (eds) *Gender Under Scrutiny*, Buckingham: Open University Press.

Wright, C. and Jagger, G. (1999) End of Century, end of family?: shifting discourses of family 'crisis', in Jagger, G. and Wright, C. (eds) *Changing Family Values*, London: Routledge.

Young, L. (1996) *Fear of the Dark; Race, Gender and Sexuality in the Cinema*, London: Routledge.

Young, R. (1994) *Colonial desire: hybridity in theory, culture and race*, London: Virago.

Printed in the United Kingdom
by Lightning Source UK Ltd.
107186UKS00002B/247-342

9 781872 767529